W9-DGE-701

Dora Vallier

Translated from
the French by
Jonathan Griffin

The Orion Press

New York 1970

Abstract Art

First published in France under the title *L'art abstrait*,
© Librairie Générale Française, 1967.

Translation ©1970 , Grossman Publishers, Inc.

Library of Congress Catalogue Number: 75–86121

Manufactured in The Netherlands.

Designed by Jacqueline Schuman.

To
Pierre
Rouve

Contents

Contents

To
Pierre
Rouve

ABSTRACT ART

Introduction

Abstract art was born with this century—almost exactly. First in painting, then in sculpture, there appeared forms not containing an image of the outside world. The artist no longer names, he expresses. It is for the spectator to catch, by his own reactions, the significance of what is expressed.

The first work that set out deliberately in this direction was a watercolor by Kandinsky. Its date, 1910, marks historically the beginning of abstract art. The discovery of abstract watercolors or drawings belonging to the same year, or even a little earlier, among the work of other artists, does not alter the case, for these were occasional gestures; there is no lack of them throughout the nineteenth century, and even before then, in the preparatory studies it was usual to make for a picture. But none of those apparently abstract forms is an instance of the kind of abstraction that became prevalent in twentieth-century art.

Kandinsky, though the first painter in whom abstraction arose from a profound conviction, was not the only one. A few years later—in 1914—Mondrian in turn, coming by a quite different path, abandoned figuration. Almost at the same time a third painter of importance, Malevich, arrived at abstraction by yet other ways. One of these artists was living in Munich, the second in Paris, the third in Moscow. In fact, abstract art arose and installed itself from one end of Europe to the other at the beginning of the century. It followed close upon fauvism, expressionism, and cubism, assimilating some of their elements, just as they had assimilated preceding contributions; but in the direct line which establishes the continuity of art from century to century there had arrived a new fact: real objects indissolubly linked to form had been superseded. So abstract art breaks with the past: with the immediate past, with the more distant past, with the still more distant—probing further and further back, one asks oneself how far the rupture goes.

Have there been abstract forms in the past?

In seeking antecedents for abstraction, we can draw upon that extension of history which now enables us to take in man's artistic activity from the remotest times and in the uttermost parts of the world. Space and time, laid out before us, join in forcing us soon to the conclusion that abstraction lucidly conceived— deduced from the very essence of art, as it has been in the twentieth century—never existed before. The full, deliberate abstract operation is without precedent. Whether right at the start of the paleolithic, during the neolithic, or in the iron age; whether at a few moments in antiquity, or among the barbarians at the height of the Middle Ages; among the nomads of the steppes, or in primitive tribes at the antipodes: wherever form

has departed from realistic representation, it has hit upon an appearance of abstraction without being abstract in the sense characteristic of present-day art. Generalizations in this field are dangerous, yet it seems clear that the tendency to abstraction was in every case the result either of a will to stylization, to schematization, or of some contraction of a realistic form into a sign: in all those cases the presence of real objects persists right through the creative process, which transforms them but does not repudiate them. The consequent relative abstraction is only an end product. Never a point of departure. No such thing as a consciousness of "going abstract." The most telling example that bears on this is the art of Islam, commonly regarded as eminently abstract because it is the only one in which a renunciation of reality is imposed by religion; it is therefore an absolute obligation, which the artist respects. What he does is to abstain

1. Painting on beaten bark (New Guinea).

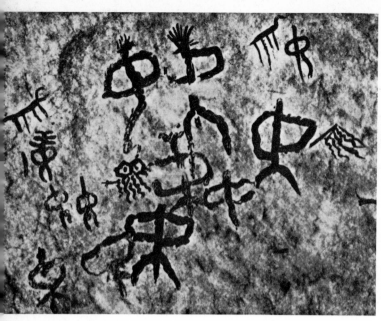

2. Paleolithic: schematic human and animal figures, painted, in the cave of La Graja (Spain).

from representing the human face or figure. But the continuous line of his arabesques is often adorned with flowers, birds, or stylized animals: reality is there, inscribed in these forms, which we wrongly call abstract (because they are stylized). Or else we call them decorative—a second mistake, as instructive as it is crass. Decorative—these forms placed on the mosque walls side by side with the sacred texts, which are also reduced to calligraphic signs and offered to the sight as well as to the mind? Certainly not. Only, their original value as symbols has disappeared—has given place, in us, to aesthetic appreciation alone. We run this risk of looking at things in a wrong way every time we pass from one civilization to another, crossing the centuries in order to extract forms from them here and there: involuntarily we add a different, purely aesthetic significance where the form's old significance has been lost.

has departed from realistic representation, it has hit upon an appearance of abstraction without being abstract in the sense characteristic of present-day art. Generalizations in this field are dangerous, yet it seems clear that the tendency to abstraction was in every case the result either of a will to stylization, to schematization, or of some contraction of a realistic form into a sign: in all those cases the presence of real objects persists right through the creative process, which transforms them but does not repudiate them. The consequent relative abstraction is only an end product. Never a point of departure. No such thing as a consciousness of "going abstract." The most telling example that bears on this is the art of Islam, commonly regarded as eminently abstract because it is the only one in which a renunciation of reality is imposed by religion; it is therefore an absolute obligation, which the artist respects. What he does is to abstain

1. Painting on beaten bark (New Guinea).

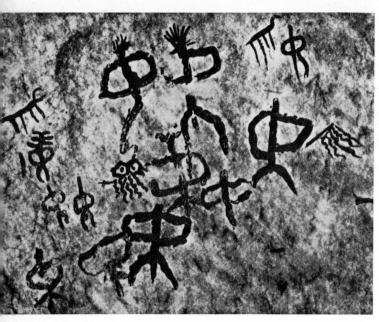

2. Paleolithic: schematic human and animal figures, painted, in the cave of La Graja (Spain).

from representing the human face or figure. But the continuous line of his arabesques is often adorned with flowers, birds, or stylized animals: reality is there, inscribed in these forms, which we wrongly call abstract (because they are stylized). Or else we call them decorative—a second mistake, as instructive as it is crass. Decorative—these forms placed on the mosque walls side by side with the sacred texts, which are also reduced to calligraphic signs and offered to the sight as well as to the mind? Certainly not. Only, their original value as symbols has disappeared—has given place, in us, to aesthetic appreciation alone. We run this risk of looking at things in a wrong way every time we pass from one civilization to another, crossing the centuries in order to extract forms from them here and there: involuntarily we add a different, purely aesthetic significance where the form's old significance has been lost.

form and wears it away: the necessity of repeating the same object in a number of copies brings with it first the stylization of the concrete object adopted as ornament, next its schematization (a process also exemplified by the heads on coins), until at last, helped by haste in execution, we come down to stereotyped abstraction. The form — simple or composite, it makes no difference — becomes then a hulk left empty by the disappearance of the symbol; for we must not forget that all the abstract elements of ornamentation — the spiral, the Greek key pattern, the swastika, and so on — began by having a precise symbolic and even ritual value, like the cross to Christians. Life and death were present in them, for whole communities; and whenever this is the case, the permanence of the consecrated sign relegates aesthetic considerations to second place and then does away with them. And so this type of abstraction lies outside artistic creation — except at the moment of its genesis, which is lost in the darkness of the ages (although a structuralist analysis might perhaps unveil it). Not only, therefore, has ornamentation, taken as a whole, no

5. Coin from Gaul: Atrebates. Laurel-wreathed head with profile missing.

6. Coin from Gaul: Nervii. Same elements transformed into ideogrammatic expression.

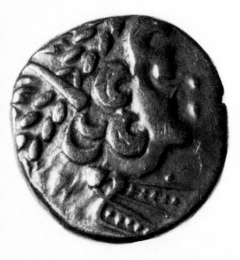

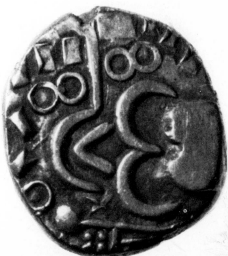

3. Neolithic: inside of cup.
Painted earthenware (Susa).

4. Bronze standard in the form of
a bird's head (Ulski).

It would also, for the same reason, be misleading to associate abstract art with the ornamentation on pottery, which is the type of abstraction most common throughout the ages. Leaving aside its arrangement, which obeys a rhythm (and rhythm is a particular modality of abstract form whose examination here would involve too long a digression), such ornamentation always starts from a stylized realistic motif, then loses itself in the symbol, and still survives as a meaningless apparent abstraction which has persisted from the dawn of civilization down to our time. It still turns up in the decoration of craftsmen's products, folk pottery, the work of the cabinetmaker, goldsmith, and silversmith. Industrial production, when all else had failed, put an end to this routine abstraction, which has nothing to do with art. It constitutes a kind of inferior cycle in the history of art, one that is tied to the everyday, in which current usage uses up

5
6
7

points in common with the abstract art of today: there is an antinomy between the two, in spite of the appearances that, at first sight, suggest affinities.

It is only through extrapolation that we might, up to a point, trace in the past the same mental process that governs twentieth-century abstract art. And one would have to look for it in the feeling, which has grown in the course of time, that every work of art, in its parts and as a whole, obeys a secret harmony which is therefore invisible, therefore independent of what is represented. This intrinsic harmony, signified by the "golden number," is pure abstraction. The experience extends through millennia: it was current practice among the Egyptians and among the Greeks, was first codified in Roman times by Vitruvius (first century B.C.), was then brought into the service of perspective in about the middle of the fifteenth century through Leon Battista Alberti, and culminated in the well-known treatise *De divina proportione*, published in 1509, in which Luca Pacioli, helped by the ideas of

7. Coin from Gaul: Velocasses. Head composed of symbols.

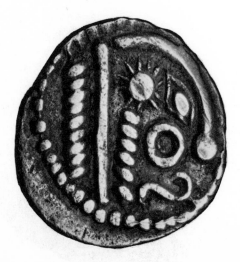

Piero della Francesca, linked form deduced from the golden number with universal perfection. There is an implicit conviction common to all these researches, that of the abstract power of forms: a form can be significant, beautiful, satisfying to mind and eye, even when it represents nothing. Although this efficacy of pure form is concealed behind figuration in both the sculpture of antiquity and the art of the Renaissance, there is one field in which its power is strikingly manifest: that of architecture. Architecture — that non-figurative art which the thought of antiquity had so much trouble admitting as an art — is the only one of the forms of the past that is related to twentieth-century abstract art.

8. Aurignacian: meanders traced in clay by fingers. Cave of Gargas.

At the opposite pole from this total consciousness of the abstract value of form, one might adduce the gesture-magic of Aurignacian man, imprinting the traces of his fingers in the fresh clay of the cave of Gargas without depicting anything except, perhaps, the faculty of creation possessed by his hand. Wherever it touches, this gesture, issuing from the subconscious, draws on the same sources as do some of the abstract forms of today.

There we have, in fact, two divergent creative stances, which meet again, unexpectedly but explicably, in abstract art as it has evolved since the beginning of this century. On the one hand, and in an initial phase, abstraction has tended to be a science of beauty conceived as an order and harmony; and this is what has been called "geometrical abstraction." Later, from 1945 onward, we witness a different abstraction, which is not the search for form but, on the contrary, the impulse to express – in advance of form and even apart from it – the whole richness and spontaneity of the inner life, with the artist projecting himself immediately into his work; and it is this that has been called "lyrical" or "informal" abstraction.

Abstract art and aesthetics

Although abstract art as it emerges in the twentieth century is without precedent, its gradual and slow preparation can be perceived from the changes that took place in the very conception of form – the field of aesthetics. The absence of figuration, though it ranks as a rarity in the history of art, in no way upsets aesthetic speculation, since the aim of this is to throw light on the work of art without being concerned with its subject. Two centuries ago, when aesthetics as a branch of philosophy made its appearance, Western thinking had reached the stage of being sure

that it was not accounting for artistic creation when it simply described a work of art; for this, apart from those of its elements susceptible of description, comprised something that could not be reduced to its external features. So the distinction between content and form came to be made. Next, the examination of these in detail led to their being set in opposition, and it was then that the autonomy of form emerged. Aesthetics had scarcely had time to formulate this (and the credit for it belongs to the nineteenth century) when form, now recognized as independent, began to liberate itself from content, to become its own content — and its liberty was bound to lead it to abstraction. This indeed happened, at the beginning of this century.

Historically, this awareness of the autonomy of form has its origin in the idealist philosophy. Kant was the first to make a distinction between "free beauty" and "adherent beauty." By free beauty he means the beauty of ornamental motifs — that is to say, a form that by itself signifies nothing — as distinct from the beauty, termed adherent, of any concrete being or object, beauty that acquires a meaning because it adheres to that being or object. Even though, later, Hegel's aesthetic admitted only adherent beauty (closely tied to the expression of the idea), still the notion of "free beauty" was destined to make headway, all the more so because the development of modern art eventually helped to clarify it.

In this connection the considerable and rather surprising part played by neo-classicism, at the time of its triumph in Europe as the nineteenth century opened, is worth noting. Though it was harmful to artistic creation, a dead-end for art, still it helped to deepen the notion of form. Winckelmann, in his advocacy of Greco-Roman sculpture, naïvely imposed it as a model to be followed, not suspecting that all he would get would be copies. But the copy is itself a service, even if slavish, to a given form;

and even though, in the neo-classic climate, all this came down to an entirely negative sort of work, very close to counterfeiting, it did nonetheless contribute to familiarizing men's minds with the idea of form, at that time still vague. In this way neo-classicism, precisely when it impoverished art, favored aesthetic reflection. As an ideal it perished, but the dream of a perfect form, and the formalism which it engendered, survived.

Under the grip of romanticism the mainstream of art through-out the century (especially in France) evolved toward a more and more subjective, more and more free expression, which carried it away from tradition—and yet the consciousness of a sovereign, absolute, in some obscure way traditional form persisted, and was to come into the open as the century drew to its end. The subjective deviations of impressionism and also of realism (did not Zola himself, in spite of his creed, demand of a work of art that it should above all reveal to him the artist's personality?) were succeeded by a recall to order. This time the order was definitely that of the form itself, and this whether its advocate was Seurat or Cézanne or Gauguin—or even Maurice Denis, when in 1890 he wrote the famous sentence: "Remember that a picture, before it is a warhorse, a nude woman or anything at all, is essentially a plane surface covered with colors assembled in a certain order."

At that moment abstract art was virtually born. But during those years signs came from a quite different direction.

While in France it was the practice of art that was leading toward abstract form, in Germany it was speculative thinking. Germany in the nineteenth century lacked great painters but possessed a constellation of philosophers. The speculation which arrived at abstract form owed everything to philosophy and to the great impulse it started in the fields of history and philology. As Lionello Venturi saw clearly, "the same reasoning process that has led men to split up a historical text into its sources, has

led them to disintegrate the work of art into the elements of its taste."

This "splitting up" of the work of art, completed by an analysis of its components, gave rise to the theory of pure visuality, which claimed to be a science of art distinct from aesthetics because it studied the phenomena of vision and excluded the feelings. Due principally to the philosopher Konrad Fiedler (1841–1895) and, to a lesser extent, the sculptor Adolf Hildebrand (1847–1921), it had its source in the friendship between these two men and Hans von Marées (1837–1887). This strange German painter, whose sensibility far outstripped his talent (and who interested Klee very much at a certain moment), was in his own way going through a neo-classic crisis. He visited Italy, but the study of the monuments of the past, instead of influencing him, drove him to face certain theoretical problems. His time in Italy involved his eye and his mind in a long process of contemplation which he described to his friends in his letters. He gradually became convinced—and in this he was close to philosophers like Herbart and Zimmermann—that the work of art is essentially a will to form realized in obedience to the norms of vision. The subject is merely appearance. There was nothing systematic about the ideas Hans von Marées was expounding—simply the desire to pin down an authentic experience, and the hope that by communicating it to others he would find they shared it.

From this exchange of ideas there emerged in due course the theory of pure visuality formulated by Fiedler. He thought out art afresh in philosophical terms, starting from the ideas of Kant and in the light of the experience of Marées. Bent as it is on capturing the elusive, his thought presents itself most often in the form of aphorisms, and this compression enables Fiedler to exhibit what cannot be proved: that art is a specific language and elaborates itself according to laws of its own, which cannot be reduced to concepts. His aim—the aim of pure visuality—is to

and even though, in the neo-classic climate, all this came down to an entirely negative sort of work, very close to counterfeiting, it did nonetheless contribute to familiarizing men's minds with the idea of form, at that time still vague. In this way neo-classicism, precisely when it impoverished art, favored aesthetic reflection. As an ideal it perished, but the dream of a perfect form, and the formalism which it engendered, survived.

Under the grip of romanticism the mainstream of art throughout the century (especially in France) evolved toward a more and more subjective, more and more free expression, which carried it away from tradition — and yet the consciousness of a sovereign, absolute, in some obscure way traditional form persisted, and was to come into the open as the century drew to its end. The subjective deviations of impressionism and also of realism (did not Zola himself, in spite of his creed, demand of a work of art that it should above all reveal to him the artist's personality?) were succeeded by a recall to order. This time the order was definitely that of the form itself, and this whether its advocate was Seurat or Cézanne or Gauguin — or even Maurice Denis, when in 1890 he wrote the famous sentence: "Remember that a picture, before it is a warhorse, a nude woman or anything at all, is essentially a plane surface covered with colors assembled in a certain order."

At that moment abstract art was virtually born. But during those years signs came from a quite different direction.

While in France it was the practice of art that was leading toward abstract form, in Germany it was speculative thinking. Germany in the nineteenth century lacked great painters but possessed a constellation of philosophers. The speculation which arrived at abstract form owed everything to philosophy and to the great impulse it started in the fields of history and philology. As Lionello Venturi saw clearly, "the same reasoning process that has led men to split up a historical text into its sources, has

led them to disintegrate the work of art into the elements of its taste."

This "splitting up" of the work of art, completed by an analysis of its components, gave rise to the theory of pure visuality, which claimed to be a science of art distinct from aesthetics because it studied the phenomena of vision and excluded the feelings. Due principally to the philosopher Konrad Fiedler (1841–1895) and, to a lesser extent, the sculptor Adolf Hildebrand (1847–1921), it had its source in the friendship between these two men and Hans von Marées (1837–1887). This strange German painter, whose sensibility far outstripped his talent (and who interested Klee very much at a certain moment), was in his own way going through a neo-classic crisis. He visited Italy, but the study of the monuments of the past, instead of influencing him, drove him to face certain theoretical problems. His time in Italy involved his eye and his mind in a long process of contemplation which he described to his friends in his letters. He gradually became convinced — and in this he was close to philosophers like Herbart and Zimmermann — that the work of art is essentially a will to form realized in obedience to the norms of vision. The subject is merely appearance. There was nothing systematic about the ideas Hans von Marées was expounding — simply the desire to pin down an authentic experience, and the hope that by communicating it to others he would find they shared it.

From this exchange of ideas there emerged in due course the theory of pure visuality formulated by Fiedler. He thought out art afresh in philosophical terms, starting from the ideas of Kant and in the light of the experience of Marées. Bent as it is on capturing the elusive, his thought presents itself most often in the form of aphorisms, and this compression enables Fiedler to exhibit what cannot be proved: that art is a specific language and elaborates itself according to laws of its own, which cannot be reduced to concepts. His aim — the aim of pure visuality — is to

remove form from the domains of history and psychology and tie it to our perceptive faculties. When Fiedler writes that "every art form justifies itself solely when it is necessary in order to represent something that cannot be represented in any other way," he is in fact justifying the existence of abstract form. The pure visuality position itself, in its contrast with the traditional aesthetics, admits—indeed implies—form as a visual datum fully apprehended by intuition. In this sense Fiedler, though indirectly, solved the problem of abstraction by approaching it from the side of form. From the content side, and this time by a direct approach, the same problem was to be solved a few years later by Worringer.

Fiedler's *Schriften über Kunst* (*Writings on Art*) were not published, in a critical edition, till 1914—twenty years after his death. But already in 1893 the sculptor Hildebrand had published his *Problem der Form* (*The Problem of Form*), in which he treated the same questions as Fiedler but without his acuteness and penetration. While Fiedler's writings are the real support for the theory of pure visuality, Hildebrand's book helps us, because of the success it had at the time, to understand another aspect of the origins of abstract art.

The success of the book was out of all proportion to the novelty of its ideas, and remains inexplicable until one realizes the misunderstanding it involved. With writings like Hildebrand's, as time distances them, we are sensitive to the parts in which they foreshadow the future and indifferent to the rest, therefore not much interested in going into them more deeply; but it is precisely "the rest" that explains the very favorable reception given to Hildebrand's ideas, and so shows the considerable confusion of thought that presided over the beginnings of abstract art. At the center of the confusion is the word "form," with the responses it evoked at the end of the last century. Those were the years that had seen impressionism dissolve the real; the word "form," therefore, by reminding people of the integrated system

that had been dissolved, reassured them—it seemed to some extent to connect up with the broken tradition. Hildebrand, too, thought that the stability of tradition must be won back, and form was marked out to do this. In his view it could not be done without many subtle innovations; but his contemporaries neglected these nuances—quite unlike us, who see only them and pay no attention to their context, which is essentially academic.

The same equivocal relation between abstract form and academic ideal existed in France. Maurice Denis had a balanced, conservative mind. The development of his painting proves this—it led to a last resurgence of the neo-classic. In painting, his dream was the re-establishment of a past order. And he was the man who, in a tone of injunction, defined the art with a lucidity that none of his contemporaries possessed. But (just as with Hildebrand) if one takes Maurice Denis's famous sentence in its context, one soon sees that the injunction referred implicitly to the dangers of impressionism: unconsciously it was aimed at restoring a dead value. In the impressionist conception of a picture there really was such a departure from tradition— the first since the Renaissance!—and the consequent disarray gave such actuality to the problem of form that men were being led to analyze the modalities of form with an insistence never known till then. Abstract art was to result from that. Paradoxically, this revolution of form was preparing—unforeseeably —under cover of ideas of restoration.

The decisive step to the conception of a non-figurative plastic expression was taken in Germany in Wilhelm Worringer's celebrated essay *Abstraktion und Einfühlung*, published in Munich in 1908. It was, as is well known, a doctoral thesis presented a year earlier at the University of Berne, and the boldness of its content may have something to do with the author's age. Worringer (born in 1881) was twenty-six at the time. Schooled in

German philosophy and influenced especially by Schopenhauer, he starts from the principle that the history of art must in the future be conceived as a history of "will" (*des Wollens*) and no longer as a history of "skill" (*des Könnens*) — an attitude implying neither more nor less than a reversal of the aesthetic procedure. Instead of going toward the object through analysis of its form, we should start from the behavior of the subject and approach the form from there: approach it, that is, from the inside, as an intention, instead of regarding it as a result. With this in mind, Worringer laid stress on the idea of *Einfühlung*, which had been introduced as early as 1873 by the German philosopher Robert Vischer in his treatise *Über das optische Formgefühl (On the Feeling of Visual Form)* and developed later through, in particular, the work of Theodor Lipps (*Ästhetik*, 1903–1906). When he took up again this idea of *Einfühlung*, Worringer's great merit was that he used it as a tool with which to confront the whole of the evolution of art. And so, in the very wide survey he undertook, plastic abstraction came to be studied, for the first time, as the opposite — but symmetrical — pole to figuration, and to be justified *as abstraction*.

The untranslatable word *Einfühlung* (the versions that have been suggested, such as "empathy," "symbolic sympathy," are far from exhausting its meaning) expresses a state in which feeling, as a sovereign alchemy, links the human creature to the surrounding world; *Einfühlung* — a connection between the inner reality and the external, an active fusion of affinities — steers the self toward an external form that reflects it. It is in this faculty of being one with the real that man's creative power resides; it is here that art gets its true content — in the very stuff of spiritual life. The notion of *Einfühlung* therefore accentuates very strongly the inward significance of form and, at the same time, renders secondary the reading of the things it represents.

Starting, then, from *Einfühlung*, Worringer conceived art as

the exteriorization of the relationship between a man and the outside world. This relationship, while it is expressed by form, is also and at the same time expressed by religion. Forms, like religions, can vary from age to age and from place to place, but certain forms of art will always correspond to certain types of religion. The problem once stated in these terms, Worringer could transcend what he called "our narrow point of view as Europeans," who do not see form except by reference to classical art ("all our definitions of art are definitions of classical art," he declared)—and this was the great step forward which the young student imposed on aesthetics. Basing his argument on concrete examples, he set about circumscribing the art of the Renaissance. He began by sifting the architecture and other arts of antiquity; then, coming nearer in time and place, he set over against the Renaissance the arts of the North (Celtic, Irish, Merovingian) and so drew attention to a field of abstract tendency in Europe itself. Having reached that point, Worringer propounded this conclusion: realism indicates that the human being is already dominating the outside world; *Einfühlung* can take place, for understanding has gained the upper hand over instinct. To Worringer, instinct is fear—dread in face of the reality of the world. Jean-Jacques Rousseau is wrong, he said, when he imagines the dawn of humanity as a lost paradise. Instinct is insecurity, it cannot rise to *Einfühlung*. And the degree of *Einfühlung* determines the degree of realism in art. "The impulse of *Einfühlung*," Worringer wrote, "is conditional on a relationship of total and happy confidence between man and external phenomena, while the impulse of abstraction is, on the contrary, the consequence of a great inner uneasiness in man, provoked by the phenomena of the outside world, and it corresponds, in the domain of religion, to a strongly transcendental coloring of the whole imagination."

Though he was not particularly attracted by plastic abstraction

(he described its lines as "stiff" and called its forms "crystallized, dead"), and though he lacked a prophetic feeling of its determining role in twentieth-century art, Worringer was the first to isolate abstraction as an aesthetic datum, the first to envisage a possible content of abstract form. In fact he very pertinently observed that there are moments, in the course of civilizations, when the crushing power of the gods and equally its contrary — uncertainty about existence, felt as a menace — turn men away from the real: at such moments, because men's sensibility is concentrated on what is beyond reach, art tends toward abstraction, for only abstract form can transcend the real.

This truly new conception did not directly affect the coming of abstract art. There is no evidence that Kandinsky was aware of Worringer's essay, although it was published two years before he himself began putting together the first of his writings on abstract art. That theory and practice coincided as they did simply makes clearer how deep were the reasons bringing abstract art into being. There was nothing random about the plastic experiment, any more than about the philosophical conception which slightly preceded it: both were obeying one and the same imperative; both arrived at the moment when Western civilization, surveying its own acquisitions, was examining its history and considering the validity of its findings.

Worringer's conception of abstraction could not have been reached without that deepening of the knowledge of art itself which marked the end of the nineteenth century. The first and still superficial approaches to art, which in the middle of the century produced a few encyclopedic manuals, gave place to exercises of judgment that sought to reach the essence of art. Through direct and increasingly profound analysis of works of art, men moved on to the underlying principle. The notion of style was being clarified. The importance of the creative process

began to take first place. An awareness of the universality of art was affirmed alongside the relativity of the various inter-pretations of form. Aloïs Riegl—whose views were to mean a great deal to Worringer—paid attention to the constructive principle of the ornamental motif, taking in his stride both pierced Hellenistic sculpture and Islamic arabesques (*Stilfragen*, 1893). Fiedler's influence in due course helped Wölfflin to elaborate his system of visual symbols, the object of which was to show the general development of art from inside, without dragging in any element that might interfere with perception of form (*Kunst-geschichtliche Grundbegriffe*, 1915). A language came into being—it is still in use—that sprang from a consummate maturity of thought: the same maturity that arrived, by way of form, at abstract art. And because it fits into such a context, because it comes of such a period, twentieth-century abstract art is, in my view, a phenomenon that has no equivalent in the past.

Abstract art as a phenomenon

Abstract art is a phenomenon, not just a tendency. Its evolution during these fifty years has been one in which, from the start, there were several distinct streams, which sank out of sight, then rose afresh after some years, near to us, in greater volume but now confused. The development of abstract art falls clearly into periods: the first, between 1910 and 1920, the period of its origins, displays an extraordinary creative vitality. A second period, from 1920 to 1930, brings the practical application of abstract forms to architecture, furniture, the graphic arts: it is the end of the 1900 manner and the emergence of what one must indeed call the twentieth-century style. Then, around 1930, the expansion of abstract art begins: throughout Europe a great many

artists become converted to abstraction, but aesthetically this phase is a regression — abstract form becomes exhausted and quickly sinks into a kind of academicism. By 1939, at the outbreak of war, abstract art seems to have lost all its creative force. But immediately after 1945 it takes on a new vigor. And now the United States joins in. During the fifties, all over the world, the most vital art is governed by abstraction. But it is precisely here that the confusion at once shows itself: many artists who might be considered abstract are really figurative. One may not recognize in their pictures any definite and namable object, but still they are consciously depicting reality. What is this reality, which looks abstract and is not? We shall see at the end of this book, when we have examined how the artists present it. For the moment we will simply note that abstract art has gone so deep that it has affected and transformed figuration. This process — disturbing, because it dislocates logic — is still going on, so that only the future can tell the exact dimensions and effect of abstract art. All we can do is to bring out the main lines of it. From its recent results we cannot get far enough away to form a clear judgment, but our horizon widens as we go back toward its origins.

The following pages submit to this perspective imposed by time. They adopt, so to speak, its form — a pyramid with its base toward the past and its apex toward the present.

The beginning of abstract art can, without hesitation, be identified with the work of Kandinsky — not only because chronologically he was the first to arrive at an abstract vision that was a deliberate act and not a passing impulse, but also, and above all, because he was the only one of the pioneers of abstract art who was not caught up in cubism. In consequence the flowering of abstract form retains, in his work, an almost ideal purity. Kandinsky stakes everything on color, seen as a complete means of expres-

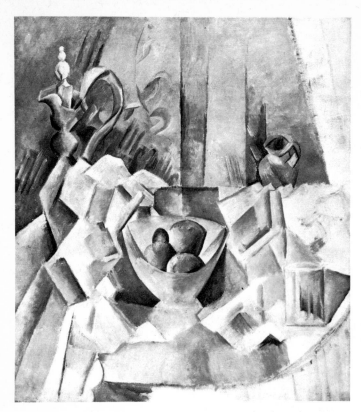

9. Pablo Picasso,
Still Life, 1908.

sion capable of receiving an emotive charge that is self-justifying
when it responds to a spiritual impulse — spiritual almost in the
mystical sense. One finds in his attitude an echo, though modified,
of the "beau mystique" which Gauguin and the symbolists
prized; perhaps also a trace of that pure wavy line which is
present, in its languorous state, in Art Nouveau and the work of
the Nabis, but becomes tension and explosive form in Kandinsky.
It is a tension of the hand, striving to set color free; for to
Kandinsky, especially at the start, the content of an abstract
picture lay essentially in the color, taken as the expression of
that "inner necessity" which he saw as the motive force of art.

artists become converted to abstraction, but aesthetically this phase is a regression—abstract form becomes exhausted and quickly sinks into a kind of academicism. By 1939, at the outbreak of war, abstract art seems to have lost all its creative force. But immediately after 1945 it takes on a new vigor. And now the United States joins in. During the fifties, all over the world, the most vital art is governed by abstraction. But it is precisely here that the confusion at once shows itself: many artists who might be considered abstract are really figurative. One may not recognize in their pictures any definite and namable object, but still they are consciously depicting reality. What is this reality, which looks abstract and is not? We shall see at the end of this book, when we have examined how the artists present it. For the moment we will simply note that abstract art has gone so deep that it has affected and transformed figuration. This process— disturbing, because it dislocates logic—is still going on, so that only the future can tell the exact dimensions and effect of abstract art. All we can do is to bring out the main lines of it. From its recent results we cannot get far enough away to form a clear judgment, but our horizon widens as we go back toward its origins.

The following pages submit to this perspective imposed by time. They adopt, so to speak, its form—a pyramid with its base toward the past and its apex toward the present.

The beginning of abstract art can, without hesitation, be identified with the work of Kandinsky—not only because chronologically he was the first to arrive at an abstract vision that was a deliberate act and not a passing impulse, but also, and above all, because he was the only one of the pioneers of abstract art who was not caught up in cubism. In consequence the flowering of abstract form retains, in his work, an almost ideal purity. Kandinsky stakes everything on color, seen as a complete means of expres-

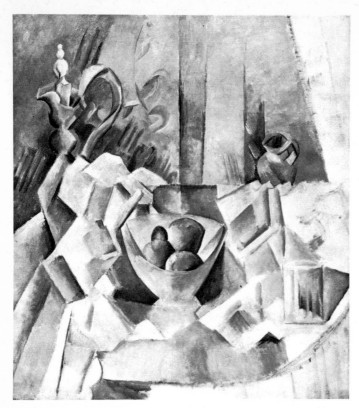

9. Pablo Picasso,
Still Life, 1908.

sion capable of receiving an emotive charge that is self-justifying when it responds to a spiritual impulse — spiritual almost in the mystical sense. One finds in his attitude an echo, though modified, of the "beau mystique" which Gauguin and the symbolists prized; perhaps also a trace of that pure wavy line which is present, in its languorous state, in Art Nouveau and the work of the Nabis, but becomes tension and explosive form in Kandinsky. It is a tension of the hand, striving to set color free; for to Kandinsky, especially at the start, the content of an abstract picture lay essentially in the color, taken as the expression of that "inner necessity" which he saw as the motive force of art.

If color could perform this task which he assigned to it, it was because his own development made this possible. The status of color among the resources of painting had changed considerably in the course of a few decades. Manet had already made an end of those gradual transitions from one color to another: he accentuated the construction of a picture by means of contrasted and surprising touches which he placed conspicuously at various points. Gauguin at once followed this up with his question: "Where does the execution of a picture begin? Where does it end?" With this, the doctrine that a painting must be "finished" was refuted: the academic (or photographic) smoothness had

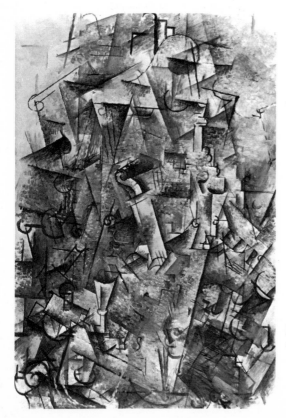

10. Georges Braque,
Harp and Violin, 1912.

lost its *raison d'être*. The existence of color — that entirely relative existence, clearly comprehended by Baudelaire when he defined color as "a harmony of two tones" — was affirmed by making its very relativity a force, a dialectical principle. The optical law of colors, the law of simultaneous contrast, governed impressionist vision; but unquestionably, when envisaged in this way, color is an abstract datum, separated from the local tone (and so from reality) and given over to speculation. And when the rebellious, impatient Gauguin asked himself what is the color equivalent for light and gave the answer "Pure color!" —

11. Piet Mondrian, *Composition No. 1* (Trees), 1911.

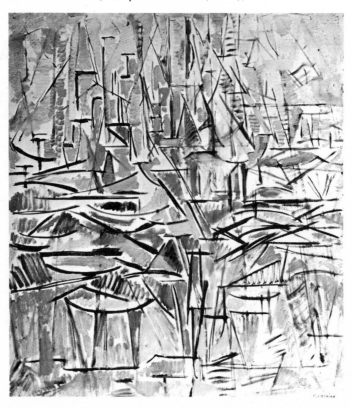

fauvism was only the next step. This idea of the omnipotence of color was what guided Kandinsky — as he himself confessed — when he took the plunge into abstraction.

While color (and with it touch) was freeing itself from representation and emerging as a value on its own, at the same time construction, the conception of volume and that of line were changing, thanks to Seurat and Cézanne. In their pictures form consolidates itself, takes its stand against the ephemeral. It is the invariable, which the painter establishes beneath the variable. Painting

12. Casimir Malevich, *The Guardsman*, 1912–1913.

rises from the accidental to the absolute, from the concrete to the abstract, from the object to the geometry of the object. Cubism was a continuation of Cézanne.

And so form led straight to abstract art. The cubists certainly did not reject reality. Objects and human beings are present in cubist pictures. But their forms, instead of being reproduced literally, are analyzed, and what gives the composition an abstract look is the analysis, which was pushed further and further in successive pictures. In cubism at the start the object predominated; then analysis gradually gained the upper hand. In the last phase of cubism, in 1912 and 1913, Braque and Picasso advanced to a synthesis of all the data which had emerged from the analysis of the forms; but this did not mean that the outside world was repudiated.

What is more, as if cubism was summoned to take one further step, Mondrian took as his starting point the final state of synthesis reached by cubist painting and purified its features until he obtained an abstract composition. Similarly, though not so systematically, Malevich in turn gathered up the cubist heritage.

Thus, between 1910 and 1916, abstract art revealed its debt to the preceding evolution of color and of form. Kandinsky tried to give abstract art a firm basis by rationalizing an intuitive experience of color. Mondrian rationalized the behavior of form, in the conviction that he would reach an absolute. But Malevich in one leap, and by an extraordinary short cut of the imagination, found the culminating point of this double process of rationalization when, in 1918, he painted his *White Square on a White Ground* (or *White on White*). Absolute form and color can only be the end of painting — a disturbing message, whose relevance only increases with the distancing of time. For the development of abstract art has finally demonstrated the limits of the rational, and these have let loose its opposite — the irruption of the irrational into the very center of abstraction. This second phase

of the abstract is what we have been witnessing since the end of World War Two.

There was, then, an initial time during which geometrical abstraction aspired to a rational absolute. Painters were fascinated by the use of the drawing pen, sculptors obsessed by the right angle. Both were making the supreme effort to forget their individual sensibility in order to arrive at some universal expression. And because it remained within the framework of the rational, this branch of abstract art has tended to dominate our minds to the exclusion of all other branches, as if it alone represented abstraction, whereas it was at most one state, the first, even though there have been continuations of it later, after abstract art had already rounded the cape of the irrational. But in this second phase of abstraction definitions founder and any clarity is soon hard to come by. It is all very well to tell oneself that, in the doing away with the subject, the preconceived idea of things went at the same time, and that in consequence both geometrical abstraction and the non-geometrical kind have taken their stand side by side, beyond appearances: what makes them different still grows deeper and deeper. The irrational remains irreducible to the rational. The irrational and its source, the subconscious.

Abstract art and the subconscious

As soon as anybody raises the question of the subconscious in discussing art, one thinks of surrealism. This is doubtless because surrealism deliberately attached itself to the subconscious by following Freud's theories closely, while at first sight abstract art seems to be resolutely turning its back on these. Its freedom from any literary concern, the primacy it gave to form and, lastly, the frank opposition between it and surrealism during the thirties

have made us dissociate abstraction and the subconscious. Or, more exactly, not associate them.

But in evolving as it has, abstract art has enabled us to see how much the field of the subconscious explored by surrealism was reduced by the fact that it stayed within the limits of figuration. It was a bold, revealing exploration, and nobody denies its historical importance; but it could only be partial as long as it busied itself with elucidating the subconscious and aimed at dominating it, because by doing so it imposed on the subconscious, which is limitless and shifting, the rigid limits of the conscious. One branch of abstract art since 1945 has been doing the exact opposite: by every possible means it has been tearing off strips from the subconscious and presenting them to be looked at as they are — stammerings that are still formless (Wols), or breathless incursions (Pollock) — its aim being to draw the sensibility right into what has no name, so as to experience this directly. It is not, any more, the subconscious that emerges into the light of consciousness; it is consciousness that, with the help of the senses, is compelled to face the darkness of the subconscious. It is headlong descent into experience. Consciousness has ceased to be the norm. The symbolism that was axial to psychoanalysis is dissolved. Has abstract art attained other, underlying symbols, down in the deepest layers of the subconscious? That is the question. But whatever the answer — whether posterity accepts or condemns the art of today — it is certain that, in this also, abstraction expresses its time: it is part of that return to the sources of human nature which characterizes the twentieth century.

185

181

Abstraction and the renewal of the techniques of painting

To say "subconscious" is to say "eruption" and to imply a union between the hand and the means of expression so intimate and immediate that the gesture of painting completes itself instantaneously. Postwar abstract painting has proved to be gestural ("action painting," as the Americans call it) or calligraphic (in the Far Eastern way) or informal. All these are tendencies that reject control by consciousness. And, by this fact, they are attacks on technique. At first the abstract painter found it enough to give colors and forms a total independence: now he feels the need to go outside the traditional technical means.

Once again the distant origins of this condition of rebellion take us back to the impressionists. Their anti-conformism started an era of audacities that repudiated the plastic conventions one after another. Gauguin took to painting on a tacky canvas. Van Gogh used a full impasto. What began as a license became the rule—a fresh method of plastic expression. Color, that "complicated hymn" as Baudelaire called it, acquired an unforeseen materiality (to be carried to its extreme in twentieth-century art): and so became the vehicle of a spontaneity whose expression had been impossible with the old techniques. Wherever the process of painting departed from academic ideas of what it should be, the future abstract art began to show. One has only to isolate a detail chosen at random from a picture by Monet, Van Gogh, Gauguin, *13* or even Cézanne, and one gets an abstract picture. In a decade or *14* two this partial liberty would extend to the whole picture. Later, in the work of the postwar abstract painters, color would make its material properties dominate: instinct would have dethroned thought. This is where the clearest line of demarcation comes between the two phases of abstract art, the first still bound up with the traditional idealist philosophy, the second already

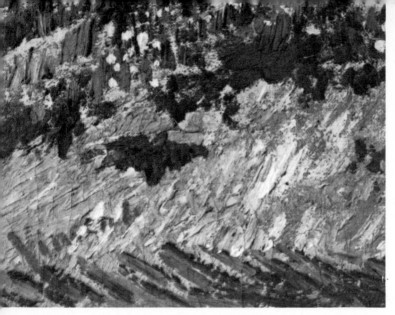

13. Vincent Van Gogh, *Les Moyettes*, detail.

14. Paul Cézanne, *The Montagne Sainte-Victoire*, detail.

governed by the existentialist philosophy. An abstract painting that hinged on space — space the "dimension of being," as Sergio Bettini put it — has been succeeded by another which is deployed in time — time as "emergence of what exists."

The margin of abstract art

All these transformations of the language of painting, which began in the nineteenth century and have been deepened in the twentieth, both those that concern form and those that concern color, have in the end converged: they have set painting free from what made it an art of imitation. For the new generations anecdotal content is relegated to the secondary position, and the painting is centered upon itself. This is why, in practice, figuration has so often merged into abstraction without meaning to. Between 1910 and 1920 there are plenty of examples of a passing, momentary abstraction in the work of artists who, in other pictures, remained figurative.

Such was the case with a series of small watercolors — *Abstraction 2* is one of them — painted by the American Arthur Dove in 1910 and revealing a sensibility and originality that are astonishing for the period. Such, again, was the case with Fernand Léger, when in 1913 he painted some of his vigorous contrasts of forms. Or again, Wyndham Lewis, the leader of English vorticism: driven by a violent desire to make a clean sweep of the past, he created in 1913, among others, a totally abstract *Composition* which is one of his most interesting achievements. At the center of futurism — which aimed at expressing movement and, through this, came close to abstraction — Giacomo Balla painted a series of abstract works which include his *Mercury Passing in Front of the Sun* (1914). Morandi purified the odd climate of "Metaphysical Painting" to the point of

15

16

18

19

15. Arthur Dove,
Abstraction 2, 1910.

16. Fernand Léger,
Contrast of Forms, 1913.

17. Giorgio Morandi,
*Metaphysical Still
Life*, 1918.

abstraction in pictures like his ocher and gray *Metaphysical* *17*
Still Life (1918), in which he articulated the abstract language
with an ease that comes near to being a tour de force: the rigor-
ously spare, incisive construction, instead of making the forms
stiff, leaves them seemingly in suspense, and the resulting space,
far from being stated, appears to be itself questioning.

A little later, in 1921, Jacques Villon was several times
tempted to represent abstract notions—*Joy, Withdrawal, Red* *20*
Balance: these are so many abstract pictures, yet they fit
smoothly into his work as a whole because abstraction is a logical
consequence of the use of the golden number, for which he had
opted ten years earlier—as did, indeed, the whole of the group
who exhibited under the label "Golden Section."

21 Lastly, the Russian painter Michel Larionov, the promoter
of rayonism, came to abstraction around 1912–1913, as is clear
from some of his pictures, which were, however, preceded and
followed by figurative works.

 These abstract moments (and they are not the only ones —
22 more can be found in the work of Klee, of Carrà), dotted about
23 among figurative pictures, show how closely abstraction and
figuration (in the form this took at the beginning of the century)
were related, and how easy it was to pass from one to the other.
All the avant-garde figurative movements — cubism, futurism,

18. Wyndham Lewis,
Composition, 1913.

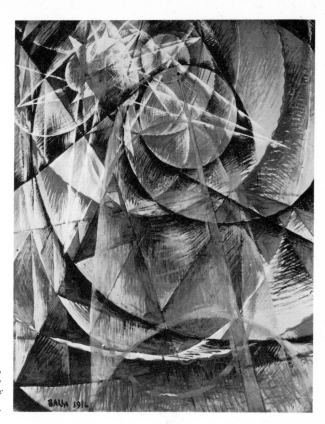

19. Giacomo Balla,
*Mercury Passing
in Front of
the Sun*, 1914.

the Golden Section, vorticism, rayonism, and even metaphysical
painting—touched abstraction. All (except metaphysical painting)
were called abstract when they first appeared, and this for the
simple reason that their means of expression were really abstract.
Their figurative aspect has, in fact, only become "visible" with
distance, with the passing of time, after our sensibility, modified
and matured as it has been by the evolution of forms, reached the
stage of distinguishing between true and apparent abstraction,
and drawing frontiers between them. Frontiers, it should not
be forgotten, exterior to the movement of art itself: landmarks,
to take bearings by, nothing more.

20. Jacques Villon,
Red Balance, 1921.

21. Michel Larionov,
Blue Rayonism, 1912.

22. Paul Klee, *Before Blossoming*, 1924.

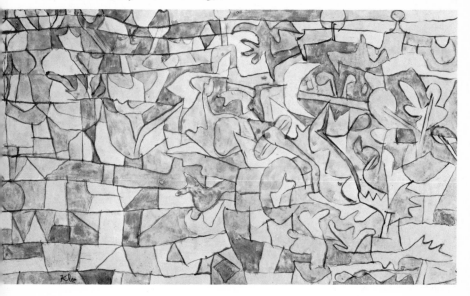

This general tendency to abstraction, which is characteristic of twentieth-century painting as a whole, came (as we have seen) through the taste for aesthetic speculation inherited from the nineteenth century. To understand how this speculation continued till it cleared the way for abstraction, one need only turn to the work of Robert Delaunay.

Delaunay concentrated his attention on studying the chromatic circle, which had set Seurat dreaming so furiously: because he was trying to express light itself, he produced in 1912–1913, among other pictures, several abstracts like his *Circular Forms* and some of his celebrated *Simultaneous Windows*, which had many imitators. But it was not till the thirties that a deliberate will to abstraction showed itself in his work.

24
25

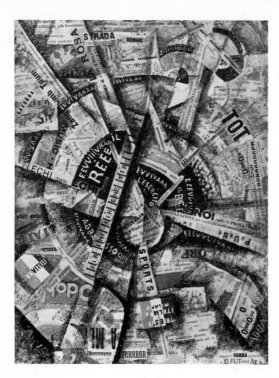

23. Carlo Carrà,
Interventist Manifestation,
1914.

24. Robert Delaunay, *Disk*, 1912.

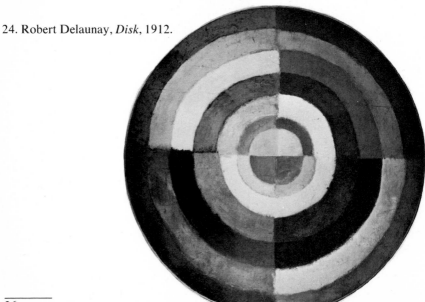

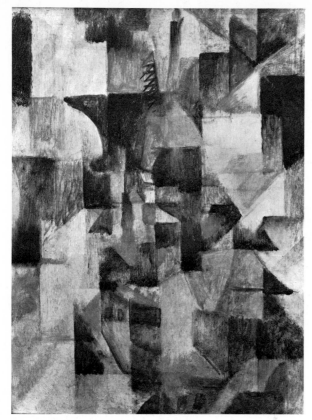

25. Robert Delaunay,
*The Windows on
the Town*, 1912.

Similarly Kupka reached abstraction by way of aesthetic speculation. He was close to the Golden Section painters, with their passionate discussions about the harmony of proportions, and produced his first abstract pictures in 1911–1912. We shall examine later the place of these two artists in the evolution of abstract art: here their precocious activity as abstract painters is simply brought up as an example of how abstraction was inextricably mixed in with the origins of contemporary art.

And because this was so, even dada at its beginnings touched on abstraction.

Dada and abstraction

Because abstract art was completely tied up with the rescinding of the aesthetic principles till then considered to be eternal, it was a matter of course that the corrosive spirit of dada attacked the abstract forms. "What is the value of art," dada asked itself, "and is there any?" Since the plastic means of expression were no more than pure conventions, they would not change their nature even when transgressed as they had been at the beginning of the century. Fallen from its absolute pedestal, art had no place except in relativity. Revolt and irony disarticulated the forms and borrowed color from old bits of paper, rags, and rubbish.

26. Frank Kupka, *Blue and Red Vertical Planes*, 1913.

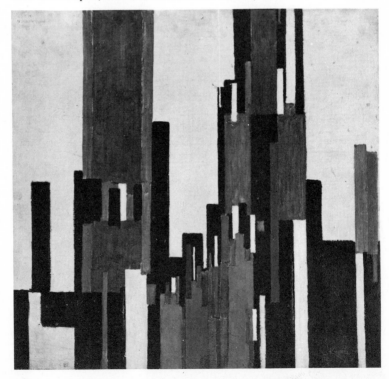

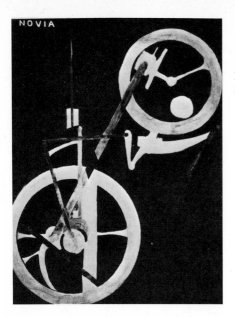

27. Francis Picabia,
Novia, 1917.

28. Max Ernst,
*Mechanical Impressions
Heightened with
Colors*, 1920.

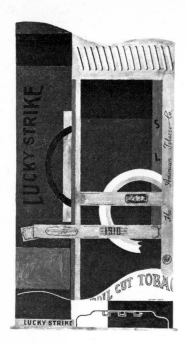

29. Stuart Davis, *Lucky Strike*, 1921.

30. Man Ray, *Collage*, 1918.

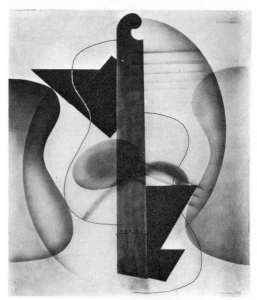

31. Jean Arp, *Da's Kit*, 1920.

In the products of dada, art shook itself to bits like a machine put together wrong. And the dislocation did not spare abstract form. This can be seen in some of Picabia's pictures, such as his *Novia* (1917), or in some of Max Ernst's drawings, like his *Mechanical Impressions Heightened with Colors* (1920); or again in the first sculptures of Jean Arp, like his *Construction in Polychrome Wood* of 1920; or in Stuart Davis's celebrated picture *Lucky Strike* (1921); and lastly in the collages of Man Ray and, above all, those of Schwitters — the Merz pictures which he executed from 1919 onward. Here was the desacralization of art (Marcel Duchamp carried it to its extreme in everything he undertook), and the parodistic consecration of the machine, whose productive — and totally abstract — automatism was cited to corroborate the gratuitousness, the uselessness of any human gesture: a derision reflecting perfectly the crisis which had given birth to dada.

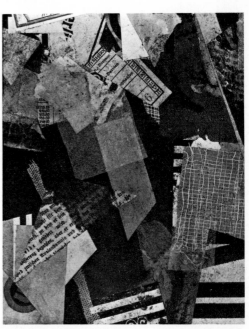

32. Kurt Schwitters, *Merz Picture*, 1920.

So, by its sneers, dada insinuated that, after all the values of the past had been denied successively by figuration and by abstraction, the precariousness of human creation was visible like the casting of a shadow, for the first time in history.

Of all the margins of abstract art, dada is certainly the most ambiguous — but also the one in which the extent and complexity of that twentieth-century phenomenon, abstraction, can best be discovered.

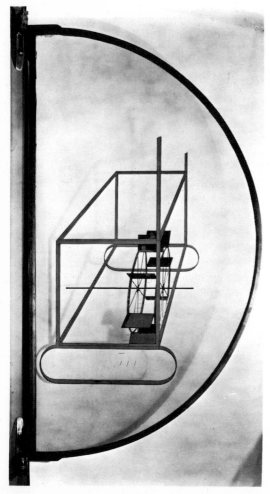

33. Marcel Duchamp,
Watermill within Glider
1913–1915.

Part 1 / **The origins of abstract art and its expansion**

Vassily Kandinsky

In 1910 Kandinsky painted his first abstract picture (Color plate, number I). He was forty-four. It was the event of his life. True, the suppression of the concrete object had been developing for a long time; but, once realized, it was a fact which Kandinsky felt the need to justify. To his experiments in painting he added his writings, as though he owed other people a thorough explanation of his enterprise. And so he was the first — soon followed by Mondrian and Malevich — to undertake the defense of abstract art. Indeed it is from the passion these painters put into their writing that one can recognize how vital a blow the new mode of expression struck at tradition. While searching for itself, abstract art had to plead its cause. As we have seen, it stemmed from a full maturity of aesthetic thinking: no wonder, then, that its first masters tried, as it were, to step back in order to estimate their

own actions, and that it was they who evaluated the relation of the new form of expression to the past — sometimes also, prophetically, to the future. Hence their writings, intended originally to explain their paintings, complete them: they unveil the primary stuff out of which abstract art has been elaborated. Through them, with some surprise, we discover in these painters, alongside the exploits of abstraction, certain intellectual elements which no one would have thought of connecting with their aesthetic ideas if they themselves had not mentioned them. Who, for instance, would have associated Kandinsky's painting with the bloodless *fin-de-siècle* spiritualism? Or Mondrian's with theosophy? Or that of Malevich with Russian nihilism? These are minor elements of the period, embedded deep in the art of the abstract painters and giving out radiations there — strangely sublimated sources, which the history of abstract art would do wrong to neglect. In the spirit of the first abstract painters intellectual speculation accompanied their plastic researches: it followed them step by step, and with its aid the work of each artist finds its proper historical position.

The coming of abstract art had in it a deep-seated logical order untroubled by anything accidental. For instance, Kandinsky's first abstract picture was a watercolor, not an oil painting. The spontaneity and rapid execution required by the watercolor technique suited the liberation at which the artist was aiming: the hand was pace-setter to the mind: Kandinsky would need another year of intense work to arrive at the same degree of freedom in oils. By 1911, when he painted some of his *Improvisations* in oils, he was at length master of the new kind of expression, which he had sought both through practice and through reflection. Already in 1910, parallel with his first abstract experiments, Kandinsky had begun writing his *Über das geistige in der Kunst* (*Concerning the Spiritual in Art*): he completed it gradually, and it appeared in January 1912. He was fully conscious

of what a strange adventure was his, and he set himself to tell
of it as objectively as possible, avoiding the anecdotal. A stiff
avant-garde breeze was blowing in Munich at the time: *Concerning the Spiritual in Art* went through two editions in one year,
and in due course there was a third. Although some of the critics
—as he himself tells us—had taken his book as "a bad joke," he
at once wrote another, called *Rückblicke* (*Looking Back*), which
appeared in 1913. This time one feels definitely that Kandinsky
is writing for his own public—for those who had read *Concerning
the Spiritual in Art* with interest. His tone has changed: expansiveness has taken the place of carefully sober exposition.
Kandinsky is giving us his intimate thoughts and feelings—in
fact an autobiographical sketch, but a specialized autobiography
that seeks to show the gradual progress of abstraction and
nothing else. His joys and griefs move forward with his memories,
his childhood games are linked to the impressions of the mature
artist; Kandinsky's personality emerges entire—and it commands
admiration. Having decided to follow the traces of whatever may
have acted on him and determined his painting, he has to grapple
with the fugitive substance of the subconscious, and in order to
keep hold of it he lets his past life come and recompose itself
through associations of ideas, or rather of sensations. The purpose of his narrative dictates its form, and this—already in 1913
—anticipates Proust: chronological order is neglected, for what
Kandinsky is trying to rediscover through his autobiography is
the inner time that nourishes his work. Beyond question he was
gifted as a writer, and loved handling words; from childhood he
had spoken German in his native Russia, and he wrote it with
ease: indeed in the same year he published a book of poems,
Klänge (*Sonorities*), which he illustrated with woodcuts. But the
fact that, in the effort to tell of his experience as an abstract
painter, he arrived spontaneously at a narrative form that would
prove to be one of the major advances of twentieth-century literature, is a striking example of the unity given to a period by its

34

34. Vassily Kandinsky, woodcut illustration for *Klänge*, 1913.

particular physiognomy. Because, at the opening of the twentieth century, the ambition of creative artists was to edge their way in behind appearances, such a man as Kandinsky instinctively wrote his account of his life in the Proustian way. He took as basis the continuous web of existence: the nature of what he had to say compelled him to place himself in "duration" (in the sense Bergson was to give to the word in those same years). And everything he tells us in this way about himself, his parents, his life in Russia, his travels, and his time in Munich becomes much more than a biographical account: *Looking Back* is a document essential to the understanding of Kandinsky — it contains the "key" to the man, and so to the work.

(*The Haystack*): "Part of my enchanted Moscow was already there, on that canvas." So that one is the more astonished — though not completely — by the contrast when this man, who is so close to us, shows that he has a certain *fin-de-siècle* side to him: "Everything," he writes, "shows me its face, its inner being, its secret soul, which keeps silent more often than it speaks," and he adds, "Thus every point and every motionless line became alive for me and offered me their souls."

But the word "soul," which recurs so frequently in Kandinsky's writing, is disconcerting to us precisely when we realize that, in this painter, its pallid rays gave so much vigour to what were revolutionary plastic convictions. For instance, starting from the communion of the soul with the all, he arrives at this: "That was enough to make me discover, with my whole being and all my senses, the potential existence of an art which still remained to be worked out — and which now, in opposition to figurative art, has been called abstract art."

A few decisive events had made Kandisky foresee the existence of the form of art of which he would eventually be the promoter. They were — first, and almost simultaneously — the revelation of Monet at the 1895 French impressionist exhibition in Moscow (which he had visited when still a young member of the law faculty and an amateur painter), and a performance of Wagner's *Lohengrin* at the Court Theater.

"Till then I had known only naturalist art and, to tell the truth, almost exclusively the Russians. Suddenly I found myself, for the first time, in the presence of a *painting* which represented, according to the catalogue, a haystack, but which I did not recognize. This incomprehension troubled me and nagged at me hard. I considered that the painter had no right to paint in so imprecise a way. I felt obscurely that the object (the subject) was missing in this picture. But I found with astonishment and confusion that it not only produced surprise, it imprinted itself

indelibly on the memory and kept forming itself afresh before one's eyes in all its details. All this remained confused in me, and I was not yet able to foresee the natural consequences of this discovery. But what did emerge clearly was the incredible power — something I had never known before — of a palette which surpassed anything I had dreamed of. The picture seemed to me gifted with a fabulous power. But unconsciously the 'object,' used in the picture as an indispensable element, lost for me its importance."

As for *Lohengrin*, Kandinsky had the impression, as he listened to Wagner's music, of reliving the hour before sunset. "The violins, the contrabassoons and, in particular, all the woodwinds brought before me the splendor of that hour. I seemed to see all my colors, I had them before my eyes. Disheveled, almost extravagant lines were drawing themselves as I watched. I did not have the courage to say straight out that Wagner had painted 'my hour.' I was discovering in Art in general a power I had not suspected, and it seemed to me obvious that painting possessed forces and means of expression as powerful as those of music. But my inability to discover them myself, or at least seek for them, filled me with bitterness."

Already in 1889 an official journey to the Vologda district in Northern Russia, to study the workings of criminal law in the rural communities, had revealed to him the spellbinding power of painting. "I still remember how, the first time I went into an isba, I stood rooted to the ground with amazement at the astonishing paintings all around me: tables, benches, enormous stoves, wardrobes — everything — were covered with primitive decoration in bright colors. When at last I penetrated into the room, I found myself completely surrounded by painting, as if I myself had gone inside the painting."

Another journey in the same year, to St. Petersburg, had enabled Kandinsky to discover Rembrandt's work, in the Hermi-

tage. The great contrast between the light and the dark parts in the Dutch master's pictures, "the gradation of the secondary tones," and above all "the simplifying effect of the juxtaposition of contrasts" had overwhelmed him. (On the other hand a third journey, also in 1889 and this time to Paris, has hardly any place in his memories. Had he gone there to see the dispersal of the Exposition Universelle? – in any case this first contact with Paris contributed nothing to the painter he was to be).

Such were the acquistions of Kandinsky's sensibility when in 1896 he moved to Munich, to work there at painting. He was thirty. His vocation had conquered the career he had first chosen. But what did he know, technically, about painting? As an adolescent he had had a few drawing lessons, just as he had learned to play the piano and the cello. Later he had also done some painting. But now, clearly, Kandinsky came up against the exigencies of the craft. At the school of Anton Azbé, where he went to begin with, he found the models repugnant – "expressionless," as indeed they are, "for the most part stiff, clumsy." The anatomy teaching did not attract him either: "I drew, took notes at the lectures, and I breathed the smell of corpses." Such is the laconic memory that remained with him from his first school. Dissatisfied, and on the advice of Franz Stuck (another painter well known at the time), he prepared the entrance examination for the Academy – and failed. Stuck nonetheless took him into his own studio, and thanks to him Kandinsky at last felt he was making some progress. Stuck warned him "against the extravagances of color" and advised him to work in black and white, concentrating on form alone. He also taught him "to finish a picture, to carry it through to the end." Five years passed in this way – years that count for hardly anything in Kandinsky's work, except as apprenticeship. He managed to surmount the initial conflict between academic teaching and his own feeling,

35

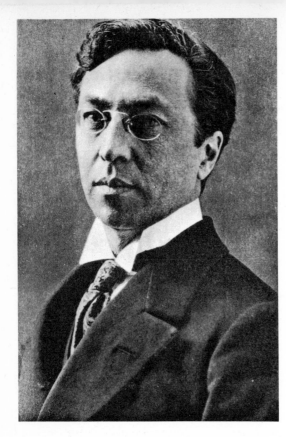

35. Kandinsky in 1912.

which had made him at the time of his Academy setback unable to consider "the accepted drawings" as anything but "insipid." He came to terms with the conventions, so far as one can judge from his only known painting of those years, an entirely traditional portrait of a woman, which he did in 1900: it certainly shows that Kandinsky had acquired some technique.

From that point his personal researches could begin. He painted some pictures in which the old fascination of color regains the upper hand; some are on imaginary medieval subjects, others are landscapes of the country around Munich. What he tried to express in all of them was not the thing painted but that which emanated from it — the "fabulous," the "sunset hour."

He made sketches from nature, by preference in places that had some atmosphere, such as old-world Schwabig and (later) Murnau; but it did not take him long to find out that he worked better from memory, in the studio. He now "entered the true domain of Art, which is," he observed pertinently, "an exclusive domain, like that of nature, of science." And in this domain Kandinsky advanced from revelation to revelation.

In the churches of Bavaria and Tirol he found again what he had experienced earlier in the isbas of Vologda—the feeling of the fullness which painting can attain. Their ornaments, he observes, "are so strongly painted that the object dissolves among them," and he decided to aim at obtaining the same power in his pictures, so that those who looked at them might have the impression of being *inside* the painting. Nor did he forget the now distant lesson of Rembrandt. He had in fact come to see that in a picture by Rembrandt there is a kind of "duration." "I explained this to myself by the fact that, to comprehend this kind of painting, one had first to saturate oneself in one part of the picture, then in another, and that it incorporated, as though by enchantment, an element which is foreign to it and seems at first incompatible with it: time." (He himself confesses that this discovery left its traces in his pictures up to about 1908).

Kandinsky, it is clear, was one of those artists in whom critical intelligence matches emotional power. While extraordinarily sensitive, he was capable of reflecting with equal intensity on what he experienced. And this particular temperament of his, this ability of his mind to receive any impression and analyze it and in the process enlarge it, was precisely what eventually brought him to abstract art.

One day an unexpected sight took Kandinsky by surprise. "It was at the approach of twilight, I was just back with my box of paints after doing a study, still deep in my dream and in the

meaning of the work done, when suddenly I saw on the wall a picture of extraordinary beauty, shining with a ray from within. I stood there bewildered, then moved closer to this rebus-painting, in which I could see only shapes and colors, while its tenor remained incomprehensible to me. I soon found the key to the rebus: it was one of my own pictures which had been hung upside down. Next day I tried, by daylight, to recover the impression of the evening before, but I only half succeeded. Even upside down I could still see the 'object'... Then I knew definitely that 'objects' were harmful to my painting. A frightening abyss was opening at my feet, while at the same time a quantity of possibilities were offering themselves to me, together with all sorts of questions full of responsibilities, the most important of them all being: 'What must replace the object?'

"The danger of a decorative kind of painting rose before me, and the inexpressive apparent life of stylized forms could only alarm me. It was only after many years of patient work, of constant strenuous thinking, of numerous careful attempts at developing the efficacy of pure forms, at living them in their abstractness, at plunging deeper and deeper into those unfathomable depths, that I arrived at the forms of painting I now work with... It took a very long time before I found a good answer to the question: replace the object with what?"

"Concerning the Spiritual in Art"

Kandinsky's first book, begun in 1910 and finished a year later, contains simply the motivation of the answer he had already found. His intentions are clear: on the one hand he wants to fit abstract art into the culture of that time, on the other to explain to the reader the painter's attitude toward abstract means of expression; also, finally, with both emotion and lucidity, he

tells us how he himself has turned to abstraction. To bring out his highly subjective experience and reveal its objective bases, he seeks and finds support in his own culture. He had a mind that was open, full of curiosity, and accustomed to keeping itself informed—the books he quotes or mentions range through many fields, from literature to science via ethnography. And because his thorough education, especially in art and music, gave him great sureness of judgment, Kandinsky does not hide what he thinks. His harmonious nature saves him from any excess, and the directness and frankness of his thinking gives *Concerning the Spiritual in Art* a tone and a life that are remarkable, quite apart from its historical value.

His point of view emerges unequivocally from the general considerations which he outlines at the beginning of the book. He is convinced that the new century is marked by an important spiritual turning-point. "The soul" is "coming to itself again" after "the crushing oppressiveness of the materialist doctrines which have reduced all life to a senseless, detestable joke." Art, he writes, "is entering on the path at the end of which it will once more find what it has lost—what will become once more the spiritual ferment of its renascence. The object of its search is not the material, concrete object, on which it concentrated exclusively during the preceding period—a stage now passed—but will be the very content of art, its essence, its soul..."

Even more than in that passage, Kandinsky shows his connection with the *fin-de-siècle* climate—and with the vague spiritualism against which the twentieth century is so definitely reacting—when he proceeds to praise the Theosophical Society, which he takes as confirming his own theories. For all the skepticism that surrounds it, "this great movement," he affirms, "is nonetheless a powerful spiritual ferment... It is a cry of deliverance which will touch desperate hearts oppressed by the darkness of night. It is a helping hand extended to them and showing them the way."

It is not surprising that preoccupations of this sort led Kandinsky into mistaken estimates of some events, even artistic ones. Pertinent as his judgments on his time and his contemporaries usually are (like his lapidary summing up of Picasso: "His strength lies in his boldness"), he could still range Rossetti and Burne-Jones, Boecklin and even Segantini alongside Cézanne: he saw in all these artists one and the same striving to get beyond the realistic element in painting and attributed to them all the same importance — whereas, if posterity ever made a cruel distinction, it is between them, with Cézanne on one side, at the summit, and the others in oblivion.

This double — and very human — allegiance of Kandinsky, to the past and to the future, is chiefly reflected in the language he uses. A languishing echo of Baudelaire's "colors and sounds answering one another" floats over his writings, in spite of their real content, which is quite different. At ease in an often dim terminology, what his thought really does is to bring out the part played by instinct in artistic creation. In his striving to apprehend, as profoundly as possible, the art of the inmost man, Kandinsky is liberating instinct from all the tangled growth around it; he is giving it its true value — though he does not use the word "instinct," which frightens him. One of the merits of the twentieth century has proved to be its legitimation of that irrational power, and in the field of art Kandinsky contributed greatly to this process, even though he was not very clearly aware of it. He could feel, better than anyone, the sovereignty of the painter's instinct, as is shown by the mere fact of his having been one of the first, along with Picasso, to appreciate the painting of le Douanier Rousseau (he bought one of his pictures before 1910 and kept it for the rest of his life); and yet he places the painter's work under the sign "Reign of the Spirit," as a preparation for the "Age of Great Spirituality," and rejoices that Maeterlinck, one of his favorite authors, shares this insight.

When, in Kandinsky's writings, one comes up against the part of him that belonged to what was already past and done with (and it is like touching with one's finger the time he lived in), one feels all the more strongly, by contrast, the amplitude of his contribution. This, which is now inseparable from our sensibility and will always remain valid, never impresses us so much as when we see it rising from under the clutter of his period. Then one understands fully the force which severed Kandinsky from the past and drove him toward the future.

This force becomes manifest in the second part of *Concerning the Spiritual in Art*, which is based not on received ideas but on Kandinsky's intuition. As soon as he allows his experience to speak, a new age arises under his pen. Convinced, and rightly, that it is "the power of emotion" that renders an artist's message valid, he sees the kernel of a work of art in an "inner necessity" and considers the colors and forms themselves as the means best suited to the inner necessity, the purest of all means when the purpose is to express an emotion in a picture. This question of purity of means leads Kandinsky to compare painting with music. "For centuries," he observes, "music has been *par excellence* the art that expresses the artist's spiritual life. Apart from a few exceptional cases in which it has diverged from its own spirit, its means never serve to reproduce nature, but to give to musical sounds a life of their own. For a creative artist who wishes and is driven to express his *inner world*, even successful imitation of natural objects cannot be an end in itself. And he envies the ease, the facility with which music, the most immaterial art, achieves the aim. That he should turn toward that art and try to find similar procedures in his own is understandable. Hence, in painting, the present research into rhythm, into abstract, mathematical construction, and also the value now attributed to the repetition of colored tones, to the dynamism of color."

That is why, according to Kandinsky, the painter's first task is to make himself aware of the specific properties of color and of form. This awareness is the essential subject and *raison d'être* of *Concerning the Spiritual in Art.*

"It is easier to paint nature than to struggle with it," Kandinsky notes. The corollary of that remark was his absolute conviction that in art "the part that is veiled is the strongest." Far removed from any symbolist inflection, and simply by the acuteness of his intelligence, he embarked on a study of the means available to painting. What, without realizing it, he was struggling to grasp was the behavior of instinct, which he was trying to build into a system—it was the mystery of the power of instinct. And yet he thought he was dealing with spiritual correspondences. The fact that certain effects of colors had been observed in animals worried him, but this did not destroy his faith in the spiritual value of color. "Color contains a force that is still imperfectly known but is real, is evident, and acts on the whole of the human body," he declared; and with the certainty that he was opening the way to this still stammering knowledge, he suddenly spoke of art as nobody had spoken of it before him:

"Bright colors attract the eye more and hold it more. Colors that are bright and warm hold it more still: just as flame attracts a man irresistibly, vermillion attracts and irritates the gaze. Bright lemon yellow hurts the eyes. The eye cannot endure it. It is like an ear torn by the harsh sound of a trumpet. The gaze blinks and moves away to plunge into the deep calms of blue and of green."

Kandinsky goes on to review all the colors, their mixtures, their affinities, and their oppositions. What he has to say is so pertinent and illuminating that each one of these passages is important and it is hard to choose from among them:

"Blue appeases and calms as it becomes deeper. As it slides toward black, it becomes colored with a more than human

sadness, like that into which one is plunged in certain grave conditions that have no end and can have none. When it grows lighter — which hardly suits it — blue seems distant and indifferent, like the pale blue height of the sky. In proportion as it grows lighter, blue loses more and more of its sonority, until it is no more than a silent repose and becomes white.

"Passivity is the dominant characteristic of absolute green. Whether it shifts toward lightness or toward depth, green never loses its original character of indifference and immobility.

"Red, limitless color, essentially hot, acts internally as a color overflowing with an ardent and agitated life. In this ardor, this effervescence, there appears a kind of male maturity, turned *toward itself* and scarcely concerned with what is outside ... Hot red, rendered more intense by the addition of yellow, gives orange. The movement of red, which was enclosed in itself, becomes transformed into irradiations, into expansion.

"Violet is a cold red, in both the physical sense and the psychical. It has something sick, extinguished, and sad about it. This, no doubt, is why old ladies choose it for their dresses. The Chinese have made it the color of mourning. It has the muted vibrations of the *cor anglais*, of the low notes of the clarinet, and as it deepens it corresponds to the grave tones of the bassoon."

And lastly, black: "Like a 'nothing' that has no possibilities, like a 'nothing' that is dead after the death of the sun, like an eternal silence, with no future, without even the hope of a future, black resounds within. What corresponds to it in music is the pause that marks a full close, which will perhaps be followed later by something different — the birth of another world. For everything that is suspended by this silence is finished forever: the circle is closed."

Having thus defined the action of color in itself, Kandinsky goes on to write about its possible ways of harmonizing with form, in fact about the relation between form and color: "'Harsh'

colors bring out their qualities best in a pointed shape (yellow, for instance, in a triangle). The colors that can be described as deep are reinforced, and their action intensified, by rounded forms. Blue, for instance, in a circle."

Kandinsky concludes by stating (and one can feel the full impetuosity that animated him) his own essential aim: "Conflict of sounds, balance lost, 'principles' overturned, the unexpected drum roll, great questions, aspirations with no visible aim, impulses apparently incoherent, chains broken, bonds snapped, joined again in one, contrasts and contradictions – that is what our *Harmony* is. *The composition which is founded on this harmony is an agreement of colored and drawn forms which have, as such, an independent existence proceeding from Inner Necessity and constituting, in the resulting community, a whole which is called a picture."*

It would be impossible to imagine a better definition of the pictures Kandinsky painted in 1910 and in the next few years. That extremely rich period of his work, reflecting his full maturity, lasted until 1914. Two clearly distinct stages had preceded it: first the years of apprenticeship, from 1896 to 1900, and then the years in which the painter was beginning to look for his personal way of expression by choosing between the acquisitions of his period.

Kandinsky was so lucid an artist that there is no need to interpret his intentions. It is enough to read what he wrote: "The problem of light and of air in the impressionists has never interested me much. It has always seemed to me that the clever discussions on this subject did not have much to do with painting. The neo-impressionists' theories seemed to me far more important: they, to put it briefly, were concerned with the action of color and left in peace the problem of air." If we add to this definite interest in neo-impressionism the fact that Kandinsky

spent a year in Paris, in 1906, at the very moment when the
Fauves were triumphant, the two elements that characterize
his painting at this period stand out clearly: while he was follow-
ing the ideas of the neo-impressionists with regard to the action
of color, the intensity of his palette fully equaled that of the
Fauves. It is quite clear that Kandinsky was constructing his
paintings with color, whether he proceeded by superimposition
of tones or used mixtures obtained first on the palette. His

36. Vassily Kandinsky, *Church*, 1910.

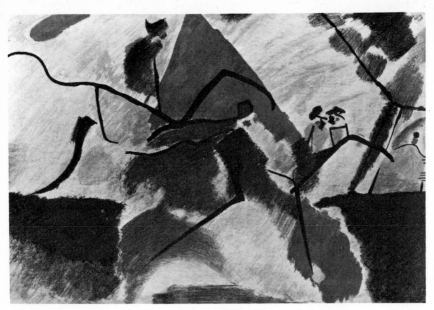

37. Vassily Kandinsky, *Impression V* (public gardens), 1911.

range of tones was often surprising and his impasto luxuriant. While the paint was laid on thickly, his touch gradually lengthened and became a tense, rapid brushwork; those contrasts of light drive like flashes of lightning across the landscapes which Kandinsky painted in Paris in 1906. Up to then, in the first years of the century, alternating his techniques, he had done several paintings in tempera; but now he concentrated almost exclusively on oils. And it is from the handling itself, from the material handling of color, that the forms of his Murnau landscapes seem to arise. These landscapes, in which an inner resonance now completes the image, are the prelude to his first abstract paintings.

Murnau, the small village near Munich which Kandinsky painted in 1908 and 1909, appears completely transfigured in his pictures. The tension of touch and the construction by contrasts, both of which could be felt in his preceding pictures, now animate the whole surface, and Murnau is the distant

38. Vassily Kandinsky, sketch for *Improvisation 14*, 1910.

pretext for a collision of strongly colored shapes – a collision powerful enough to burst the form. The color overflows the limits of the object depicted: it is as though its own force is compelling it to spread. Toward 1910 Kandinsky begins to use, in order to compose his picture, large spots of various colors, which the brush strokes, in the course of their inflection, steer in one direction or another. At the same time his palette grows lighter, becomes more luminous. A typical example of this final figurative moment in Kandinsky's work, on the very threshold of abstraction, is the picture called *Church*, painted in 1910. The belfry and roof of the church, as well as the tree trunks low down on the right, are still clearly recognizable; but they are not detached from the other elements of the composition – sky, earth, vegetation: together they form a striking unity. The particular, as it disappears, has given birth to something more vast. It is the passage, as Kandinsky puts it, "from the material to

36

the spiritual"—or if one prefers, the disappearance of the cerebral categories under the weight of the immediate reaction of the senses. And it is not surprising that the artist's imagination should have been strongly stimulated by this.

All through 1910, before and after his first abstract watercolor, the outside world was to persist in Kandinsky's pictures, with this ambivalent aspect. When one considers, after the event, the slowness with which he detached himself from reality, his prudent progression toward abstraction in the very midst of the fire that is characteristic of his painting during those years, one cannot help being astonished: Kandinsky's behavior seems so contradictory—he is hesitant about the suppression of the object, impetuous in the extreme in his way of transcribing it. But as

39. Vassily Kandinsky, *Improvisation 20*, 1911.

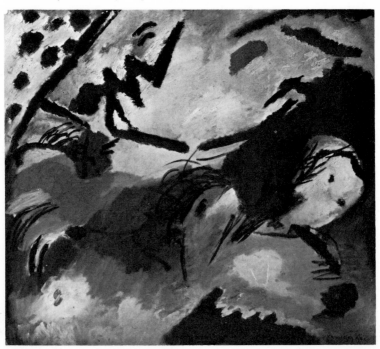

40. Vassily Kandinsky, drawing for *Composition II*, 1910.

soon as one examines his work more closely, one perceives that the impetuousness is in fact a consequence of the hesitation. Kandinsky is afraid of falling into some form that is not significant (as we have seen, he later confessed that at this time the question for him was "what to replace the object with"). Instinctively, therefore, he tended to call upon strength of emotion to replace the support from outside. The more he felt that that support from outside was superfluous, and the more it therefore weakened, the greater became the impetus of the brush stroke; and a day came when this impetus took over. The patches of color and the strokes became really headlong in Kandinsky's abstract water-colors, with a freedom that was to inspire a whole school of painters forty years later. The painter's object—as his develop-

ment showed—would seem to have been to attain the same freedom in his oil paintings; but because with oils, unlike water-colors, the first strokes are extremely poor in comparison with the possibilities of the technique, he was to find that he had to restore the value of the first impulse by using the full resources of oil painting—and so to make its slowness of execution fit in with the explosive rapidity of his sensation. It is here that Kandinsky's intelligence proved of inestimable value. By dint of reflection he succeeded in rendering synchronous "external time" and "internal time," and in this way laid the foundations of an abstract art free from any of the decorative elements whose intrusion he so feared.

This progressive realization of an abstraction seen to be possible took place in the series of pictures he painted in the years from 1910 to 1914. He himself divided these into three different

37 kinds: first, those which he called *Impressions* and which, as the name shows, represented for him "direct impressions of external nature in a drawn and painted form." He did six of these, all in 1911. Next came the pictures that proceeded "from expressions, for the most part unconscious and often formed suddenly, of events with an inward character"; these are called

39 *Improvisations*; numbered in order, from 1 to 35, they extend into 1914. Thirdly and lastly, there come Kandinsky's most ambitious pictures. These are "expressions which form them-selves in a similar way" (to the *Improvisations*) "but which, elaborated slowly, have been taken up afresh, examined, and worked on for a long time after the first sketches, in an almost pedantic manner"—and to the confession in this last phrase he adds: "Intelligence, awareness, lucidity and a precise aim play a major part here." These pictures he called *Compositions*, they are all of large size, and each of them is a summing up of Kandinsky's successive researches between 1910 and 1913, by which date he had advanced far enough in abstraction to be

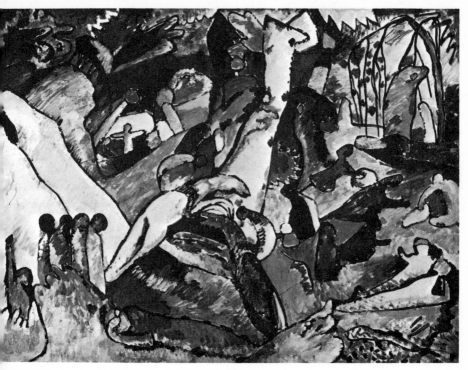

41. Vassily Kandinsky, *Composition II*, 1910.

able at last "to consider art and nature as absolutely separate domains."

Thus, while the first *Compositions* are still tied to the external world (*Composition II*, of 1910, clearly suggests human figures distributed at various points on the surface of the painting as a whole), the last ones—*Composition VI* and *Composition VII*, both dating from 1913—already show abstraction in full bloom. For each of these paintings Kandinsky first made jottings and watercolor sketches, in even greater number than for his other pictures. (There exist sketches even for the *Improvisations*, in contradiction to what the name might suggest—yet another

41
42
44
45
46

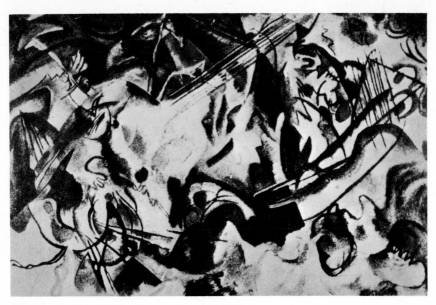

42. Vassily Kandinsky, *Composition VI*, 1913.

proof that at this period Kandinsky was advancing with infinite precaution.) In the *Compositions* he never improvised. Other things apart, he was intimidated by painting, almost like a romantic: "The word 'composition' always moved me," he wrote in *Looking Back*, "and I set myself, as my aim in life, to paint a 'composition.' This word affected me like a prayer. It filled me with respect." That avowal gives us an idea of how important the *Compositions* were in his own eyes, and we can imagine from it the attention and controlled fervor he devoted to them. The development of each one of them that can be studied from sketch to sketch enables us to note that already in 1910 the whole was organized from an abstract kernel: this is quite clear when one compares the first jotting for *Composition II* with the final picture. It is plain that Kandinsky's initial vision contained only the general movement of the composition: he indicates hastily,

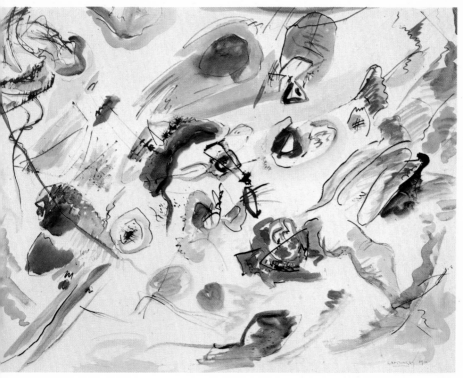

I. Vassily Kandinsky, *First Abstract Painting*, 1910. Watercolor, 50×65. Paris, Nina Kandinsky collection. Photo Galerie Maeght.

by a few arrows, certain ascending, descending, or rotatory directions which the forms are to follow. What concerns him in the sketch, more than the aesthetic result, is that it should establish as a whole the tension, the emotion impelling him to make the picture. The details will come later.

Such, roughly, is the path that led Kandinsky to an abstraction that was no longer spontaneous but thought out—to that of the great *Compositions* of 1913, which are considered, in virtue of their chromatic and structural wealth, as final statements.

After 1913, for the rest of his life, Kandinsky used the title *Compositions* two or three times only. The word no longer had the same attraction for him. He had gone into the world of abstraction definitively, and could explore it without anxiety. His painting was *alive*, it could not be confused with decoration. Its

43. Vassily Kandinsky, pen and ink drawing for *Composition VII*, 1913.

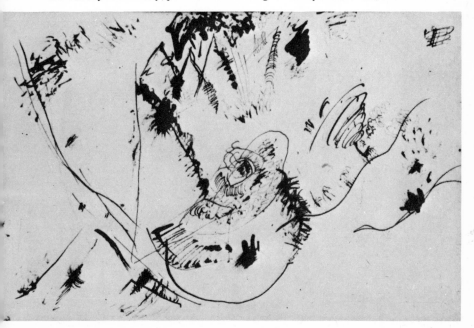

colors arise in profusion, the shapes are lost and found again, a vibration and movement of life attract the gaze. One may have a personal preference for the tense luminosity of some of the paintings he did before 1913, with their large white surfaces out of which all the other colors seem to spring: no painter before then had given to white the task of constructing the picture, in full equality with the reds, blues, and yellows, all of them caught at the height of their force. If that period of Kandinsky's painting (known as his "dramatic period") has an inspiration and an impetus that are less in evidence later, the "classic" stability which his work afterward attained remains nonetheless essentially original.

44. Vassily Kandinsky, study for *Composition VII*, 1913.

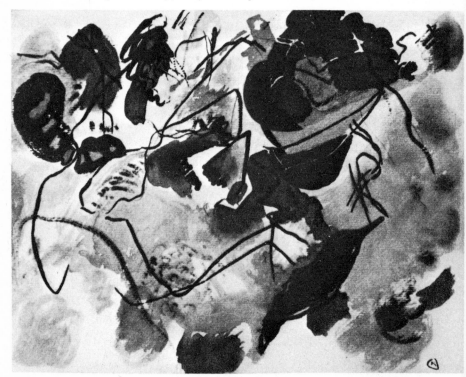

In 1914, when war was declared, Kandinsky left Germany and returned to Moscow. With his love of life, and especially of serenity of mind, he was deeply affected by what was happening. The intense work of the years 1910–1914 was followed by an unusual inactivity. From 1900 onward he had kept a diary in which he carefully noted his pictures as soon as they were finished; under the year 1915 he noted: "No painting." That shows how great was the crisis he was passing through. Two small watercolors were all he produced during the year. Then, after a heavily slowed-down production in 1916 and 1917, the same note recurs for the year 1918: "No painting." In 1917 he had married Nina de Andréevsky (after a divorce, and after

45. Vassily Kandinsky, watercolor for *Composition VII*, 1913.

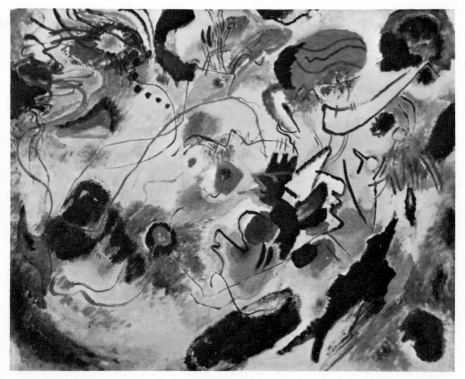

ending his liaison with Gabriele Münter, a painter whom he had met in Munich).

In the same year, 1917, Russia was shaken by the October Revolution. The man of action in Kandinsky came to the fore again. This side of his character had already shown itself during his time in Munich: in 1901 he had founded the "Phalanx" group, and in 1909 the "Neue Künstlervereinigung" (New Artists Union), both of which aimed at reacting against the academic spirit; and finally in 1911, with his friend the painter Franz Marc, he had published the famous almanac of the "Blaue Reiter" (the Blue Horseman), which remains one of the great artistic events of the century. In the Almanac, as well as in the two exhibitions organized under the auspices of the "Blaue

46. Vassily Kandinsky, *Composition VII*, 1913.

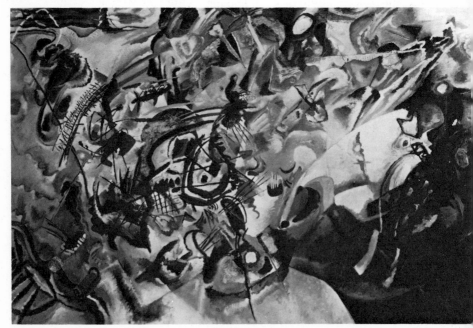

Reiter," Kandinsky affirmed his aesthetic position, advocating the synthesis of the arts – an idea which was particularly dear to him, and for which, in his judgment, the public had to be prepared. Indeed, the "Blaue Reiter" was entirely directed toward this.

While the war put an end to these projects of Kandinsky's, the Russian Revolution – so he believed for a time – opened new possibilities for him. In 1918 he joined the Fine Arts Department of the People's Commissariat for Public Education and became a teacher in the state schools. In 1919 he founded the Moscow Museum of Artistic Culture and took part in organizing a number of museums in the provinces. In 1920 he was appointed a professor at the University of Moscow. In 1921 he founded the Academy of Artistic Sciences. The demands of the revolution, however, ceased to correspond to his views: at the end of 1921 he left his country and returned to Germany.

During these years in Russia Kandinsky was too much absorbed by the self-imposed task of making culture accessible to the people to be able to do more than a little work of his own. In 1917 and again in 1920 – possibly because he thought it necessary to bring his own painting within the range of all – he painted several figurative pictures, while continuing to do abstract work. Back in Germany, he took up his own artistic life afresh. He was invited to teach at the Bauhaus: there he again met Klee, with whom he had been acquainted earlier in Munich. In 1925, when the Bauhaus moved from Weimar to Dessau, the two painters occupied neighboring houses and a firm friendship arose between them.

At the Bauhaus, Kandinsky found once more the harmonious existence that was favorable to his work. He now entered what may be called the "classical period" of his painting. Just as with the earlier period, his development was explained in a book – *Punkt und Linie zu Fläche* (*Point Line Surface*) – which appeared

in 1926. While *Looking Back* had revealed the subterranean paths to abstract art and *Concerning the Spiritual in Art* had been its reasoned defense, this third book of Kandinsky's is wholly an exposition of his method. In fifteen years the situation of abstract art had changed radically: abstraction was now an admitted form of art. In 1917 a group of artists in Holland had gathered around Mondrian and had undertaken the defense of abstract art in the review *De Stijl*. In Russia, as early as 1916, Malevich had made himself spokesman for abstract tendencies and had created "suprematism." The researches of Tatlin and, later, those of the "constructivists" had placed sculpture also under the sign of abstraction. In short, abstract form had suddenly gained ground, and at the moment when Kandinsky's book appeared it was in full expansion. This explains the tone of the new book, which presents itself as a full-dress treatise on abstract painting, a good many of whose pages are meant for specialists only.

Methodical by nature, Kandinsky had no trouble in becoming didactic. He had the teacher's vocation — but this did not diminish his originality, since his teaching concentrated on a subject matter that was still to be explored. And so *Point Line Surface* is important reading, not only for its faithful reflection of Kandinsky's own development but, just as much, for the understanding it gives us of geometrical abstraction as a whole.

"Point Line Surface"

This time, Kandinsky's aim is perfectly clear: he is trying to construct a theory of art on scientific bases. He realizes with regret that painting "possesses the minimum of exact terminology"; he says that, under such conditions, his task is going to be extremely difficult and even impossible and, again and again,

he complains that the notions at his disposal are so vague. And yet he believes firmly that aesthetics will in the end forge precise terms. The time has come for it, in his view, "to undertake an analysis of the whole history of art by reference to its elements," and he is the first to regard what he is writing as a contribution toward this effort. Starting from his own experience, which he even explains in diagrams, he sets out to clarify the theory of plastic art in spite of the rudimentary state of the language available. Engaged in such a task, Kandinsky has now completely changed his style: not a trace of his *fin-de-siècle* spiritualism, only a research that is bent on being "scrupulously exact" and indeed has recourse to illustrations in the effort to be more explicit. The texts which he quotes as reference include works on the development of the technique of painting, the value of signs, botany, biology, and the formation of crystals. To help in his investigations, Kandinsky draws on recent scientific findings — not surprisingly, since his ambition both as a painter and as a teacher at the Bauhaus was to introduce the rigor of science into the practice of art. In this spirit he subjects the means of expression of art to an analysis, starting from the smallest element, the point, and proceeding methodically to the line, and, from that, to the painted surface.

The close examination on which Kandinsky is embarking is apparent from the very first pages. The geometrical point, invisible, immaterial, equivalent to zero, "is the smallest self-contained form. It is turned in on itself," Kandinsky writes, adding with his usual acuteness: "That is why it has found its first material form in writing; it belongs to language and signifies silence... It remains in place, with no tendency to move either horizontally or vertically, either forward or backward." Kandinsky's striving for precision is as great as can be; and yet his artist's sensibility is still there, under the surface, and when it breaks out, with its flowering now controlled by sobriety, it

expresses itself with admirable concision: "If the desert is a sea of sand formed only of points, the indomitable and furious capacity of wandering that there is in these 'dead' points inspires in us a well-founded fear."

In art also the point, that simplest part of form, can have an analogous action. But where is the frontier between point and line? Kandinsky's answer is: in "time that materializes in space." In relation to the point the line is time, because it is "a succession of points. It is the track of a point in movement." And so he examines the characteristics of the line, and after studying the diminution or increase of force according to whether the line is straight or curved, he arrives at this conclusion, in which all the subtlety of his thinking is manifest: the contrary of the straight is not the broken line but the curve, because of the perfected suppleness it possesses, because of its "maturity."

To bring out the difference between point and line, Kandinsky refers, in this as in *Concerning the Spiritual in Art*, to music. "The organ," he observes, "is as typically linear as the piano's nature is based on points." He mentions also the dance, whose movement is contained in lines. And he cites the Eiffel Tower as the perfect example of a building raised up in lines, where line has eliminated surface altogether.

After exploring at length the many properties and functions of the line, Kandinsky attacks the surface, which he defines at the start as follows: "While the straight line represents the absolute negation of the surface, the curve *contains its kernel. . . .* Sooner or later it returns to its point of departure. The beginning and end unite and disappear at the same moment." One is face to face then with "the circle, the original surface" par excellence — "the most unstable" materially (when one tries to keep it steady) and at the same time "the most stable" spiritually (as circumscribed space).

Carried along by his desire to clarify everything and classify

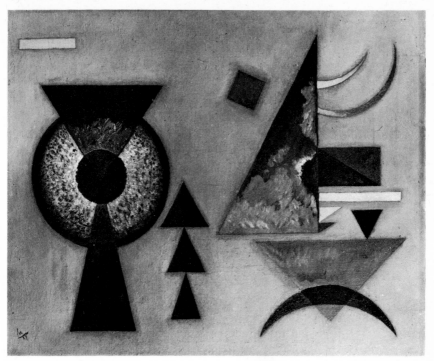

47. Vassily Kandinsky,
Soft Hardness, 1927.

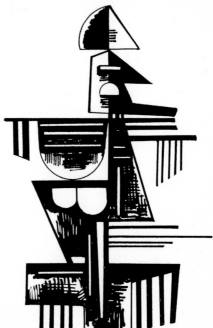

48. Vassily Kandinsky,
drawing in India
ink, 1930.

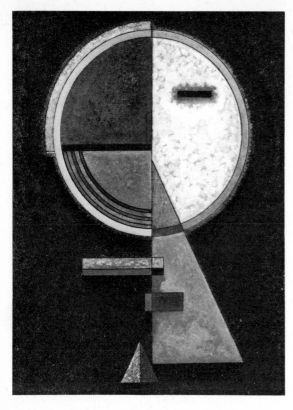

49. Vassily Kandinsky,
Unstable Compensation, 1930.

everything, Kandinsky advances resolutely from page to page;
but when at last he must study closely the nature of the painted
surface, he comes up against the ineffable. The limit which he is
trying to take us past by means of words is one that his painting
alone can pass, to tell of what is beyond it.

In the course of this second phase of his development, which
began in about 1922 and ended only with his life, Kandinsky was
guided by the awareness he had acquired of abstract art — "of its
rights and duties," as he put it. He was convinced that forms are
variations on a single theme, that underneath the action of con-
traries and through the similitudes and oppositions their infinite

possibilities spring from one principle only. He had decided to
concentrate on the principle. Just as he had been afraid of the
decorative at the time of his first steps into abstraction, so now
he dreaded that a free abstract composition might reproduce *47*
certain internal aspects of the real (conformations of crystals, *48*
vibratory movements of plants — these are his own examples). *49*
On this point Kandinsky is categorical: "It is unthinkable," he *50*
says, "to situate the inwardness of one world in the externals of *51*
another." Abstract art must find the equivalent of what in nature
is organically necessary. Between these two worlds, the real and
art, parallel and confronting each other, there can be no contact.
Art must dominate the real. Every repetition of a natural element
in an abstract composition is a weakness. Therefore, for fear of
involuntarily ending up by reproducing some real aspect or other,
which would be a flaw in the absolute system of abstraction,
Kandinsky chose obedience to the principle. The resulting

). Vassily Kandinsky,
 Cross-red, 1931.

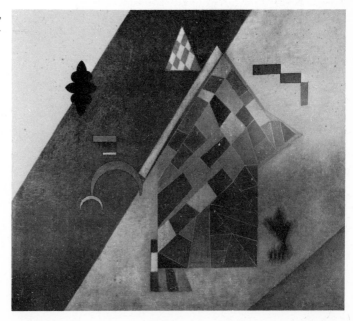

stiffness in the forms of his painting was a deliberate act, dictated by Kandinsky's whole development, much more than a result of his teaching at the Bauhaus. Without any doubt, this rationalization of the creative process was the inevitable price to be paid for the painter's lucidity, which became extreme with age. Some people feel that the consequent absence of spontaneity gives Kandinsky's later pictures a quality of intellectual perfection which makes them less satisfying than his earlier works. It is possible. But the imagination he displayed until the last day of his life is amazing.

In a play of curves and straight lines, working with the drawing-pen and compasses, alert to shade his palette so that no color is repeated from one picture to another, he managed to reconcile

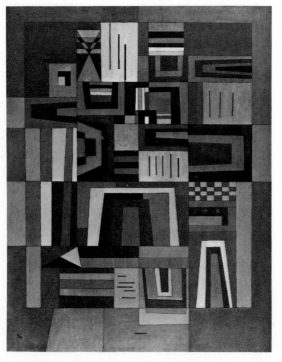

51. Vassily Kandinsky,
Pink Compensation, 1933

the exigencies of his chosen principle and those of his heart.
Kandinsky had understood how the format dictates the com-
position of an abstract picture, he knew better than anyone the
virtues of color, he had meditated for a long time and then ex-
plained and defined the properties of form; and, no doubt because
this science, in his case, was not learned from others but dis-
covered, he was not encumbered by it. It did not interfere with
the deployment of his forms or prevent their renewal. Only, it
excluded all uncertainty. A picture by Kandinsky no longer ran
any risk—this was the only indication of the great knowledge
that presided over its execution.

Rarely, in fact, does painting give the impression that Kan-
dinsky's does, of being controlled down to its smallest detail—

52. Kandinsky in 1938, in
his studio at Neuilly.

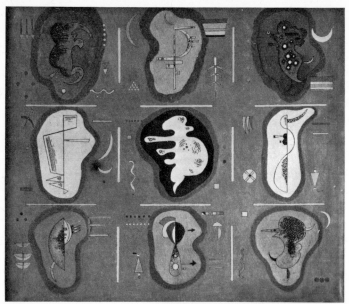

53. Vassily Kandinsky,
Each for Himself, 1934.

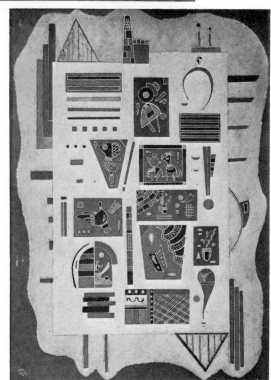

54. Vassily Kandinsky,
Conglomerate, 1943.

and it is tempting to say "controlled in advance" to an extent that seems inconsistent with artistic creation, which is adventure. The unknown revealed by the painting affects neither the painter nor his proceedings: it is the effect and proof of the supremacy of abstract form, as he had wished it to be. The world of perfect harmony, which *Concerning the Spiritual in Art* had declared to be promised to men, had come — but only in painting. Attached as he was to this ideal, which he had originally thought of as more than an aesthetic ideal, Kandinsky made it into a carapace for himself when political events brought havoc to his way of life.

In 1933 the Nazi government closed the Bauhaus; Kandinsky left Germany and went to live in France. But the change of country and of company had scarcely any influence on his painting. The pictures he produced in his studio at Neuilly-sur-Seine *53* (where he worked until his death in 1944) give the same impres- *54* sion of serenity. Their surfaces now tend to divide into compartments, their forms to become more slender. As for the colors, right to the end they never cease to enrich themselves with fresh nuances, and to unite in harmonies that no painter till then had ever tried. His mind seems occupied by the idea of many wholes, each a universe. Through all the variety of his pictures, the aim of his painting remains the same — "to find life, to render perceptible its pulsations, to establish the laws that govern it," as he himself stated it at the end of his book *Point Line Surface*, as the conclusion to his theory of abstract art.

Piet Mondrian

The singularity of Mondrian's work, the type of abstraction which
he conceived, the breadth of creative gesture which he eliminated,
the limitations which he imposed on the means of painting, the
powers of imagination which he shut up in the imperceptible,
the whole conduct and procedure of his work, its aim and the
approach it implies, act on the spectator almost at once: at first
sight, what is extreme in Mondrian's pictures either bewilders or
fascinates — any middle reaction is excluded. Either one considers
that so extravagant an abstraction sacrifices the potentialities
of painting — a reproach often leveled at the artist in his lifetime —
or one has the feeling that this Spartan quality of form represents
plastic expression at its highest, its quintessence for once
unveiled. But in either case — whether one takes Mondrian's
abstraction as being beyond painting or this side of it — the

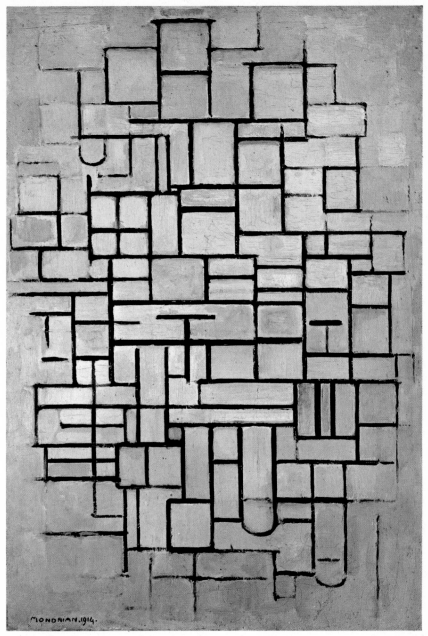

II. Piet Mondrian, *Composition Number 6*, 1914. Oil, 88 × 61. Loan S. B. Slijper — The Hague, Collection Haags Gemeentemuseum.

problem is the same: his pictures fit in badly with our habits, they go outside the experience we have of painting or do not come into it. They are something different, by excess or by defect.

What makes Mondrian so strange is this: in his way of conceiving abstraction, excess and defect are interdependent— symmetrical consequences of the ambition of a painter who was pursuing an ethical dream with aesthetic means of expression. It is this incidence of ends upon means of another nature that gives Mondrian's language its unique character in contemporary painting, indeed in painting in general. The bias that governs his pictures takes them to the limits where they stay—but are they the limits or the beginnings of painting? His pictures maintain themselves there with perseverance, in a kind of aura which they have created—this was surely their purpose. It is an aura produced by the painted surface, and it foregoes the spells of painting for the sake of a higher order. This transmutation of value is what Mondrian was ardently determined to achieve in his work: in his eyes, to give art a rectitude was the mission of abstract form. It was a mission in the sense of the word that only a theosophist could intend. As soon as he came to pure abstraction, in about 1914, it assumed for him the significance of a mission: he was to dedicate the rest of his life to it, day after day, moment by moment, with the steady, unshakable fervor of a man serving a great cause. For painting, as he conceived it, liberated Mondrian from his demons. He engaged in it not only with his faith, his convictions, and his gifts, but also with all his complexes. The strict Calvinism in which he had been brought up was inextricably mingled with his father's dominance over the obedient son that he was; he was stifled, rebellion was impossible, and all this tormented part of the man, though it eventually had its outlet in painting and found the way of salvation in form, left deep marks on the painter. By turning to theosophy, Mondrian ran exactly counter to puritanism—to

that puritan spirit which, throwing a veil over art as over some guilty pleasure, had dissociated ethics and aesthetics. The task of this painter, who for a moment had thought of becoming a priest, would be to bring the two together; and in order that the beautiful and the good might become one, he would carry form to the greatest purity possible. In his paintings he would never cease to purify purity, as if this were the guarantee of the fusion of the ethical and the aesthetic, and in so doing he gives us the strongest proof that for him beauty was a moral value, to which painting attains only with the greatest difficulty.

For this reason, if one wants to understand the painter, it is indispensable to know the man—to catch him off his guard in his everyday life, with his habits and his manias, as he appears in the evidence of his contemporaries, especially in the notes of the devoted Michel Seuphor. I say "catch off his guard" because Mondrian was a secretive man—he fled from confidences. His horror of other people's curiosity was so great that he often changed baker and grocer to avoid being recognized. He surrounded his life with an intentional silence. In his writings a few avowals show through, but one can only grasp these when one knows what they refer to, they are so dispersed among statements on general questions. Mondrian's only confession, the silent one, is inscribed in his painting. It is this that we shall try to read.

Three events can help us toward a clear view of Mondrian's character: from his eighteenth to his twentieth year he hesitated between the career of painter and that of preacher; ten years later—in 1899–1900—he undertook a profound study of theosophy; and lastly there is the shock he received from his discovery of cubism, on his arrival in Paris in 1912 when he was already forty.

Mondrian's life

These three events actually dovetail into each other, form a single mesh which gives Mondrian's life the appearance of a continuous, regular movement. In this man who went forward through life without deviation and without repenting of what he had done, always straight toward the aim he had set himself, always equal to himself, always sure of his aim, it is difficult to imagine any drama—or would be if certain at first sight insignificant facts, noted by his friends, did not betray a strange uneasiness. For instance, the artificial tulip which he kept in a vase, conspicuously placed in his Paris studio—he had painted its leaves white. Or again, once when he was with Kandinsky in 1933, and another time when he was with Gleizes, he changed places at the table in order to turn his back to the window and avoid seeing the trees. Again, he refused to go to Holland for the official celebration of his sixtieth birthday, and the reason he finally gave (because people suspected him of having some resentment against his country) was this: "There are all those fields!" he muttered. "There are all those fields!"

Such a reaction to green was not merely the consequence of a hypersensitive eye. On the contrary, if it is interpreted as a refusal to listen to the appeal of nature, it may be possible to understand, underneath the impassive surface of Mondrian's character, the motives that may have determined such an attitude. Mondrian had subordinated his way of life to the spirit: he imposed the order in his painting upon the place where he lived (one has only to look at his studio); but this order (maintained, according to his friends who visited him, at the cost of a disturbing disorder in a room that opened out of it) could not stand up to the sight of nature. Force of mind, which in Mondrian took the form of a metaphysical uneasiness at first, was then turned toward action by theosophy, and was reabsorbed into

painting through the example of cubism; it triumphed—but by trampling on nature. Not by mastering it. And nature became the unlived part of life, which Mondrian dreaded—that room which he did not live in, next to his studio, full of disorder, in which people were surprised to see several photographs. In one of his writings there is this sentence: "Natural appearance, natural form and color, natural rhythm, even natural relationships, in most cases express the tragic." Or again this: "Every feeling, every individual thought, every purely human will, every particular desire, in a word, every kind of attachment leads to tragic representation and renders impossible the pure plasticity which is peace."

Under Mondrian's "anachronistic calm" (as his old friend Oud described it), underneath his proverbial evenness of temper, the insistence with which the word "tragic" recurs surely indicates an emotional disequilibrium, which was resolved—but only by being transferred onto the plane of art. There it became order—extreme order—and from there it spread and enfolded Mondrian's life. The man clung to the equilibrium he received from his painting, a fanatical equilibrium which shunned every image recalling the initial disorder. Shunned green. Called everything to do with nature "tragic."

The painter's childhood, family circle, and education account for the inhibition of instinct which marked his whole life. The personality of his father began it all. According to one of the friends of Mondrian as a young man, his father was "frankly disagreeable to be with, a sententious man, extremely cold in aspect, who imposed his will on everyone and stood no argument." His Calvinist strictness and the authoritarian intransigence of the schoolmaster that he was, combined to produce that narrow will to which his son was subjected in the small world of Winterswijk, a Dutch village surrounded by fields,

where the Mondrian family had gone to live in 1880. Piet (born in 1872 at Amersfoort) was then eight, and he lived at Winterswijk until 1892, when at last he decided to go and study painting at Amsterdam, after what must have been a real spiritual crisis. Nothing definite is known of this crisis: one can only conjecture his motives, on the basis of the few known facts.

As early as the age of fourteen Mondrian felt his vocation for art. There was a painter in his family, his paternal uncle, who came from the Hague to Winterswijk to work from nature. Piet received his first lessons from him. But his strong-willed father was against this: he must have had little appreciation for his son's gifts, the more so since he himself could draw very well; in addition, he had decided that his son should take up the career of teaching. Piet was alone, fact to face with his father. (Of his mother, who was no doubt completely downtrodden, we know nothing except that her son felt affection toward her.) At the moment of this divergence between him and his father about his future career, his submission became evident and so, at the same time, did his character: all rebellion was undermined in him, but there was a continuity in his ideas, an obstinacy, a kind of passive determination which resisted in spite of his submission. This, indeed, was the saving of him every time, and it must certainly have helped toward the compromise at which father and son then arrived: Piet was to work for the diploma that would enable him to teach drawing. In 1889, at the age of seventeen, he obtained this diploma. Then, instead of looking for a job, he devoted three more years of hard work to obtaining a second diploma, giving him, this time, the right to teach drawing in secondary schools. But when he went to the small town where he had been appointed teacher and saw the "gloomy school building," he fled.

This recoil of Mondrian's from what had not been his choice was an act of insubordination, and brought with it a feeling of guilt. It was then that he sought refuge in religion. He wanted—

55. Mondrian's Paris studio in 1926.

clearly out of an unconscious need for reconciliation with his
father—to become a priest, but this was only possible at the cost
of giving up his painting. It was a sacrifice that Mondrian did not
feel he could make. And so painting, by aggravating his feeling of
guilt, became the contrary of inner peace. When he went to
Amsterdam in 1892 and enrolled himself in the School of Fine
Arts, he chose opposition to his father; but his father, who had
brought him up in the severest Calvinism, was a symbol of his
own moral foundations: his choice was therefore a choice against
good. With the aftertaste of sin in him, Piet Mondrian learned to
paint. In obedience to the academic teaching, he learned to copy

nature. "My father being hostile, other people paid for my studies," is all he says in a short biographical notice which he wrote toward the end of his life.

Nothing of this crisis appeared on the surface. Piet and his brothers (who were also studying in Amsterdam) often went home to Winterswijk on Sundays. No explanation came from Piet. Slow, silent, withdrawn, he quitely went on with his search for the way of salvation — salvation for himself and for painting. Painting might well have the guise of the flesh, of nature, but the twenty-two-year-old Calvinist and future painter must at all costs be absolved — and painting with him. He might have been expected to turn for his justification to culture, but once again it was to religion that he turned. His father had weighed too heavily on him, it was toward him that he felt guilty; his father represented good in contrast with the painting of nature, which was evil; his father was the spirit, it was there that the son was determined to find peace again. With all his heart Mondrian launched himself into theosophy, which was in fashion at that time. As early as 1892 he bent all his intelligence to the examination of its theories, and at length, seventeen years later, in 1909, he became a member of the Dutch Theosophical Society.

Mondrian and theosophy

In view of the motives which, as we have just seen, guided Mondrian toward theosophy, and in view of the two dates just mentioned, which show that his joining the Theosophical Society was an act based on long reflection, one naturally wants to go more deeply into the meaning of such a commitment.

Mondrian himself has left us no confidences on the subject, only a few fragmentary allusions. Once (in Paris, in about 1930) he lent Michel Seuphor a book on theosophy, and when Seuphor

wanted to return it he told him he did not need it — he had a second copy. This is the more significant since Mondrian did not keep books around him: Seuphor observes that there was not "even an embryo library in his studio." The remark tells us a great deal about Mondrian: it is, surely, a vivid image of the man who has found his truth, the sage self-sufficient in his own thinking.

Another time, in 1934, in a letter to Seuphor, he speaks of the "great initiates." And toward the end of his life he wrote, in the margin of a text which declared that the religions were dead, this note: "But so many people still find help in them."

Where Mondrian was silent, certain facts speak. At his death there were found "among the few books he had kept, two short theosophical books in Dutch, both published before 1914." Another piece of evidence: in 1916 he had on the wall of his studio at Laren a photograph of Mme Blavatsky, founder of the first Theosophical Society and author of various works based on theosophy. Lastly, during those same years, there lived at Laren the theosophical writer H. J. Schoenmaekers, and Mondrian is known to have gone often to visit him and talk with him. (The book he later lent to Seuphor was by Schoenmaekers.).

From these fragmentary indications one may attempt to retrace Mondrian's spiritual itinerary. Without any doubt theosophy had everything that could attract and hold him. Its doctrine aims at union with God, and it puts forward rules of life which guarantee the triumph of the spirit — but this triumph, instead of rejecting nature, embraces it, for the first task of theosophy is the annunciation of the secret laws of the universe. It is easy to understand how, with this esoteric path, theosophy offered the young painter a support missing from the Calvinism in which he had been struggling. Without needing any modification, the conceptions of theosophy annulled his sin. What was more, the very thing that gave this sin fresh life every day — the zeal he put into studying painting, all his efforts to become a good painter —

would not only, within theosophy, cease to push him deeper into sin, but would raise him toward the supreme truth which "must be sought for by study, reflection, purity of life, and the gift of oneself to a high ideal." For theosophists, art has an initiatory function, it transmutes and sublimates the base instincts. This notion of perfectibility is one of the pillars of the theosophical theories. Redemption through action does not imply repentance—it is turned not toward the past but toward the future. Every action accomplished while observing the rules contributes to the advancement of the whole of humanity, which must move beyond the physical world and the emotional world to reach the third and last, the mental world. And indeed the isolated individual must also take the same road. Only the great initiates arrive at the end of it.

Clearly such a doctrine not only resolves a guilt complex of the type that afflicted Mondrian, but at the same time saves a man's pride by hauling him out of his spiritual isolation into solidarity with a worldwide fraternity. At point after point theosophy seemed right for the young Mondrian as he struggled with his remorse and worked on, desperately hard, in solitude and reserve. (Once during his youth he had felt at ease in life—it was in Brabant, where he had gone to work in 1904 and lived in happiness among the simple, direct villagers, who were fervent Catholics. His journey to Spain, in 1901, had on the contrary been a complete disappointment: the exuberance there and the southern landscapes were clearly too strong for him.)

There is, lastly, another element in theosophy that may have affected Mondrian. It has to do not with the pure doctrine but with the activity of the theosophical movement, which appealed (in its propaganda publications that circulated widely in the years before 1914) to those who wished "to have a place among the pioneers of the coming thought, and to be among the number of those whom future centuries remember." Mondrian was certain-

ly not the superficial kind of man who would be easily led astray by the vanity such suggestions can stimulate. But, bearing in mind the hold which these can gain over an ambitious man unable to realize his ambitions, and knowing the real torment that painting was to Mondrian, one is led to believe that theosophy, while liberating him from his excessive remorse, did perhaps also confirm him in his ambitions. The course of his life would bear this out: in 1899, when he had finished his studies at the Amsterdam School of Fine Arts and had to make a living by giving lessons in drawing or by executing small commissions, he went through a particularly difficult period. Various disappointments added to his material difficulties; and it was at that moment that, by reading and discussion, he deepened his knowledge of theosophy, which had interested him since 1892.

It seems, then, clear from this brief analysis that for Mondrian theosophy was the condition of his fulfillment, because it made

56. Piet Mondrian in 1944.

it possible for him to live in peace with himself and — to make use again of psychological terms — enabled him to liquidate the guilt complex which was threatening to stifle him. On the plane of the subconscious he was reintegrating the paternal hearth. Painting had set him against his father, and seemed to have outlawed him from Calvinism: now he was returning into that spirituality which he had thought of as lost forever — and he was being admitted to it *with* painting.

In accordance with the rhythm of his temperament, which was a slow one, Mondrian had let theosophy take hold of him gradually. But the theories of theosophy and its vision of the world, once accepted, were lived by him with such conviction that all his painting was now to be influenced by it.

Mondrian's first attempt to introduce a theosophical content into painting goes back to 1911 (two years after he joined the Theosophical Society). This is the triptych called *Evolution*, which represents a woman's body, nude and hieratic, painted on each of the triptych's three wings with variations symbolizing the three states of spiritual accession defined by theosophy. It is curious to note how, in his search for a plastic symbolism, he has recourse quite unconsciously to a geometrical form, and how, in his use of it, his love for almost imperceptible nuances already makes its appearance: the nipples and the navel are indicated, on the first wing, by tiny triangles with their points downward; on the second wing these triangles have their points upward; and on the third wing they are no longer triangles but scarcely visible rectangles. The meaning of the symbolism is obvious: earth and heaven, nature and spirit balance in the third state, which is the highest — the triangles find their completion in the rectangle. How can one fail to see in this — in embryo — the whole future of Mondrian's painting?

This picture is the only one of its kind in Mondrian's work, but

57

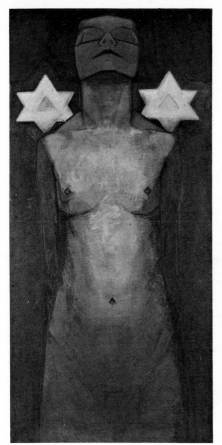 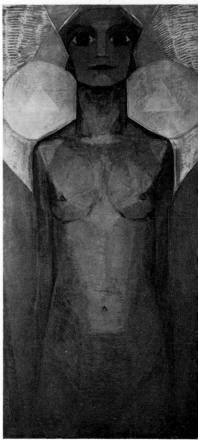

the fact that Mondrian conceived it seems to me significant. From the beginning of his career he had painted only still lifes, flowers, and landscapes: his painting therefore belonged to the physical state, the lowest in a theosophist's scale of values, and clearly this too close bond with nature troubled Mondrian in the long run. In view of the theosophical doctrine of perfectibility, and no doubt also for very personal reasons, he aspired to go beyond this

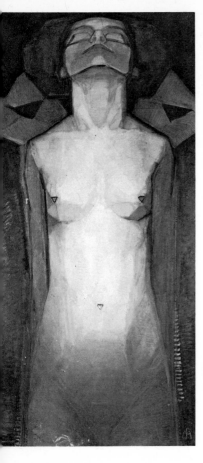

57. Piet Mondrian, *Evolution*, triptych, *c.* 1911.

first stage and to raise his painting above nature. This is what he was trying to do in the triptych *Evolution*. The attempt was not followed up, because it came just before Mondrian went to Paris.

In Paris in 1912 cubism, at its stage of synthesis, was in full spate, and Mondrian did not take long to recognize in the cubist conception the higher state of painting to which he aspired. For him cubism was to have, in the domain of the plastic, a function

similar to that of theosophy on the psychological plane: it would show his painting the path it must take. With the energy, profundity, and obstinacy that were characteristic of him, Mondrian explored the cubist vision to the utmost and then let himself be guided again by his theosophical ideas toward greater and greater purity. He even, in due course, borrowed the language of certain theosophical books for use in his writings on art – borrowings that were wholly logical because the abstraction which he attained was in his eyes the faithful illustration of the great truth revealed by theosophy. And yet this perfect attainment, the impassive façade of his forms, concealed a flaw – that uneasiness of his at the sight of green, that fear in the presence of life.

Mondrian's painting

Mondrian was forty when he came to Paris in 1912, and had behind him twenty years' experience in painting. His first and definitely academic pictures (still lifes and landscapes in the pure Dutch tradition) were succeeded by researches of his own, which had been gaining strength for about ten years. He had painted from nature in the neighborhood of Amsterdam, then in Brabant in 1904 and 1905, and finally, near the sea at Domburg in Zeeland, where he lived for two whole years, 1909 and 1910. Following the example of the impressionists, Mondrian at that time worked in close contact with nature; but the atmosphere of his landscapes is the very contrary of the serenity and joy of living which fill the impressionist pictures. The range of his colors is muted – dark greens, blues, gray-blues. And yet his qualities as a painter make themselves felt in the subtlety of the harmonies, all of which are intentionally chosen so as not to exalt the light but to smother it. This same desire is also stressed by his rather frequent use of violet, a color difficult to handle and rarely loved

by painters. The reason for this somber palette is, for once, explained by Mondrian himself, in the biographical note of 1942 already mentioned. He tells us that at that time he loved the absence of light — "a stormy sky and even moonlight" — so much that he made sketches by night by the light of the moon. In those landscapes, therefore, he was expressing first and foremost that attraction which night had for him — and which seems to me revealing with regard to his psychological condition and his peculiar attitude toward nature. The only light that attracts him is full sunlight because "its density," he says, concentrates the forms; but it does not appear in his pictures until later, during his time at

58. Piet Mondrian, *Rose, c.* 1910.

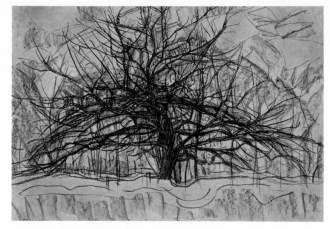

59. Piet Mondrian,
Tree: first version,
1910–1911.

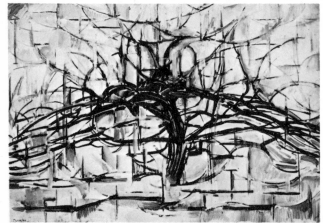

60. Piet Mondrian,
Tree: second version,
c. 1911.

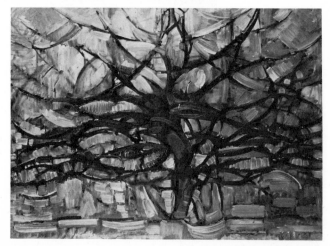

61. Piet Mondrian,
Tree: third version,
1911.

Domburg, when he was working side by side with Toorop and Sluyters, the two painters who at that time represented the Dutch avant-garde. In the work of this period his palette becomes much lighter and at moments seems to echo the violent effects of the Fauves. A curious alternation of techniques is to be observed: sometimes he uses fluid colors, which he spreads in large brush strokes; sometimes, on the contrary, he paints with juxtaposed touches, giving play to the full thickness of the paint. But what is already striking in Mondrian's procedure is the repetition of the motif and the imposing frontality of the forms as he conceives them, whether it is the Domburg church tower or a nearby light-house, a windmill or a tree, or again the long series of flowers which he drew and painted tirelessly at this time — flowers that are always one single flower, seen full face and set down with a sensual avidity. In a rather strange way, all the sensuality rigorously excluded from Mondrian's landscapes seems, at this period, to flow together into his drawings and paintings of flowers, which he often did to make a living, while he reserved for the rest of his works the complete austerity of his commitment as an artist. If, then, there was in him a division between flesh and spirit,

58

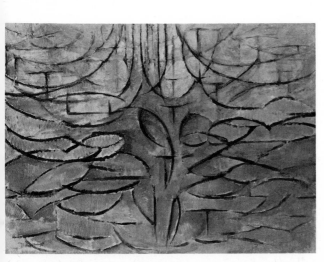

62. Piet Mondrian, *Tree*: fourth version, *c.* 1912.

63. Piet Mondrian,
Domburg Church Tower, c. 1909.

64. Piet Mondrian,
Church Façade, 1914.

cubism could only make the barrier between the two thicker and consolidate their separation. Thus, at the very moment when his experience as a painter was distancing itself from nature under the influence of cubism, there was also a part of Mondrian, deep down in him, which evidently felt this distancing as a deliverance.

The expansion of Mondrian's painting under the cubist influence was immediate. For him, unlike all the other artists, cubism was not a lesson but a revelation. What it brought out at once in his new paintings was the personality he had always had, relieved now from the realistic conventions and at last free. His development, which until then had advanced slowly, heavily, now accelerated. There would never again be any groping, any hesitation in his work until the end of his life. Thanks to cubism

Mondrian had seen into himself clearly. With an inexorable strictness he moved toward abstraction, and when he had reached it, it took on, for him, a double significance — moral and aesthetic. The absolute abstraction to which he came in 1920 is the crown of a whole life, the summit of form, the logical conclusion of the change which takes place in his painting in 1911–1912.

The progress he made during those eight years represents perhaps one of the most exciting moments in the art of our time. This painter, who had always been inclined to repeat the same motif — it was clearly less important in his eyes than the way in which he treated it — applied himself thoroughly, from 1911 to 1914, to extracting from the object painted its abstract essence. From picture to picture the same motif, looked at from the same angle, passes through successive states, which show us exactly how the form separates itself from the concrete content and acquires an abstract content. The case is unique: in these cycles painted by Mondrian — the tree cycle, the church, the sea, the dunes — each picture, each drawing is in itself a finished work, and yet, taken all together, they give us the impression that we are present at the ineffable gestation of form.

Mondrian's cubist pictures differ from orthodox cubism not only in their purpose but in their colors. Certain bluish-whites, certain blue-greens (turquoise blue mixed with the green of rusted copper), certain gray-pinks are not to be found in the cubist palette. Another peculiarity: in these pictures, as in Mondrian's early landscapes, the subtlety of the harmonies still tends to veil the light, to make it indirect, diffused. From his past also the artist gets this mastery of the brush stroke: his touch runs over the surface of the canvas, sometimes broken up, at others con-tinuous, according to the planes he wishes to stress or to at-tenuate. And so from whole to detail, from conception to execution, Mondrian moves forward by combining what he has already acquired with everything he is now discovering in picture

59
60
61
62
63
64

after picture: into each new picture he puts *everything* that has preceded it. In this way the completion of a whole cycle, that of the tree, becomes a point of departure for a fresh cycle, that of the sea, which in turn is resumed in the church cycle. The composition proceeds by simplifying itself, but this kind of simplification is synthesis—it is every time a simplification of the totality of the previous experiments in painting. It is a procedure that enables the painter to catch sight, through the incidental differences, of a fundamental identity: the form that expresses the church joins onto that of the sea. Mondrian had discovered a new value—the sign. After having eliminated the curve from his compositions (except as an accent among the straight lines and their intersections at right angles), he had suddenly found himself in the presence of the sign.

 The initial object in his cubist pictures was now far behind him. With the swiftness of a geometrical progression Mondrian's implacably logical advance had led him in two years, from 1912 to 1914, to the threshhold of abstraction.

 At the moment when Mondrian's work was beginning to take this decisive turn he was again in Holland. He had left Paris in order to be with his father who was seriously ill, and the declaration of war in 1914 kept him in his country. He was to stay there till 1919, going on with his work in a favorable climate, thanks to the neutrality of Holland. According to one of his friends, the musician Van Domselaer, Mondrian in 1914 "already considered that his work was completed, that he had done what he had to do." Even though it seems to us difficult to accept this statement without qualification (Mondrian had given himself body and soul to painting, he was too deeply committed to be able to stop like that), there must be some truth in it, to the extent that Mondrian at that time was—probably—aware of having attained a type of form which satisfied his aspirations.

 His first notebooks seem to date from the same year. In these

65
66

67

65. Piet Mondrian,
Sea, c. 1914.

66. Piet Mondrian, *Sea,*
1913–1914.

67. Piet Mondrian,
Composition of Lines
(*Plus and Minus*), 1917.

his experience as a painter mingles rather strangely with his convictions as a theosophist. To him the "slow and sure path of development" is an axiom, covering his own development both as a painter and as a man. In conformity with the idea of rein-carnation (one of the main supports of theosophy) he likens art to "an old soul that must live in a new body," and as "modern science has confirmed that matter and force are one" (another favorite idea of the theosophists) he believes that he has realized in his painting "the unity between matter and spirit." He there-fore feels certain that he has contributed to the coming of the future society, a balanced and happy society in the image of that world of tomorrow which the teaching of theosophy is preparing. Indeed, it is enough to recall that the first duty of an enlightened theosophist consists in "ascending from personal consciousness to individual consciousness" – in other words, from the particular to the universal – for the underlying ethical significance of Mondrian's aesthetic effort to become clearly apparent. Does not theosophy teach that "an object is the more beautiful the more it reveals the laws that condition it and the place that it occupies in the universe"? Against this background it was in-evitable that cubism should engender abstraction. In the same notebook belonging to 1914 he wrote: "The masculine principle being represented by the vertical line, a man will recognize this element (for example) in the trees rising from the forest. He will see its complement (for example) in the horizontal line of the sea." This is the path Mondrian had been following in his paint-ing. He states it because he has already arrived, in his painting, at handling principles, not contingent forms. For the same reason he can now make this other statement, in which he reveals with-out knowing it the deeper reason for his attachment to theosophy: "Art being superhuman, it cultivates the superhuman element in man, and is, in consequence, a means toward the development of humanity, just as religion is."

The ineradicable filial submission and feeling of guilt which had weighed down Mondrian's youth were thus, in 1914, finally resolved, otherwise he would not have written those lines. The psychological function of theosophy in Mondrian's life was at an end. But since the theosophical doctrine had taken the place of intellectual education for him, he would continue to use its support to give his researches a wider scope.

In 1916, at Laren, where he lived, Mondrian was able to have long conversations with the theosophist Schoenmaekers. The man himself—a former Catholic priest who had gone over to

68. Building of the Maine-Montparnasse Group: detail of façade.

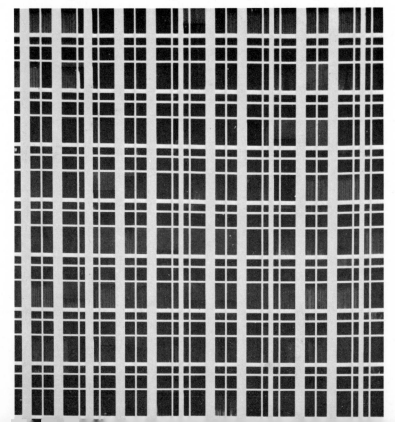

theosophy—did not very much appeal to Mondrian, who found him too cerebral, but his writings had interested him enough to leave a deep mark on him. From Schoenmaekers Mondrian borrowed not only ideas, but also the terminology he would use in due course to explain his own painting. As for the dialogue form that he adopted in his writings, it may well have come to him from books designed to popularize theosophy, in particular from Mme Blavatsky's *Key to Theosophy*. These writings of Mondrian's eventually appeared in the review *De Stijl*, founded in 1917 at the same time as the group of the same name (of which more will be said later). In the pages of *De Stijl* in which he is trying to define his conception of painting he used the expression "*nieuwe beeding*". This he borrowed from Schoenmaekers' book *Het nieuwe Wereelbeeld* (*The New Image of the World*); it is usually translated as "Neo-plasticism" or "New Plastic" but its real meaning would be something like "the new fulfilment of form."

Neo-plasticism or the new image of the world

In Mondrian's thinking, neo-plasticism was nothing less than the new image of the world. He entrusts the expression of this to form because he believes in the power of form—the more firmly since he knows its capacity to rise above the contingent and to maintain itself in the essential by means of abstraction. The direction taken by his work during these years was governed by a strange confusion: Mondrian was convinced that he was realizing the ideas of theosophy, which he thought of as prophetic, whereas in fact he was following his intuition as an artist and it was to this that he owed his premonition of certain aspects of the coming world, whose contemporaries we now are. Who has not been struck by the resemblance between the organization of the

façades in the architecture that has become current since
World War Two and the neo-plastic painting of Mondrian? So
the absolute abstract form conceived by him was a profound
expression of our time. Whether accepted or repudiated, this
form answers to the exigencies of present-day life: the age has
recognized itself in it. The importance of this extraordinary
painter could have no better proof. Painting, at the extreme limit
to which he took it, has fertilized architecture.

68

The stages Mondrian passed through to arrive there are all
recorded in his pictures. We have seen how in 1912 cubism
put an end to his earlier research. In 1914, similarly, the appear-
ance of the sign closed one period of his work and opened
another. This in turn ended, in about 1920, with the first neo-
plastic pictures. From cubism to the sign and from the sign
to neo-plasticism — this was the course of Mondrian's abstract
painting.

Once the sign had appeared — that last refuge of the real,
an extract from its structure — Mondrian extended it to the
whole picture.

Till then he had proceeded by deduction, now he advanced
by induction — from the sign he ascended toward the principles
governing form. He demanded of the sign that it should be
initial, in the full sense, and he observed its behavior as one
follows an experiment in the laboratory. The sign was the straight
line which he drew either vertically or horizontally — that is to
say, in the two most purely opposed directions; but when he had
sprinkled the surface of his canvas with these signs, what resulted
(he now discovered) was the force of symmetry and asymmetry.
For Mondrian, to discover was to become aware and at once to
take a step forward.

67

The series of these pictures constructed with signs (later they
came to be called "pluses and minuses") was already leading

69. Piet Mondrian,
*Composition with Planes
of Pure Color on
a White Ground*, A, 1917.

him to look at his painting in terms of what he saw to be the
fundamental and contrary plastic principles, symmetry and
asymmetry. Mondrian thought he recognized in their action
the law of nature, the first law from which all the others derive.
From that moment he determined that his pictures should appeal
only to the pure action of symmetry and asymmetry, and he
would express this with the plastic means that were right for
its purity—the means he had already forged for himself. Content
and form were now dovetailed together in his painting. "The
whole of life, in greater and greater depth, can be reflected in
the picture." he wrote in *De Stijl* in 1917; and toward 1920,
when he painted his first neo-plastic pictures, he was profoundly
convinced that he had attained a universal expression which

coincided with the quintessence of painting. Never, after that, did he abandon these views—he felt certain that "the New Plastic is an art of adults" while "the old art is an art of children." Fifteen years later. after having painted pictures which are simply the same picture taken up again with scarcely perceptible nuances, he was still insisting on the same point: "Life," he said, "is simply to go on continually going deeper into the same thing."

Few artists have had the theosophist Mondrian's certainty of having arrived at the Truth. He had no doubt that the good, the beautiful, and the true converge in neo-plastic painting. "Things give us everything, but the representation of them gives us nothing," he had noted timidly in one of his 1914

70. Piet Mondrian, *Checkerboard Composition in Light Colors*, 1919.

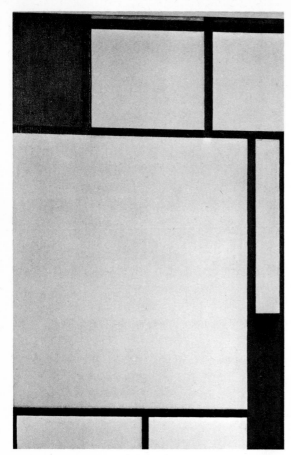

71. Piet Mondrian, *Composition*, c. 1922.

notebooks; but now he was categorical: "The New Plastic
is the equal of nature." He wrote in a letter to a friend in 1923
that being obliged to paint flowers to make a living was "after
all not so terrible," because neo-plasticism "was founded
once and for all." And with a surprising humility (a sympathetic
trait in a man who was so severe and sure of himself) he added:
"I ought, though, to be thankful to make a little money in order
to eat."

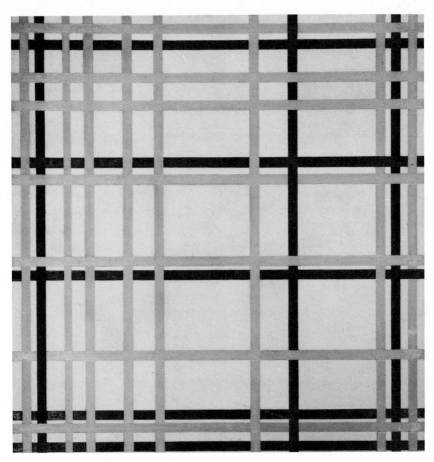

72. Piet Mondrian, *New York City*, 1942.

In many of his writings (which are a long way from having
the brilliance of Kandinsky's writings) Mondrian comments
untiringly on his neo-plastic work. The work which preceded
it — and which, simply as pictures, often surpasses it — is of only
secondary importance in his eyes: it is merely part of an advance
of which the end alone counts. And since this end, as Mondrian
understands it, is so rigid, so obstinately exclusive, a part of
the "being" of painting is entirely rejected in advance. All

instinctive liberty, all irrational suppleness of color are absent from Mondrian's neo-plastic pictures. By way of compensation he has given solid foundations to form. The right angle, as the relation between two extremes, is in fact the plastic expression of that which is constant. The picture's construction, based on relations only, is capable of making indirectly perceptible

73. Piet Mondrian, *Broadway Boogie Woogie*, 1942–1943.

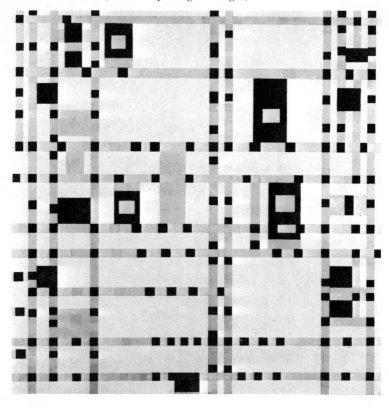

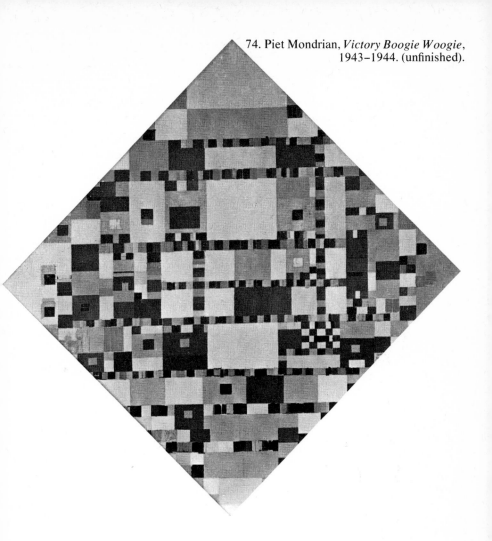

74. Piet Mondrian, *Victory Boogie Woogie*, 1943–1944. (unfinished).

a dynamic movement, by establishing its equilibrium. Nothing is more completely motionless than the parts of a Mondrian picture taken separately, but as soon as they are considered all together their immobility becomes active, it recomposes an equilibrium. Quite clearly form—everything that is line and plane—can achieve order in this mathematical world into

which Mondrian's paintings penetrate. But how can color hold its own with this eminently rational structure?

This is the question that began to weigh on Mondrian's work *69* as soon as neo-plasticism was fully realized—it was to raise its head twenty years later.

70 Between 1917 and 1920, when he moved on from lines intersecting at right angles to rectangular or square planes, the presence of the plane and its extent called for color. In order to realize this "plane painting in the plane," as he set himself to do, he then began experiments with color: he had recourse to clever mixtures of colors, and obtained extraordinary, extremely refined tonalities—pale pinks, pearly blues. The love for veiled color, which had long before been evident in his painting, appeared once more: in some pictures painted in 1919, by forcing white into his mixtures, he arrived at an opalescence which is an achievement in itself. But it did not satisfy Mondrian: this scale of translucencies, which seems to be made of submerged vibrations, scarcely belongs to the same nature as the right angle—its airy lightness separates it from that. Was it for that reason, and because he realized that color, unlike form, would not let itself be controlled by reason, that Mondrian, under the influence of his friends the painters who formed the *De Stijl* group, adopted the three primary colors (blue, yellow, and red), seconded by the two non-colors (black and white)? Black he reserved for the broad bands separating the colored planes; as for white, which sometimes becomes a very light gray, he used it as a kind of toning-down surface. Mondrian's pictures, having ceased to have a central form, took as their center this wide expanse of non-color, against which the true colors ring.

Such is really the chromatic system that governs Mondrian's *71* neo-plastic pictures invariably, for more than twenty years.

Then, in 1942, a picture like *New York City* appears and *72* breaks with this system. For the first time the lines which divide

the surface are light, and in the very next pictures they become divided into sections, small red and blue segments. The monumental style of neo-plastic painting has given place to a syncopated rhythm: this is true of Mondrian's last two compositions on a large scale, *Broadway Boogie-Woogie* and *Victory Boogie-Woogie*. The latter remained unfinished.

73

74

From 1940 onward the painter lived in New York. He had left Paris in 1938 for London, and moved on from there to the United States. In spite of his age (he was then sixty-eight) Mondrian was far from feeling lost in the great American city. On the contrary, New York enchanted him. He felt at ease in that town with its streets at right angles, where the skyscrapers affirmed that domination of man over nature which had been the dream of neo-plasticism. Whether from euphoria at the sight of this "world of tomorrow" which had already arisen, or from age, or because the unlived part of his life was taking the upper hand, Mondrian was in rebellion against the austerity of his own style: "It is only now that I see that my pictures in black, white, and very few colors are merely drawings in oils," he wrote to J. J. Sweeney. He asserted that "the destructive element is too much neglected in art," and he explained that, if he was attracted by a musical form like the boogie-woogie, this was because he felt that is was close to his own intentions — it broke the melody by continually setting its means of expression against one another.

In 1944 death put an end to this unexpected outburst of youthfulness. It was an end like a row of dots . . .

Casimir Malevich

In 1918 Malevich exhibited his *White Square on a White Ground.*

84

Only the slight inflections of the touch make the square form stand out from the ground. If one tries to pin it down, to apprehend its limits, it vanishes, only to rise afresh as soon as one's gaze embraces the whole picture, only to disappear again, then to reappear, ceaselessly submerged and present in what is indeed the extreme limit of colors opening on to the unlimited — no picture in the recent or ancient history of painting is more significant in its refusal of any kind of sign. No painter has been less understood by his contemporaries than Malevich was when he suddenly set abstract painting "in that interior region which we can only designate under the veil of 'no'" — the region of which Maurice Blanchot speaks, where "impossibility is no longer privation but affirmation." Malevich himself wrote: "As soon

as we turn the instruments of our intelligence upon the objects of the material world, they explode; the height of intelligence, its deepest depth, its widest scope, its furthest reach, is explosion." The work of art conceived as an explosion, as a "mystery that enthrones" in René Char's phrase — the whole adventure of Malevich's "suprematism" seems to touch the tensest part of present-day sensibility.

Light still needs to be thrown on this painter, who is unquestionably one of the most interesting of this century. Two dates for his birth (close together it is true) are given by his most careful biographers, Werner Haftmann and Camilla Gray. Malevich seems to have been born in either 1878 or 1879 near Kiev. While there is agreement about where he was born, there are two versions as regards his family. One of them says that his father was foreman in a sugar refinery while his mother was of Polish origin and probably illiterate. According to the other version his mother was Russian and his father was Polish, the bailiff of a farming estate. It is known, however, that by 1895 Malevich was already attending the painting school of Kiev. Did he move on to continue his studies in Moscow in 1900 or in 1905? Here again opinions diverge. In any case, from 1910 onward Malevich is to be found in the ranks of the Russian avant-garde, where he soon occupied a leading place. It is supposed that he went to Paris for a short time in 1912. In 1916 he launched suprematism, the abstract movement whose leader he was, and at the same time published his theories under the title *From Cubism and Futurism to Suprematism.* After 1917, because the Revolution had for a time identified itself with the avant-garde, Malevich's activity redoubled: he exhibited, went on writing and publishing, and taught at the Vitebsk Art School — later, beginning in 1922, in Petrograd. Supported by Lunacharsky, he devoted considerable energy to the democratization of culture. But he began to be surrounded by a growing hostility. The Revo-

lution was entering its second phase. Malevich fell into disgrace. During the last years before his death in 1935, he painted only portraits and realistic landscapes. Yet before he died he had painted his coffin all over, in the style of his former abstract pictures.

The silence of death which closed over his paintings would no doubt be continuing still if he had not, in 1927 before he fell out of favor, received authorization to leave the Soviet Union and visit Poland and Germany, on the occasion of a retrospective exhibition of his work which was to be held first in Warsaw and then in Berlin. This three months' journey was decisive for his posthumous glory.

Summoned back urgently, Malevich returned to Leningrad, leaving in Germany all the pictures of his exhibition, some drawings, some notebooks, and also a long manuscript, *Suprematism or the World Without Object (Die gegenstandslose Welt)* (*Супрематизм—Мир как беспредметность или освобождённое ничто*), which was at once issued as one of the Bauhaus publications. This text has never been published in Russia. The pictures and drawings (some thirty canvases dating from 1900 to about 1925 and as many drawings) have been exhibited since 1957 in various museums in Europe (Amsterdam, Brunswick, Berne, London, Leverkusen), and it is they that have caused the "resurrection" of this painter, most of whose work is kept in the inaccessible storerooms of the Leningrad Museum.

Clearly the reason why Malevich's painting managed to impose itself with such authority is that its day had come. The pictures known to us were not understood when they were exhibited in Germany in 1927, any more than the publication of his *World Without Object*, also in 1927, enabled people to apprehend this painter's profound originality at its true value. That non-apprehension has been attributed to the bad translation of Malevich's writings. (In 1962 a new edition, revised and cor-

76

75. Photograph of Malevich,
taken in Warsaw, 1927.

rected by W. Haftmann, was brought out in Germany and may be considered definitive.) But the real reason perhaps lies elsewhere. At that time abstract art was still in the process of growing, while Malevich's painting had pressed on headlong and was already revealing its extreme limit. In his pictures abstraction had gone so far that it was taking painting—all painting—to its own end, to the "revealed nothing,"
as he himself defined the point he was aspiring to reach, because there alone, in the "revealed nothing," the real is passed by and that which transcends it is allowed to appear. There is in

76. Photograph of Malevich's room in Russian Art Exhibition, Berlin, 1927.

Malevich's sensibility a kind of panic flight into greatness, which precipitates the development of his painting. At one go, and even before having analyzed the possibilities of abstract art, he perceives their furthest point. And this point once reached in his "white on white," it is as if he himself was the first to be dazzled by it—he could not rest until he succeeded in apprehending it also through language. Malevich wrote several hundred pages about that single point at which form and color, having become absence, reveal the supreme presence. His writings were so abundant, and the coherence of his beliefs is so great (in spite of the breathless style in which they are expressed) that one wonders whether the really perilous leap, which one watches taking place in his painting, was not his means of liberating himself from a kind of intellectual obsession—in certain respects almost a mystical one. Certainly Malevich's writings about "the world without object" are later (four years later) than his white pictures, but these extreme pictures, which appear in his work without any preamble or preparation in the field of painting itself, nonetheless find their explanation in his writings.

In short their sudden coming was probably the consequence of the intensity that was characteristic of Malevich's thinking. To come to terms with life Malevich, like some of Dostoevski's heroes, had to sift its premises thoroughly: for him, as for them, metaphysical uneasiness was a part of existence. What drove him to write was not an idea, still less the desire to construct a theory of painting: it was an open wound, and he rushed on without stopping because he could not do otherwise.

The precipitation characteristic of Malevich's development as a painter did not show itself in the pictures themselves, which are always worked out very carefully; it belonged to the period of their conception, not to that of their execution. This is quite clear, even though the dating of his pictures is generally approximative — especially with the early ones, when his name was not yet figuring in the activities of the Russian avant-garde.

During the first years of the century, as is known, he painted vaguely impressionist pictures; these, in about 1907–1908, gave place without transition to a series of gouaches, which by the violence of their color remind us of the Fauves, but also suggest the "Brücke" group of German expressionists by the inclination they show toward subjects with a moral or social ring to them: the man with the spade, the man with the sack, the floor polishers — all these gouaches by Malevich are concerned with the world of manual work. What is curious is the way in which, after accepting them, he transforms the two influences, the French and the German: it already reveals the dominant characteristics of Malevich's sensibility as well as his gifts. He easily overcomes the technical difficulties of this free kind of painting, which is built up with big brush strokes: not a sign of awkwardness in his movements, habituated though they had been to the impressionist multiplicity of small touches. A constant amplitude makes the form overflow, and this amplitude is applied to sym-

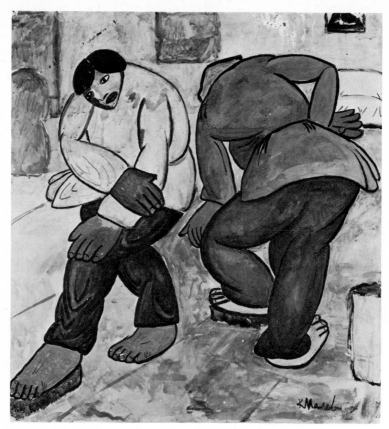

77. Casimir Malevich, *Floor Polishers*, c. 1911.

bolic ends—Malevich uses it to suggest weight, which in his mind is associated with the world of manual work illustrated in the subject matter; the people have hands and feet that are enormous in relation to their stature, and these, in addition, are painted in bright red. This, then, is the use Malevich makes of pure color! The chromatic boldness of the Fauves and the "Brücke" interest in subject matter join together to become, in the work of this Russian, the vehicles for an emphatic symbolism. This same symbolism persists in one of Malevich's first cubist

77

attempts (which dates from about 1912 and makes us think *78*
chiefly of the researches of Léger). Then the taste for symbols
disappears from Malevich's work as suddenly as it had appeared.

Fresh influences take hold of his painting: it becomes entirely
governed by advanced cubism with its concern for the division
of space. But Malevich was not made to be an imitator: his
conception of cubism as synthesis quickly led, in his pictures, *79*
to a super-imposition of incongruous objects. Yet what is most
remarkable about these pictures is that in some ways they
prefigure dada and the Merz pictures of Schwitters — for example
when Malevich introduces bits of dress material and lace into
some of the pictures he painted in 1914.

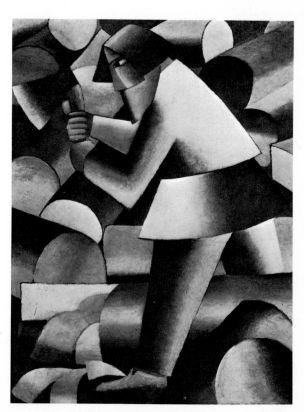

78. Casimir Malevich,
The Woodcutter, 1911.

Some of the sources of Malevich's work at this time are evident. Even if he did not visit Paris in 1912, he could have studied cubism in the house of the Moscow art collector Shchukine, who accumulated fifty pictures by Picasso dating from before 1914, about ten of them being cubist paintings. Starting in 1906, Shchukine and Morosov had formed, almost at one stroke, their fabulous collections, at that time the only ones in the world in which it was possible to see four hundred pictures extending from the impressionists to Picasso; and these collections were to contribute greatly to the education of the young Russian artists. In addition, luxuriously produced reviews, already containing reproductions in color, kept the Russian intelligentsia abreast of the artistic and literary life of western Europe: first came – from 1898 to 1904 – the review *Mir isskoutva* (*The World of Art*), founded by Diaghilev, animator of the Ballets Russes; it was followed by the reviews *Apollon* and *Zolotoe Rouno* (*The Golden Fleece*). In 1908 this last had also organized the first exhibition of French art which included, among others, several Fauve pictures; then, in 1909, a second exhibition in which there were already some cubist compositions. In the same year the Russian press reproduced the *Futurist Manifesto* immediately after its publication in *Le Figaro*, and the futurist influence quickly made itself felt in Russian avant-garde circles. Unlike cubism, which was concerned only with form and was a purely plastic revolution, futurism was aggressive: Marinetti attacked society, with no holds barred, and ceaselessly provoked public opinion. And this provocative side of futurism attracted the Russians – Marinetti's fanatical faith in a new age, which artists and writers must forge, fitted in with their aspirations. The 1905 revolution had already shaken the country, and the conviction that life ought to be based on new foundations was shared by the whole of the intelligentsia, which displayed a curiosity and an openmindedness that existed nowhere else at

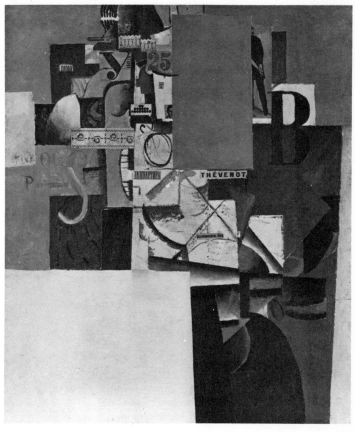

79. Casimir Malevich, *Woman beside an Advertisement Pillar*, 1914.

that time. According to the Russian philosopher Nicolas
Berdyaev, these characteristics of the beginning of the twentieth
century were already to be found "in the psychic structure of
the cultivated stratum of the nineteenth century," where they
were a sign of the loss of roots and a rupture with the present,

and this in all fields. Here, then, was a state of mind more open to influences than any other: it explains not only the immediate repercussions each of the Western avant-garde movements had on the artistic plane, but also the convulsive activity which distinguishes the Russian avant-garde from the Western.

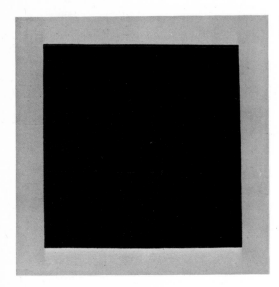

80. Casimir Malevich, *Black Square*, c. 1913.

Malevich did not escape this atmosphere — I even believe that it was this that gave his pictures a certain quality which anticipates dada. Camilla Gray tells us that on the back of one of his 1911 pictures called *The Violin and the Cow*, Malevich had written: "The non-logical collision of two forms, the violin and the cow, illustrates the moment of conflict between logic, natural law, common sense, and bourgeois prejudices." This feeling of the absurd, which was soon to explode with dada, was able to exist

in the pre-1914 Russian atmosphere. Up to that time, therefore, and as long as he was painting his cubist pictures (which he himself called cubo-futurist), Malevich was no exception to the general rules determining the Russian avant-garde as a whole. But in December 1915, when he showed his first abstract pictures at the "0,10" exhibition in Petrograd, he took a step forward which can no longer be explained in the Russian context, and which no longer relates to the Western avant-garde, for the simple reason that Malevich had suddenly arrived at that absolute abstraction which, apart from him, Mondrian alone was seeking during those years. Where the Dutchman was advancing cautiously, the Russian arrived at one leap and went straight to the summit: among the pictures hung on the line at that exhibition, there was a picture by Malevich of a black square on a white ground—uniting and confronting the two non-colors and the most affirmative form.

80

Where do these abstract pictures by Malevich come from? Unexpected though they were, they had roots. But what roots? Remote but certainly present, there were the influences he had undergone. Only these were now filtered, refracted as through a prism by Malevich's temperament. Out of cubism he had retained the essence: the necessity of animating space by inscribing form in it. For when the cubists broke up the object they did it to make space live. This new vision is never a mere fragmentation of the object in accordance with its facets, except to those imitators who miss, precisely, what Malevich understood better than anyone—that the cubist picture is, before anything else, an affirmation of space. Malevich may well have been attracted early by abstraction (Kandinsky's researches were known among his compatriots), and in his mind it would join up with the lesson of cubism: in painting his very first abstract pictures he was already aiming at the pure expression of space.

What is striking, in fact, in these pictures by Malevich is the relation between the forms and the space surrounding them, the interval which, while separating them, makes them gravitate toward one another.

If proof of this active presence of space were needed, it would be enough to isolate one of the forms, and look at it by itself,

81. Casimir Malevich, *Suprematist Composition*, 1914.

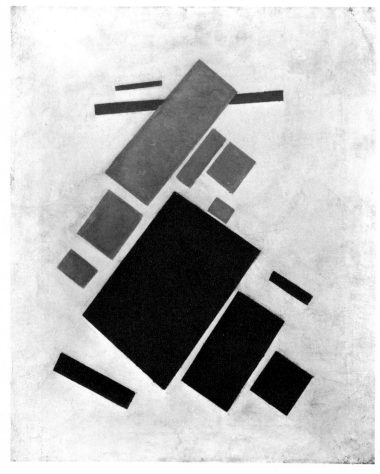

for it to become an ordinary inert plane; then, as soon as it is restored to its environment, it comes to life again—a tension passes through it which catches the eye and leads it on at varying speeds. To Malevich a composition is a harmony of rhythms, which are realized in the space of the picture just as a musical phrase is realized in time. So, in view of this artist's acute, eager

82. Casimir Malevich, *Dynamic Suprematism*, 1914.

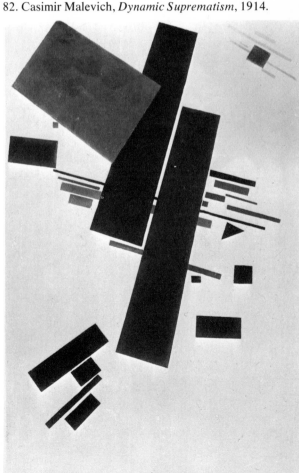

81

sensibility, it is not surprising that he should have tried to resolve
the whole picture into a single harmony — the square in a square
82
space. Here, unlike his other pictures, in which the colors are
83
lively and varied, he very logically stresses the radical character
of the composition by bringing together the two opposite poles of
color, its end and its beginning: black and white. But to do this
was to lay hands on the very principle of painting — and Malevich,
who was well aware of this, was determined to emphasize it,
not to shirk it. He called his abstract pictures "suprematist,"
by which he indicated clearly that what he was seeking to express
was a supreme condition of painting. What he himself had to say
at the time about these decisive years is not accessible (to our
great regret, his *From Cubism and Futurism to Suprematism*,
published in 1916, is unobtainable), so that to enlighten us we
are left with the development of his painting.

Malevich sent some fifteen suprematist paintings to the Tenth
State Exhibition which opened in Moscow in December 1918.
84
Among them there was one of a *White Square on a White*

83a, b, c. Casimir Malevich, *Suprematist Drawing*.

Ground. No picture like it had been conceived since painting began. Malevich was fully conscious of what it was he had undertaken: consistent as he was, he found, after having achieved the *Black Square on a White Ground*, that the contrast—black on white, in that case—could be resolved by setting off the same against the same, white against white, as though setting I against self, and that this contrast at last does away with objective reality and asserts itself as a new reality equal to the one it has destroyed. Absence of object becomes pure presence of abstraction.

80

A short note by Malevich in the exhibition catalogue betrays his exaltation: "Now man's way is clear through space. Suprematism is the semaphore of color in the unlimited. I have pierced the blue shade over the limits of color, I have penetrated into white; by my side, comrade pilots, steer your course in this space without end. The free white sea stretches before you."

It is clear from this that Malevich was intoxicated with his joy. By abstraction he had touched the limit *allowed* by painting. He had made it visible. His white painting overhangs the precipice where painting ceases to exist. But how can anyone stay at this

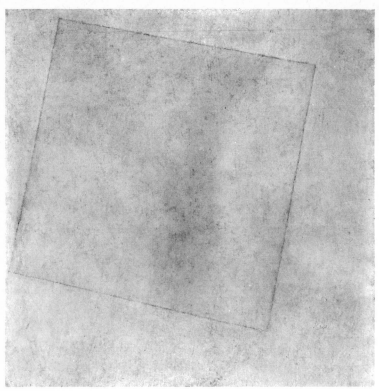

84. Casimir Malevich, *White on White*, exhibited in 1918.

height? How can painting, which is movement, be maintained there?

At this point Malevich quarrels with painting, denounces its means of expression as insufficient. With a Promethean force of will he intends to apprehend by thinking the expanse beyond the white, to discover the finality of painting unburdened of the weight of reality. This extravagant ambition is recorded in the three hundred pages of his *World Without Object*. He wrote it four years after painting his white pictures—in 1922, when he had passed the age of forty. And this book, which seeks to contain

the end and the infinity yielded by the experience of painting, is the most disturbing defense of abstract art that has ever been undertaken.

"The World Without Object"

Malevich's sensibility, intelligence, culture, extremism, and passion—his whole nature—are unveiled in this book, and so is the enthusiasm of these first years of the Revolution with, there on the horizon, a new age to construct. In the man as he appears there, it is easy to recognize the child who used to get up in the night to watch the lightning tearing the darkness—who loved that terrible image of a moment. That childhood memory, which comes from an unpublished notebook of Malevich's (quoted by W. Haftmann), seems to me to fix in one stroke the artist's singular personality: it sets before us the extremist who painted the men with huge red hands and then took up abstraction as a redemption of form, and also that son of the people, bitten by the disquiet of Russian thinking on the eve of the Revolution, ready to put ,an end to a world so that another, better one might arise. At the moment when he wrote this book, the Revolution had triumphed, and everything Malevich had in him, his love for the extreme image, the attraction of the light which reveals by tearing, his need to make this into a symbol, to establish a system where painting would have a new function (close to that of the sacred, even if he does not say so himself)— all this material constitutes the prodigious edifice of his *World Without Object*, constructed—astonishingly enough—on the foundation of Russian nihilism.

For, along with Kandinsky's *fin-de-siècle* spiritualism, along with Mondrian's theosophy, abstract art has a third source, connected

through the mediation of Malevich with that typically Russian phenomenon, nihilism. The advance of Malevich's mind corresponds point by point with the ideological particulars of that movement, which appeared on the scene in the nineteenth century and acquired, during the years leading up to the Revolution, an influence going far beyond the militant organization with which many people hastily identify it. Primitive nihilism was a radical negation of the world as it is (a negation originally formulated, nonetheless, in the writings of two men who were the sons of priests). Its essence, as Berdyaev observes, is "the search for truth. At its deep sources and in its purest form," he says, "it is an asceticism without Grace. It cannot admit the injustice of the world and its suffering, it desires the end of this bad world, its destruction and the advent of a new world." That nihilism prepared the ground for the Revolution is certain; but it has been given less credit (in the West) for its very powerful psychological influence. (Albert Camus alone, it seems to me, was sensitive to this side of nihilism.) The Russian of that period was cut off from the present and was, in his way, an "outsider" who refused to countenance indifference and separated himself from the absurd by staking his vital energy on a Utopia. Nihilism, in the writings of Pissarev, decreed that art is contrary to the real needs of humanity; but in spite of their including this extremely clear social stance, Malevich remained saturated by the nihilist ideas: he was, before all else, a painter, but the state of mind which had determined nihilism was a part of his time, and Malevich reacted as a Russian of his time. The perilous leap which he took into abstract painting, and which abruptly annuls painting—or transcends it (as he himself believed)—is a gesture perfectly explicable in the Russian psychological context. It represents, in the field of art, the nihilistic belief in stripping everything away, the rejection of everything and the certainty that the truth lies in that "nothing"—in the "nihil." The boldness

of such an attitude is probably (to pursue Berdyaev's thought) due to the extremism characteristic of the Russian mind, which tends to deny the importance of the relative and to transport the relative into the absolute. Society's incapacity to regulate living was the basis of militant nihilism: transferred to the plane of art it came to mean, in Malevich's thinking, the insufficiency of painting's means of expression, and therefore the urgency of a radical change. A helpless despair turning into a winged hope: such is the extraordinary experience, the extraordinary path of abstract art, which *The World Without Object* retraces.

Was this connection of art with nihilism intentional, or was it an unconscious impregnation? We know too little about Malevich's life to answer that. One thing is certain: his intelligence was much more acute than is generally admitted, and in this book it is attacking a subject that is very close to us, thus enabling us to understand Malevich better than his contemporaries did. Is it because by now existentialism has given "nothingness" a familiar sound that what Malevich calls the "revealed nothing" reverberates in us and holds us? There is an exceptional solidity in his thinking, which is even more striking when we remember his painting: any attempt to tidy up this thinking, which is repetitive because it keeps turning around a single point, would be to mutilate it, to pull it away from its constant awareness of the obstacle that has to be overcome. To Malevich the obstacle is nothing less than the ineffable, the inexpressible — in short, the irreducible kernel of art, the "nothing" which engenders the all. With complete logic — in this also he was a precursor — he ends by critizing consciousness for its inability to embrace the whole. He is, in a phrase of Maurice Blanchot's, desperately trying "to make manifest an experience, to catch at its source, so to speak, not that which makes the work of art real, but that which is the unpersonified reality in it."

To Malevich human life is the scene of a conflict between the conscious and the unconscious, and it falls to art to resolve this enmity. Art must arrive at the region where "high, low, here, and there no longer exist." But the difficulty, the agony, is that in art "there is no going back" and "it would take more than the six colors and their potentialities of mixture to restore that which is." In Malevich's writings artistic creation is seen in a gloomy, often indeed tragic light. Art, which "is a convention among many others," acquires a meaning only when it reveals the truth of the world without object, the truth of the "nothing." There lies the "sacred," which no apprehensible thing can contain. Man is alone on earth. The world of objects throws him back into his solitude. This is why he in his turn must reject the world: "Are not the beauties of nature which we admire, the hills, the rivers, the sunsets, the result of catastrophes, of shiftings of weight, rather than the expression of the laws of beauty which preoccupy the artist?" The practical realism in accordance with which man imagines nature is an illusion, and Malevich refuses to be duped by it: "In what is called nature, there is no question and no answer. It is free in its nothing, free from any analysis and from any synthesis, for both of these are merely practical tools of speculation." Only suprematism represents "the nothing as answer to the totality which has become question."

After nature, nihilistic negation turns against culture: "Culture is nothing but a transfer of values," says Malevich curtly. "Little does water care when it becomes that other reality H_2O," and he concludes: "As the number of phenomena is infinite, so should the number of fields of specialization be infinite. The more the world is broken down, the more new realities will be discovered, and the more sectors of specialization there will be." Man's mistake has been to believe "that in giving each thing a name he would come to the end of nature."

Contempt for knowledge – an attitude even more Russian than

nihilism—is reinforced in Malevich by an unconscious homesickness for faith, whose place he requires art to take. It is here that the experience of abstract form comes in. By means of abstraction he believes he has touched that truth which he raises to the rank of the sacred. It is a kind of sacredness-against-the-grain: "In the vast space of the cosmic repose I have attained the white world of the absence of objects, which is the manifestation of the revealed nothing."

In a text that is written in a neutral tone, this sudden phrase in the first person—"I have attained the white world of the absence of objects"—betrays the depth of Malevich's emotion. Four years had gone by since he painted his white pictures, but the shock he had received from them was still there. The silent unity without objects, which was present behind the multiplicity of existing things, had been able to take form. He had rescued painting from the external world, he had reduced the real to silence, and in that silence the pure absence of objects had come and installed itself. This, he proclaims, is the point of departure of a new kind of painting which takes its place beyond the real.

But is it a point of departure? And not an end that is indistinguishable from the beginning, at the point where a circle closes? "Pure experience of the world without object," "man re-established in the original unity in communion with the whole," "art set free from the weight of objects"—is not all this a utopia? Malevich refused to believe that. But he recognized, nonetheless, that man's misfortune was that he could not think his thought *completely*: if he could, "practical things inadequately thought out" would be abolished. Then, and only then, man would embrace his whole existence, and it would be the coming of the world without object.

And so, for Malevich, inadequacy of painting's concrete means went side by side with inadequacy of the abstract faculties of the intelligence—in which he saw merely the power of a discon-

tinuous thinking which reveals, only as the lightning does, the mystery of that which is. Even while he was writing, perhaps because what he was trying to say derived from his experience in painting, he never ceased struggling against logic: words could not contain what the painter wanted to express. In his exasperation he plunged into prophecy: the boundless creative act inaugurated by suprematism throws light on the future, he announced, as does socialism, which is the sunshine of peoples. But in fact *The World Without Object* is a book that reaches no conclusion, that cannot reach any conclusion, because its tragedy — Malevich's tragedy — is the absence of any conclusion either in life or in art.

I doubt if Malevich did much painting after 1918, after the white pictures, which are like parapets at the edge of his work and of painting in general. In his infatuation with absolute time and his indifference to its conventional divisions, he did not date his pictures; the chronology of his work has therefore been established around and on the basis of the exhibitions he took part in. But this makes his development look like a succession of strokes which never form a continuous line — the more so since he himself gave little information about the genesis of his pictures, being too busy searching for "the foundation and the summit" of painting. He did, however, say that "the crystallization of the world without object begins where the objects' world loses its significance. In painting and in sculpture this crystallization began with cubism." But how he, Malevich, passed from cubism to pure abstraction he does not say. Never once does he mention the name Kandinsky. Was this from a lack of affinity or from a feeling of rivalry? Malevich's silence leaves room for every sort of supposition. Those who saw a good deal of him at the time — his childhood friends, Larionov and Chagall — have told us of his difficult temperament, of the feeling of superiority which he paraded and which made him often disagreeable. The evidence we possess

is so confused that Malevich has even been suspected of having dated the beginning of suprematism wrongly in 1913, out of pride, in order to claim a place in the history of abstraction. Camilla Gray supposes that, in giving this date, he was referring to the abstract setting he had designed in 1913 for Mayakovsky's play *Victory Over the Sun*. But the statement under discussion— *85* Malevich's note on the beginning of suprematism in the catalogue of the Tenth State Exhibition—is much more precise: "Suprematism was born in Moscow," he writes, "and the first (suprematist) works were shown in an exhibition of paintings in Petrograd." This exhibition can only be the Youth Union Salon, opened in November 1913, where it is quite certain that Malevich showed his first cubo-futurist experiments. The misunderstanding clears

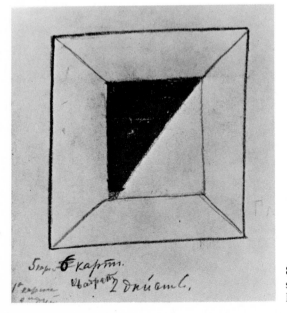

85. Casimir Malevich, stage set for *Victory over the Sun*, December, 1913.

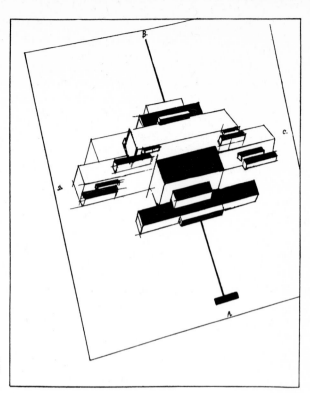

86. Casimir Malevich,
*Projects for Suprematist
Buildings*, 1924.

up if we consider a passage from Malevich's pamphlet *Bog ne
skinut (God Has Not Fallen)*, published in Vitebsk in 1922: it is
unobtainable in the West but V. Zavalischin quotes from it in his
Early Soviet Writers (New York, 1958), and the quotation makes
it quite clear that suprematism, as Malevich viewed it in 1922,
had already passed through two stages. Perhaps because by that
time he saw everything as governed by the suprematist principles,
he gives the name "cosmic Suprematism" to the abstract period
of his painting which, he says, represents "life in the spirit," and
he adds that it was preceded by "mechanical Suprematism,"
which illustrated "life in the machine." This "mechanical Suprem-
atism," then, is the same as the cubo-futurist period of his work,
and it is very probable that this did begin in 1913.

Although the dates of the movement may have to be disputed afresh in the light of fresh evidence, this cannot apply to its achievements. In the history of art, suprematism — or, more exactly, the painting of Malevich — has, once and for all, shown the limit of abstraction. Like the Pillars of Hercules in the world of antiquity, it is a limit beyond which only the imagination ventures.

The impetus of the Revolution deflected Malevich's creative energy into other activities. In the field of culture, Russia's public institutions were busy organizing and reorganizing. Malevich set himself fervently to teach painting, to execute ceramics for the state factories, to design cups and teapots for the use of the new *87* society which had come into being in the Soviet Union and to which he felt himself closely bound. The citizen took the place of

87. Casimir Malevich, cup and teapot designed for State Pottery, Leningrad, *c.* 1920.

the painter. Then, in 1924, he published a manifesto in which he declared that "suprematism is shifting its center of gravity to the architectural front." This represents a twofold integration: the individual placing himself at the service of the collectivity; the artist abandoning the fictive space of painting and turning toward real space, that of architecture.

Malevich's extraordinary temperament is once again evident in this development. The author of *The World Without Object* was a painter, not an architect, but he now fell under the spell of an architect's dream. In painting, the attraction of the absolute had led him to the white pictures, beyond which nothing more was possible: now he tried to reintroduce into human life the essential forms he had conceived in the course of the suprematist experi-

88

88. Casimir Malevich, *Model of Suprematist Buildings*, 1924–1926.

ment. It would be hard to find anything more impressive and significant than this attempt, for in the imaginary buildings for which he drew plans and made models, Malevich seems to be designing the very principles of modern architecture. At the same time he had in mind the function of color in the city of the future and wrote a *Sociology of Color*. Because he had the type of mind to which extrapolation comes easily, he not only carried out his work as an artist but also tried to make its implications clear. And it was a sound vision that made him attack the problems of architecture. This is not the place to discuss the highly complex question of the relations between painting and architecture in the twentieth century, and of the part which discoveries in the one may have played in the achievements of the other; but it seems quite clear that, with Malevich as with Mondrian, the abstract experiment in painting did, ideally at least, offer to architects a whole set of fresh forms. Mondrian's painting did result in actual architecture through the work of Van Doesburg. It is possible that no architect made use of Malevich's models. But that extension of abstract form, which time has confirmed, is something Malevich had not only foreseen but had intended to bring about.

86

Sculpture

In the matter of breaking with tradition, abstract sculpture lagged behind painting. It too was detaching itself from realism and asserting the autonomous value of form; but its situation was quite different. A sculpture, in becoming abstract, is compelled to face—and to overcome—difficulties that arise from its very existence: from the real space in which it stands. Painting creates its own space, which is imaginary. Whether it is figurative or abstract, a painting is still fiction: it is precisely against this element of fiction that the first abstract painters rebelled in the name of a greater authenticity. "Painting does not need sincerity but truth," was Malevich's dictum: so no more feigned reality in a picture, but free forms and colors which carry their significance in themselves. Painting was called upon to be itself, having till then pretended to be something else—a tree, a field. In short, thanks to abstraction, the space isolated by a picture

was encroaching upon actual space: if it was still fictive, it was nonetheless autonomous. Within this newly conquered autonomy, abstract form had innumerable possibilities.

But how could sculpture reject the actual space which is the condition of its existence? At the beginning of the century sculpture and painting were continuing to develop along parallel paths, but at different speeds because sculpture's relative lack of "material" suppleness kept slowing down its development as compared with that of painting. One after the other, then, each at its own pace, they turned to abstraction; but once they were committed to abstract forms their problems were no longer the same: the renunciation of three-dimensional space, that inevitable consequence of abandoning the realistic subject, was possible for painting, not for sculpture: a sculpture could not separate itself from actual space, could not oppose it with another space, and this impossibility considerably reduced its margin of liberty. When a sculpture is taken in the direction of abstract form, it risks becoming one object among other objects: because it shares with them the same space, the slightest thing is enough to change it from live matter into inanimate matter; and, should it try to exist wholly in the abstract equilibrium of forms, it would be entering into rivalry with architecture, here again straying from its own ground. Caught in this way between the object and architecture, abstract sculpture is threatened at every step with losing its character as a work of art. This basic condition peculiar to sculpture was bound to reduce the amplitude of its development. But outside sculpture the action of abstract form in real space has been all the more powerful: it has changed the look of our everyday objects, of our furniture. It has transformed the whole setting of our lives.

The purely abstract sculptors are very few, and the progress of sculpture toward abstraction proved to be very laborious. Over its beginnings there hangs a confusion which it is impossible

to dissipate — and this is because sculpture at grips with abstraction is itself constantly in an unstable position: it tends either to lean toward figuration or to lean toward its own destruction (as the dadaists insist). In painting, as we have seen, there were already in the nineteenth century signs pointing toward abstraction; in sculpture, on the contrary, even cubism did not bring with it fully abstract form.* In the logic of its advance cubism multiplied the points of view bearing upon an object in a picture, but in sculpture it limited and fixed them, reducing form to the cube: by doing so it turned away from traditional sculpture, which worked in the sphere and offered an infinite number of points of view to the spectator moving around it. The sculpture of Laurens, which is conceived in conformity with the definite planes of the cube, never loses sight of real objects: thus the man who is considered to be the cubist sculptor par excellence gave rise to no school of abstract sculpture.

There is a second element, also, which forbids us to see in cubism the prelude to abstract form in sculpture: Laurens himself created his first constructions in 1915, when abstract sculpture had just become an accomplished fact. This time lag, added to the inability of sculptures to get away from actual space, made a gap between the development of abstract sculpture and that of painting, even though their aspirations were identical.

Vladimir Tatlin

Abstract sculpture makes its appearance in 1914, in the mind of that strange artist Vladimir Tatlin. Both a painter and a sculptor,

*To associate Brancusi with abstract sculpture, as is often done, would seem to be a double error, for it consists in misunderstanding the profound spirituality and symbolism of his work, as well as forgetting that the characteristic sign of abstract sculpture is its liberation from closed form.

a sailor for the sake of a living, a musician for a time (which took him to Paris), the friend and archenemy of Malevich — Tatlin passed into the history of art like a meteor. Of his work there exist now only photographs, with the exception of two pieces, a composition and a relief, which are in the Tretiakov Gallery; and yet the boldness of his views and his great gifts have imposed themselves, with astonishment and admiration supplying the place of direct knowledge where this is lacking.

Unquestionably there was need of a personality as unconventional, rebellious, and candid as that of Tatlin, to take the plunge and renew sculpture, at once and radically. But first, what do we know about him?

Tatlin was born in 1885 at Kharkov in the Ukraine. His mother, who was a poetess, died when he was two. His father, a severe and methodical engineer, remarried. The gap between father and son, who had little in common, then became an abyss. Tatlin was a misunderstood child who grew up hating his parents; the painter Larionov knew him as such, long before they met again in Moscow in 1910.

At the age of eighteen, Tatlin finally left his father's house, enlisted as a sailor and, between two voyages, went first to the Penza Art School, later to that of Moscow. He took part in the manifestations of the avant-garde, and in 1912 exhibited some paintings and drawings inspired by the countries where he had gone ashore — Egypt, Turkey, Greece. Then, in 1913, he left for Berlin with a Russian folk orchestra (he played the accordion), and unexpectedly (through selling a watch which the Kaiser, it is said, had given to him) arrived in Paris. He had only one idea in his head: to go and find Picasso. And he found him. Picasso still remembers the young, enthusiastic Russian who went to his studio and asked him to engage him as a servant so that he might stay in Paris. Since Picasso refused his offer, Tatlin had to go back to Russia. But this lightning journey was for him a revela-

tion. As soon as he was back he did his first painted relief, which
89 is very close to the reliefs Picasso was creating at the time
(and which Apollinaire had just published in *Soirées de Paris*).

Tatlin, the painter suddenly turned sculptor, had committed
himself to an experiment that would lead him, very rapidly, to
conceive a completely abstract sculpture. It would be true to say
of his beginnings in sculpture that they show no fumbling in the
new technique and a surpassing quickness in assimilating the
influence of Picasso. The only explanation for this would seem
to be an innate feeling for space, developed by him unawares
while he was designing for the theater, which he did with great
application from 1911 to 1913. The stage is a real space waiting

89. Pablo Picasso,
Guitar, 1913.

for the setting to give it order. The painter whose business is to do this will, if he is at all original, work like a sculptor. This "handling" of space may well, therefore, have rendered Tatlin receptive to what was to be learned from Picasso, who was far from making his purpose immediately explicit. The reliefs conceived by Picasso at that time represent, in fact, the final phase of cubism, in which the fragmentation of space had made the object explode. In his reliefs (as also in his collages) Picasso reconstituted the object with detached bits, foreign to one another; by assembling them he creates a unity which issues from their collisions, and his purpose in using ordinary materials (wooden planks, nails, bits of string) is to emphasize by shock tactics the direct action of matter. It is, fundamentally, the same desire that led to the cubist collages, and Picasso's reliefs are really a transposition of the collages — in short, a bold commentary on the cubist principles. For this reason the lesson that emerges from them remains, in spite of appearances, bound up with painting. Tatlin applied it without hesitation to sculpture. The achievement appears considerable if one remembers that even Laurens, when he saw the first cubist pictures, had had the feeling of "a hallucination" — they had filled him with "an inexpressible disturbance," but he had not "understood them at once."

Tatlin did understand at once.

In the absence of the originals, which have been destroyed, the text of a monograph on him, published in 1921, is a valuable supplement to the surviving photographs of his sculptures (N. Pounin, *Tatline*, Petrograd, 1921). The passages quoted from it by Camilla Gray provide us with some information about Tatlin's development, and in particular about the way in which his work moved toward abstraction. First of all, there is the explanation which is given us of one of his first reliefs. It represents a bottle. The shape of the bottle, cut from a sheet of metal,

90

90. Vladimir Tatlin,
The Bottle, 1913.

is shown like an empty silhouette; and the curved, ample surface of the bottle's volume is represented by another piece of metal, rounded into a cylinder and placed rather below the bottle; finally, to express the idea of transparency implicit in the glass a bottle is made of, Tatlin has recourse to a plastic metaphor — a metallic grille, which he adds at one side of the bottle. What he is doing is clear: he is dissociating form from volume and volume from material — in short, he is letting the object deploy itself in

the space of the relief, but this space recomposes the object's unity by composing itself, by becoming "a composition with bottle." From this to a full awareness that the decisive element is this relation between space and form, was only a step. And Tatlin took it without delay. With an absolutely sure instinct he was soon juxtaposing anti-traditional materials — cement, copper, glass, iron, polished corrugated iron — and by bringing their contrasts into play he produced some reliefs of a striking harshness; then, not content to enjoy his discoveries, he decided that "art has to be taken down from its pedestal." It would be wrong to see in this desire any dadaist fervor, for it was simply the

91. Vladimir Tatlin,
Abstract Relief, 1914.

ambition to make sculpture an equivalent of reality. In practice
this was carried out by doing away with the frame surrounding
the relief, which then, left open into actual space, became a
92 "counterrelief." Tatlin created his first counterreliefs in about
1914, and they are the first examples of abstract sculpture.
Because what has disappeared in these sculptures is mass,
Tatlin — with perfect logic — cannot place them: he is obliged to
hang them, so that they may be *entirely* in space. For what,
first of all, distinguishes abstract sculpture is this interpenetration
of form and space. Abstract sculpture is not closed mass or
volume, but intersection of planes through which the air circulates
and the gaze penetrates. Later, in the course of its development,
it might on occasion appeal to mass and volume, but its funda-
mental conquest (from which figurative sculpture also was to
benefit) nonetheless remains the "piercing" of volume, the use
of emptiness as a constructive value. This line of experiment
was first pursued lucidly in Tatlin's reliefs, and brought him, not
long afterward, to his counterreliefs.

At the very moment when he conceived these, Tatlin already
had a premonition that sculpture, in order to be abstract, must
master the principles of construction. "Actual materials in actual
space" — this was his program as sculptor. With his usual consis-
tency, he then undertook the study of the particular behavior of
each material, convinced as he was that the renewal of sculpture
must proceed from a real "culture of the materials"; and he
set himself to establish the rudiments of this. Here too Tatlin
appears as a precursor. Parallel with its conception of space
abstract sculpture begins, in fact, a new era as regards the use of
materials, the matter itself being a source of renewal for the tech-
nique. Formerly sculpture knew only direct carving or molding
and casting: now sculpture is done by soldering, pasting, dove-
tailing pieces with other pieces. The verb "to sculpt" has lost
its old meaning and acquired another, far wider one, and this

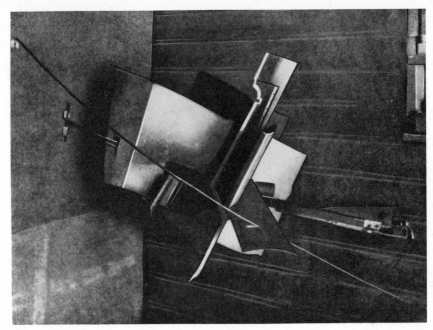

92. Vladimir Tatlin, *Counterrelief*, 1914–1915.

profound revolution began with abstract sculpture. Unable to reject actual space as painting had done, sculpture rejected its traditional matter. Painting, in becoming abstract, has remained oil painting, but abstract sculpture has ceased to be bronze, stone, marble: it has had to separate itself from its habitual material in order to maintain, while modifying them, its relationships with the space surrounding it.

This new basic condition of sculpture was perfectly clear to Tatlin, who, with a typically Russian extremism, tried to explore its possibilities to the furthest point, as his development proved. The change which had occurred in the whole conception of plastic art seemed to him radical. It affected the destiny of sculpture and called in question its destination. A work of

sculpture could and must be a total work which would find its place in the life of the city. It was in this spirit that Tatlin conceived the *Monument for the Third International*, which he had been commissioned to do. He worked on the model for this monument for nearly two years, in 1919 and 1920. To him the monument was the symbol of the new age, and he saw it as a form bound up with the dynamism of life. It consists of a triple spiral with a twisted axis, of iron. Inside this there are placed, on top of one another, a cylinder, a cone, and a cube of glass, each containing a number of rooms for conferences and meetings. At the top there is an information center for the continuous diffusion of bulletins, proclamations, and manifestoes. Each of these three parts revolves about its axis, at a speed corresponding to the revolutions of the earth, the cube at the top taking a day, the cone a month, and the cylinder a year. The monument was to be 1,200 feet high and to be built in the center of Moscow.

It was never built. But although it remained a project, it still has its exploratory value: historically, in fact, this monument – of which nothing remains but the photograph of the model – shows us how Tatlin's desire to bring sculpture into life results, when it is made concrete, in a gigantic machine – and this indicates the limits of abstraction in sculpture.

Futurism had decreed, through the mouth of Boccioni, that art must arrive at the simultaneous expression of space and of time. But the futurists – including Boccioni himself as a sculptor – were not thinking of abstract forms; for their formula, when applied literally to an abstract form, finds its perfect fulfillment in the machine. Tatlin, aware of this, tried by a real tour de force to give significance to his monument: he wanted it to be "inhabited," actually and also metaphorically – inhabited by the spirit of the Revolution, perpetually moving with the rhythm of the world. But does this additional ideological load overcome the difficulty which abstract sculpture comes up against when pushed to its

93

94

extreme consequences? It is permissible to doubt it.

And Tatlin himself seems to have doubted it. Until his death in 1953 he attempted (before going back to figurative painting under the Stalin regime) only one further work and it remained unfinished. This was a glider, which he called *Letatlin* (a name obtained by the fusion of the verb "to fly," in Russian "letat," with Tatlin), but it was a work to which the word "sculpture" in its usual sense is not appropriate. Tatlin seems to have begun work on it in about 1927. Alongside his practical activity in the

93. Vladimir Tatlin, *Monument for the Third International*, 1919–1920.

service of the Revolution (he designed clothes and furniture for industry and ran a pottery) he tried, like a new Icarus, to realize a kind of super-sculpture—a glider that must commit itself to the air and appear there in full flight, in the great free expanse, as a form in movement. It was to be a sculpture at last dominating space and time, but organically, not mechanically—like a bird,

94. Teapot designed under the supervision of the artist, 1927–1930.

not like a machine. Obviously, in this utopian work, Tatlin was fighting against aridity in abstract sculpture. There is a story that he used to take caterpillars and grubs, feed them in a box, and then set them at liberty in a field, watching them closely so as not to miss anything of their movements at the moment when they took off for the first time. Did he think he was piercing the secret of living structure? *Letatlin*—though the models and drawings for it were accepted in 1933—was never airborne.

As for the inherent difficulties of abstract sculpture, other artists had meanwhile been trying to solve them in their own

ways: Pevsner and his brother Gabo, though less intuitive than Tatlin, had seen the future of abstract sculpture in absolute rigor, and their certainty had driven them to define their own position within the tendency which, since Tatlin's experiments, was beginning to be called "constructivism."

Constructivism

In 1920 the two brothers Antoine Pevsner and Naum Gabo published a manifesto, which they distributed in artistic circles in Moscow. Although the word "constructivism" is not mentioned in the text, this manifesto is usually called *constructivist*. In fact it neither founded constructivism nor exhausted it. In it the two brothers were making clear their aesthetic position, circumstances having made this necessary: the Revolution, having begun by putting the avant-garde on a pedestal, was now tending to mix up art and socialism. The official art in the Soviet Union during those years certainly was abstract art, with Malevich and Tatlin as its leaders, but the artists were divided on the question: what must be the function of art in the communist society? One group—Tatlin, a utopian, and Rodchenko, a fanatical communist—answered that it must be entirely at the service of the people. The others maintained, on the contrary, that art is a spiritual activity which has nothing to do with practical utility. These defenders of free art were Kandinsky (at that time living in Moscow), Malevich, Pevsner and Gabo. Around 1920, then, abstract art in the Soviet Union found itself divided into two opposing clans, which used various occasions to fight each other. For instance, at the time of one group exhibition, Tatlin refused to recognize the suprematists (Malevich and his disciples) as professional painters; again, in 1918, Rodchenko exhibited a painting called *Black on Black* as a

riposte to Malevich's white paintings; and again, in 1920, Pevsner and Gabo signed their manifesto, which is a defense of pure art. Considered by the critics as constructivists (along with Tatlin and Rodchenko) they thus became representatives of one branch of constructivism—the other (connected principally with the activity of Rodchenko, as we shall see below) being directed toward the practical application of abstract forms.

Pevsner and Gabo

In 1920, at the moment of the manifesto, Pevsner (born in 1886) was thirty-four and Gabo (born in 1890) was thirty. Pevsner had gone to the St. Petersburg Academy and had lived in Paris from 1911 to 1914; from early youth he had been a painter, and produced his first sculptures only in 1922—and abstract ones, at length, in about 1927. He had been an abstract painter for some time, as certain undeniably original compositions belonging to 1917 and 1918 attest.

His brother Gabo, unlike him, had a scientific training. He went to Munich to study medicine there, became interested in chemistry, mathematics, and physics, and decided to become an engineer. But at the same time he followed Wölfflin's lectures on the history of art, met Kandinsky, read *Concerning the Spiritual in Art*, traveled in Italy in 1912 when futurism was at its height, and visited Paris where he saw the cubist pictures. In 1915, after the war had made him a refugee in Norway, he produced his first sculptures—human figures constructed entirely of planes cut down and put together again so as to avoid volume altogether. (It was at this moment that he took the pseudonym Gabo, so as not to be confused with his brother.)

Back in Russia in 1917, Gabo was attracted, like Pevsner, by the abstract aesthetic; and in 1919–1920, not long before

95. Naum Gabo, *Project for a Radio Station*, 1919–1920.

the publication of the manifesto, he did some drawings which
are completely constructivist, including the *Project for a Radio
Station*. This project, on the one hand, and the revolutionary
atmosphere, on the other, form the aesthetic and historical
context which sets the constructivist manifesto of Pevsner
and Gabo in its proper light.

95

"We repudiate volume as an expression of space," they
declared. "Space can no more be measured by volume than a
liquid can be measured in yards. Depth is the one and only
plastic expression of space. We renounce (physical) mass as
a sculptural element. Every engineer knows that the static
forces and material strength of a solid body do not depend on

its mass. . . . We are liberating ourselves from the millennia-old errors of the Egyptians, who held that the only plastic elements are the static rhythms. . . . We affirm a new element, the kinetic rhythms, as basic."

What is striking about this text is that it does not correspond either to Pevsner's painting or to Gabo's sculpture as they were in 1920, but that it does describe perfectly the sculptures both of them produced later on, after they had again left their country in 1922. Pevsner then settled in Paris (where he died in 1962), and Gabo at first in Berlin, until 1932, then in England, and from 1946 onward in the United States.

Their manifesto must therefore be considered as a program laid down with remarkable perspicacity and then carried out with method and perseverance. (It would be impossible to imagine

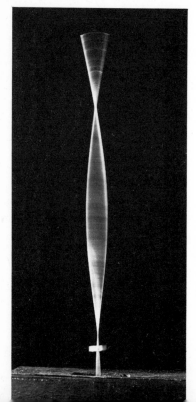

96. Naum Gabo, *Kinetic Construction*, 1920.

two temperaments more completely opposed to those of Malevich and Tatlin.) Of the two brothers, Gabo gives the appearance of being the more decided. Indeed, he later told his friend Herbert Read that he was the author of the manifesto—which explains its tone and the absence of references to painting, at a time when the second signatory was still a painter only. Does this mean that Pevsner had slower reflexes, or that he had a peculiar docility which arose, in truth, from affinities so profound as to make it possible for one brother to subscribe to what the other thought because, obscurely, he felt sure their points of view were the same? In any case the development of Pevsner and of Gabo was governed by this strange osmosis, with Gabo, the younger of the two, leading the elder—who was, however, much more than a disciple.

It was Gabo who, after having produced his *Project for a Radio Station*, and no doubt also with Tatlin's *Monument for the Third International* in mind, became convinced that if the new sculpture went on along these lines it would arrive at nothing more nor less than a construction of the type of the Eiffel Tower (dating from 1889!); that it would therefore obviously be retrograde (an opinion which Kandinsky fully shared); and that the first task of constructivist sculpture was to escape from this blind alley. Fortified by his technical and mathematical knowledge, he turned his attention to movement and, between 1920 and 1922, completed his first constructions, in which the form is obtained by movement (a cylinder, for instance, results from a rectangle in rotation). Like the scientist he was, he called these sculptures "kinetic constructions," for his aim was not mere movement but the energy of movement. Gabo was aware of the danger: sculpture must not imitate the machine. If it was wrong for constructivism to become confused with the architecture of the Eiffel Tower, to be assimilated to machines was also a blind alley. This menace of the machine haunts the whole

96

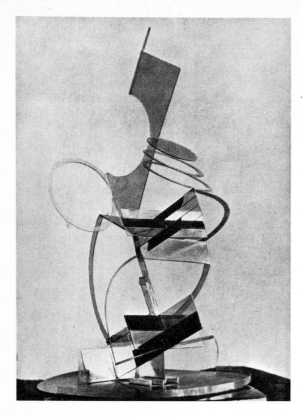

97. Naum Gabo, *Monument for an Observatory*, 1922.

development of abstract sculpture. Fernand Léger, who in his painting had often associated the machine with the expression of his period, took pleasure in recalling the enthusiasm of Marcel Duchamp, who exclaimed as he looked at airplane propellers: "Who will do better?" The question was a challenge, already anticipating the end of art soon to be proclaimed by dada. Marcel Duchamp was refusing to engage in precisely that rivalry which was to give abstract sculpture so much trouble. To meet this situation Gabo chose the wisest tactics, even at the risk of making abstract sculpture lose all expressive warmth.

After introducing movement as an aesthetic factor productive

of forms, Gabo rather quickly abandoned it in the name of "mobile movement," to which his mind had become attracted through a scientific analogy: "Look at a ray of sunshine," he said later, "it is moving at a speed of hundreds of kilometers per second." The expression of this kind of movement, which is purely abstract, delivers sculpture, according to him, from any threat of the mechanical. This deep conviction was to mark the whole of his work. In the *Monument for an Observatory*, which he created in 1922, one can already see the predilection—

97

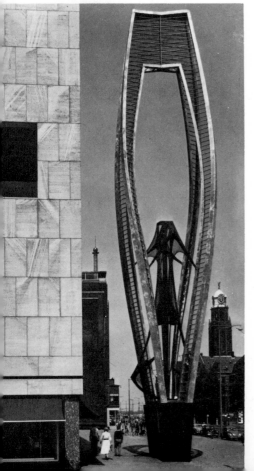

98. Naum Gabo, *Construction in Space*, completed in 1957.

99. Antoine Pevsner, *Construction in Space*. 1923–1925.

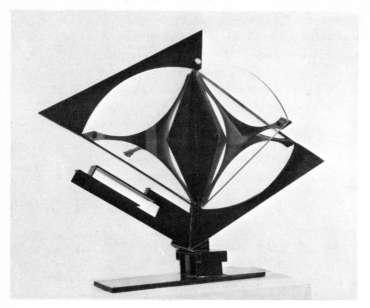

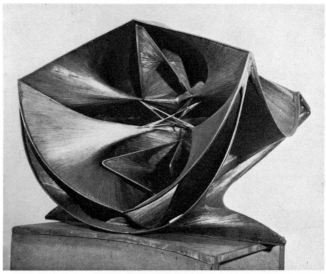

100. Antoine Pevsner, *Embryo*, 1949.

which was to remain his—for light, translucent materials like glass or Plexiglas, the (so to speak) most immaterial materials, which he uses without hesitation even in his monumental sculptures, his dream being to give his works an aerial lightness *98* (unfortunately weighed down by excess of precision).

Rigor, the will to a meticulously finished form, and the play of empty and full spaces—these are the dominant characteristics of Gabo's sculpture. Pevsner's might be described in almost identical terms: he is distinguished from his brother simply by his more and more pronounced preference for metal, a material whose solidity leads composition toward other disciplines. From this also comes the difference of spirit which, for all the likenesses, separates the work of the two brothers. While Gabo tends to do away with the effect of light and shade by working in transparent material which gives them no purchase, Pevsner seeks to deepen the shadow in his forms, which remain open on all sides. It must be said that this increase in the density of the shadow, which the composition stresses like some inaccessible mystery, is an achievement that came late in Pevsner's *99* work. Having followed his brother and become a sculptor, and having opted for abstraction as his brother had by then conceived it, he first chose to use the same light and transparent materials, but ended by detaching himself from Gabo and *100* influencing him in turn. Pevsner's personality asserted itself, he found his own material—laminae of metal which he solders one to another, packing them closer and closer until he obtains a surface that is almost smooth yet makes an extremely supple effect to the eye. The metal so treated, as though at the same time rigid and malleable, allows Pevsner to realize what seems to me his major discovery—the insensible transition from the empty to the full, their intimate connection although the one is the reverse of the other. Starting from the measured rigidity of the first constructivist works, he arrives at a continuous form,

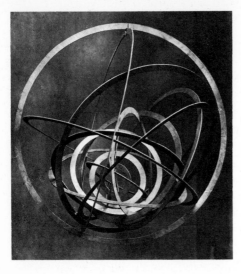

101. Alexander Rodchenko,
Hanging Construction, 1920.

a materialization of space which recalls, to some extent, the spacial development of certain mathematical formulae. This identification with a scientific reality seems to some people a defect, to others a merit. Whichever is right, clearly such a process, which becomes the literal description of certain abstract data exterior to art, raises the question (to which we shall return later): when an abstract sculpture attains absolute abstraction, does it not become concrete, in the sense that it expresses laws and an order which are invisible but actually exist?

Functional constructivism

As soon as Pevsner and Gabo came out on the side of pure sculpture, the schism within constructivism was a fact; and since, in addition, they emigrated, the two branches of this movement, with their common origin in the work of Tatlin, evolved in directions that diverged more and more.

In 1923 the review *Lef* published in its first number the pro-

gram of the Soviet constructivists, in the form of an appeal: "Art is dead!... Let us stop our speculative activity (of painting pictures) and return to the healthy bases of art, color, line, matter, and form—in the field of reality, which is that of practical construction."

The leading personality of the group was Alexander Rodchenko (1891–1957). As a former pupil of the Moscow School of Applied Arts, a proletarian by origin and a fervent Communist, he accepted with enthusiasm the idea of subjecting art to the needs of society. Up to then his activity in pure art, though it had a certain originality, showed a fundamental instability. Two sculptures of his, both produced in 1920, proceed from two completely opposite conceptions: one of them, called *Construction of Distance*, is massive, rectangular; the other, *Hanging Construction*, gives a great impression of lightness, of grace in movement, resulting from its suspension, the effect of which is completed by its components, perfect circles arranged one within another. As

102

101

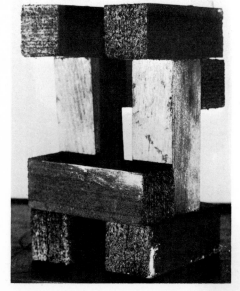

102. Alexander Rodchenko, *Construction of Distance*, 1920.

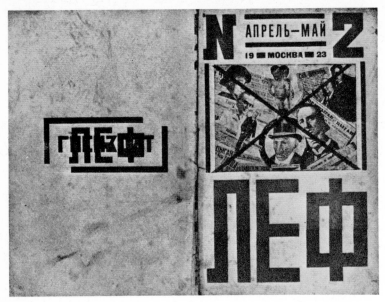

103. Alexander Rodchenko, cover of review "Lef," Moscow, 1923.

104. Alexander Rodchenko, Workers' club designed by Rodchenko.

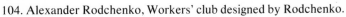

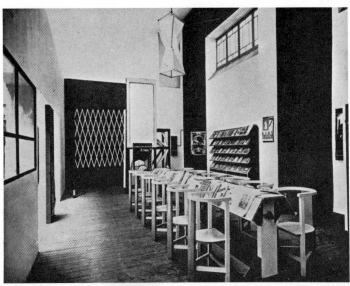

for the paintings executed by Rodchenko at the same period, their virtue is scarcely more than polemical: in 1918 (as we have seen) he exhibited a *Black Circle on a Black Ground* in order to attack Malevich, who had just exhibited his *White Square on a White Ground.* This confirms Rodchenko's incoherence as an artist.

For this reason one is inclined to think that the most authentic part of his activity took place in the field of typography and also in photomontage, of which he was one of the pioneers (he used it for the first time in 1923). The example which best sums up his graphic experiments is the cover of the review *Lef.* In addition he *103* designed furniture, which was shown in the Soviet Pavilion at *104* the Exhibition of the Decorative Arts in Paris in 1925. This pavilion, which indeed was the most resolutely modern in the exhibition, was the only one actually carried out in accordance

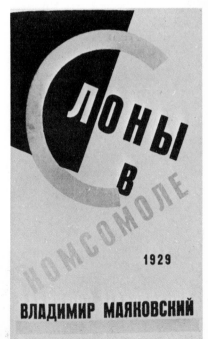

105. El Lissitzky, cover for book
of poems by Mayakovsky,
"The Elephants in the Komsomol," 1929.

106. El Lissitzky, cover of magazine "Vecht," Berlin, 1922.

with the theories of constructivism; for the social function which this had undertaken ran into a major obstacle—the economic straits which the Soviet Union was going through. Industrial design, which on the face of it should have been the first to benefit from the constructivist discoveries, hardly developed at all: for all its efforts, constructivism had less of an effect on the setting of everyday life than it had on the Soviet theater and cinema. Directors like Taïrov, Meyerhold, and Eisenstein were influenced, at a certain moment, by the plastic vision of constructivism.

The only practical field in which constructivism played a part was that of typography. The outstanding artist in this line was El Lissitzky (1890–1941). A painter by vocation and an architect by training (he had studied in Germany), he played a double part—

107

108. El Lissitzky, Abstract Painting Room arranged by Lissitzky in the Hanover Museum, c. 1925.

107. El Lissitzky, *Street Poster*, 1919–1920.

first as designer, and then as the ambassador, the propagandist, for constructivism abroad. Influenced by Malevich, he began in 1919 to design posters and printing types, and he created pages of type which are models of their kind. Unlike Rodchenko's efforts in this line, which are static and sometimes heavy, Lissitzky's have a dynamic power which arrests the eye. His frequent use

106

of the diagonal, his tense asymmetric equilibrium (of suprematist origin), give them a rhythm and an elegance to which modern publicity owes a great deal.

Between 1921 and 1930 Lissitzky traveled around Europe many times. He worked both in the Soviet Union and in Germany. In 1922 he was instructed to arrange one of the rooms in the great exhibition of contemporary Russian art at the Damien Gallery in Berlin—and then the abstract painting room in the

108

Hanover Museum (unfortunately now destroyed). In Berlin, also in 1922, he started (with Ilya Ehrenburg) the international art review *Vecht—Gegenstand—Objet*, whose cover he designed. This review contained articles in Russian, German, and French: it did not get beyond the second number, but it established bonds between the Western avant-garde and the Soviet avant-garde, which the indefatigable Lissitzky then consolidated through his personal contacts with members of the "De Stijl" group and with the Bauhaus circle. And so the abstract movements, isolated up to then, at last grew together and produced that expansion of abstract art which became evident in the thirties—but only in the West, the Soviet Union having banished the abstract aesthetic.*

While the Bauhaus was, in a way, the crucible of that fusion, *De Stijl* was by far the most active element.

*The attitude of the Russians toward abstract art has hardly changed at all, as is clear from C. E. Mójnigoun's book, *Abstraktionnism rasronchénié estétiki* published in Moscow in 1961. According to this author, abstract art is necessary to the bourgeoisie as a means of "distracting the attention of the people from the reality which surrounds it." The idealist philosophy, by denying the objective con-

De Stijl

The monthly review *De Stijl*, whose first number appeared in Leyden in October 1917, is unquestionably the publication that has contributed the most to the spread of abstract forms outside painting and sculpture, in architecture, decoration, furnishing, typography, and finally the cinema. The extraordinarily powerful radiation of its influence was due to the collaboration of two artists complementary to each other: Mondrian the theorist, and Theo van Doesburg, the man of action. Between 1917 and 1922 Mondrian published in *De Stijl* most of his writings expounding his theories. But he wrote in Dutch and, in addition, in a style so loaded with abstract terms as to appear hermetic, and it is Theo van Doesburg (1883–1931) who became their official interpreter – the brilliant and extremely sociable Van Doesburg, who was simultaneously a painter, a writer, and a lecturer, acted as the link between the solitary, taciturn Mondrian and the world. He had so lively a mind and such striking gifts that some contemporaries were inclined to think Mondrian was influenced by Van Doesburg even in his painting. This seems difficult to maintain, but there can be no doubt that the contact with this dynamic, intelligent, and openminded man was highly beneficial to Mondrian. All the more so, since their relationship began under the best possible circumstances: Van Doesburg had written in 1915 (when no one was interested in Mondrian's painting) an article praising him highly, on the occasion of a group exhibition at the Amsterdam Municipal Museum. This article was to lead to their meeting and in due course to the founding of the review – in

tent of knowledge as far as art is concerned, had definitely separated art from life. Hence abstract art, which is an evident expression of the crisis of capitalism. The fact, however, that a Soviet author has devoted considerable study to abstract art and has not concealed the part played by Kandinsky and Malevich is in itself a new element.

spite of the reserve with which Mondrian at first received Van Doesburg's overtures.

When the review was founded, the "De Stijl" group included, besides Mondrian and Van Doesburg, three other artists: the Dutchman Bart van der Leck (who stated, in a conversation with Seuphor in 1950, that he was the first to think of starting the review), the Hungarian Wilmos Huszar, and the Belgian sculptor Georges Vantongerloo. The founding members also included three Dutch architects, Oud, Wils, and Van't Hoff, whose presence underlies the direction in which *De Stijl* would move. As its name indicates, the ambition of the review was to create a style.

109

110

109. Bart van der Leck, *Geometrical Composition No. 2*, 1917.

110. Georges Vantongerloo,
Construction in Volumes,
1918.

In the first number the editorial board expounded its program
(written, it is said, by Van Doesburg): "This little review aims at
being a contribution to the development of the new aesthetic
awareness. It aims at making it modern, open to new things in
the plastic arts. Over against the archaic muddle — 'modern
baroque' — it aims at setting out the logical principles of a modern
style based on the pure equivalence of the spirit of the time and
the means of expression. It aims at drawing together the streams
of present-day thinking about the plastic arts, streams which,
while they are alike in their essence, have developed indepen-
dently of one another.

"The editors will try to achieve this by providing a platform
for the *authentically* modern artist who can contribute to the
reform of aesthetic feeling and to the awakening of public aware-

ness. Where the public is behindhand as regards art, it is the task of the working artist to awaken in the uninitiated the sense of the beautiful. The *authentically* modern artist, fully conscious of what he is doing, has a double mission to carry out. First, to produce works of art of a pure plasticism; then to enable the public to become open to this pure art. For that purpose the creation of an intimate review was essential. And all the more so because official criticism has shown a singular inadequacy as regards informing the public about abstract art. The editors of this review will therefore invite the technicians themselves to take the place of the critics, who have fallen short."

This program can indeed serve as a commentary on the activities of the "De Stijl" group on the rare occasions when it was integrally applied. Such has been its historical importance and its decisive function—thanks to the efficiency of Van Doesburg.

Soon after the review appeared some members left the group and others joined it. Mondrian himself returned to Paris in 1919, after which his only participation in the movement was through his collaboration with the review. But the "De Stijl" group was already a coherent nucleus, and in all fields its activity was inspired by the plastic vision of which Mondrian had laid the foundations. He himself, being exclusively a painter and one of very high quality, continued to apply his aesthetic intuitions in painting only; but the theosophist that he was (and we have seen the force of his convictions), being sensitive to the "new image of the world," could not help being attracted—and so influenced—by the practical applications of the new plasticism in the work of the "De Stijl" group. Were they not, in his eyes, tangible proof of the coming of a better world, a step forward on the path of that spiritual perfectibility which, according to the theosophist doctrine, ennobles and transforms matter? This, I think, is the right way to regard the relationship between Mondrian and the "De

111. J. J. P. Oud, House at Nordwijkerhout, Holland, 1917.

Stijl" group. In the presence of Van Doesburg's productions—his architectural plans or his designs for linoleums which found a wide market—and of the productions of architects like Oud and Rietveld, Mondrian changed: his own painting hardened. But this hardening, which some people have been inclined to attribute to direct influence by Van Doesburg, seems to me more likely to

113
114

112. Theo van Doesburg,
Project for a House, 1922.

113. J. J. P. Oud, *Café de Unie*, Rotterdam, 1925.

have been caused by Mondrian's certainty that a new era was beginning. That he was wrong — that his utopian imagination confused a stage of industrial development with the absolute, that he saw in increased means of mass production a triumph of the spirit — is beyond doubt (a sociological study of the facts would, I imagine, be revealing). But certainly it was in those years and in that spirit that the twentieth-century style came into being — the style of its objects and, particularly, also of its architecture.

In this connection it is symptomatic that Mondrian, the painter who purified optical perception to the point of imperceptibility and who would work at a picture for years, attached no value to the picture as unique example: the idea that a picture by him might

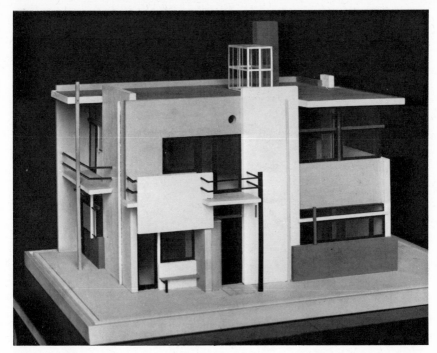

114. Gerrit Thomas Rietveld, Schröder House at Utrecht, 1923–1924.

exist in several copies did not worry him. This pleasure of his in the idea of a painting's being multiplied can be explained only in the context of the "De Stijl" group. It proves, also, how strongly Mondrian was in agreement with Van Doesburg's statement that "We must replace the brown world with the white world."

While Mondrian was meditating on the essence of that white world and filling most of the review with his writings, Van Doesburg traveled: he spent a long time in Germany, and was in close contact, between 1920 and 1923, with both the Bauhaus people at Weimar and the dadaists in Berlin. Everywhere he made disciples. Hans Richter (born in 1888, and now Professor of Cinematographic Technique at The City College, New

115. Hans Richter, fragment of film "Rhythm 21."

116. Viking Eggeling, fragment of film "Diagonal Symphony." Berlin, 1921.

117. Fernand Leger, fragment of the film "Le Ballet mécanique," 1924.

115

116

York) had been a member of the dada group in Zurich: in 1921 he joined "De Stijl", producing his first abstract film, *Rhythm '21*, inspired by the neo-plastic forms. This experiment of Richter's had been preceded by the similar researches of his Swiss friend Viking Eggeling (1880–1925), who likewise had been a member of the Zurich dada group. By 1919 Eggeling had begun painting reels of images from which he made an abstract film called

Diagonal Symphony, shown in Berlin in 1922. This film, like Richter's, was animated (made, that is to say, by filming images that had first been painted); it is the most complete experiment in abstract cinema. But the cinema, essentially a mass art, was

118. House of Theo van Doesburg at Meudon-Val-Fleuri, designed by him in 1929.

119. Sophie Taeuber-Arp, *Panel-composition*, 1927.

120. Theo Van Doesburg, architecture and painting of Salle des Fêtes, in (now destroyed) Brasserie d'Aubette, Strasbourg.

121. Sophie Taeuber-Arp, a corner of the bar of the (now destroyed) Brasserie de l'Aubette.

122. Jean Arp, main walk of basement dance hall, l'Aubette (destroyed).

scarcely touched by abstraction; nonetheless, in 1924, Fernand Léger worked with the American photographer Dudley Murphy to create the abstract film *Le Ballet mécanique* by using the current technique — filming real objects which had been so arranged as to create an abstract composition. It was by this path that the abstract aesthetic came to influence the photography of actual things and scenes. In the same way the effect of Russian constructivism is noticeable in the compositions of Eisenstein's *Potemkin*.

In 1925 the functional continuations of the abstract aesthetic began to be in evidence throughout Europe. The 1900 style of decoration, with its volutes and its overloading, was dead — this became quite clear at the International Exhibition of the Decorative Arts in Paris in 1925. But this new plastic unity, toward which painting, sculpture, the applied arts, and architecture were converging, had already come plainly into view two years earlier, in 1923, through the "De Stijl" group exhibition at the

117

123. Mies van der Rohe, ground plan
for country house, 1922.

124. Theo van Doesburg,
Russian Dance, 1918.

Léonce Rosenberg Gallery in Paris—a memorable exhibition
which showed not only the coherence of the new style but also
the imminent separation (followed by a rupture) between
Mondrian and Van Doesburg. Since 1922 Van Doesburg had
been editing not only *De Stijl* but a new review, *Mécano*, which
was dadaist in tendency. Mondrian took the view that this
venture of Van Doesburg's compromised neo-plasticism, and
from that moment the dissolution of the "De Stijl" group was
inevitable.

Van Doesburg overflowed with activity; he never stopped.
In 1926 he published a new manifesto, *The Elementarist
Manifesto*, which broke with the absolute verticality of neo-
plasticism. In 1928 he worked, along with Jean Arp and Sophie

121

125. Marcel Breuer, Kandinsky's dining room, 1926.

126. C. O. Müller, Poster for motion picture theatre, Munich, 1927.

127. Laszlo Moholy-Nagy, *Photogram*, 1925.

120 Taeuber-Arp, on the decoration of the Brasserie L'Aubette in
 Strasbourg (now destroyed). In 1929 he started a new review,
118 *Art Concret*, and designed a house for himself at Meudon near
119 Paris. Before the house was finished he died at Davos, in 1931,
122 at the age of forty-eight.

 If history has sometimes been unjust to Van Doesburg,
 if posterity rarely speaks of this man so much talked about by
 his contemporaries, it is because he was one of those highly
 gifted and attractive creatures, instant geniuses, who lack the

129. Man Ray, *Rayogram*, 1922.

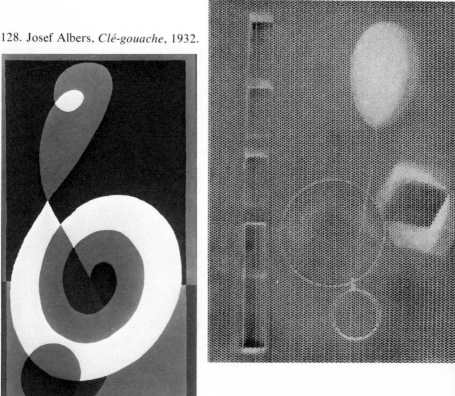

128. Josef Albers, *Clé-gouache*, 1932.

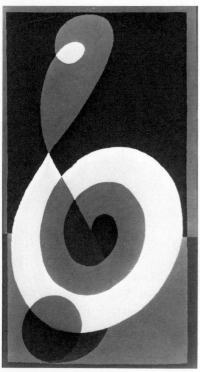

patience required by work in an art. The true dimension of Van Doesburg cannot be understood unless one takes into account the influence he exerted over his contemporaries, especially over the Bauhaus.

The Bauhaus

In 1919 the architect Walter Gropius had founded at Weimar a school of art and architecture of a new kind — the famous Bauhaus, which remains a unique experiment of its kind. With a typically German idealism this school was started in order that all the arts, all the crafts, and all the disciplines connected with the arts might be taught there with a view to their integration into architecture. It was the only place in the world where the teaching resolutely turned its back on the past and concerned itself only with the new plastic structures. The troubled years after World War One had seen the triumph of dada; but the Bauhaus represented, on the contrary, the triumph of harmony, a new harmony that was to put an end to all discords. The teachers, chosen from among the leading painters of Germany, included Kandinsky, Klee, Feininger, and Schlemmer, and in such an atmosphere abstraction clearly had the place of honor.

Van Doesburg's arrival in Weimar, according to Alfred H. Barr, Jr., "caused a veritable revolution," and the influence of neo-plasticism was immediate, especially on German architecture. The same writer, by comparing one of Van Doesburg's pictures (*Russian Dance*, 1918) with a design for a country house made by Mies van der Rohe in 1922, demonstrates this influence strikingly. It became decisive in the development of German architecture, and soon extended also to furniture and typography.

Together with neo-plasticism, the Bauhaus welcomed constructivism. Its influence was exerted partly through El Lissitzky,

124
123
125
126

and partly because of the presence of the Hungarian Laszlo Moholy-Nagy (1895–1946), who taught at the Bauhaus from 1922 onward and was entrusted with editing the famous series of Bauhausbücher (books published by the Bauhaus). He was a painter, sculptor, and photographer, strongly influenced by constructivism, and he applied a system of teaching based on the "culture of materials" in which Tatlin had believed, a system designed to develop in his pupil the feeling for the matter of works of art. Moholy-Nagy was a strange character. His name is linked, in particular, with abstract photography, of which the American Man Ray was the pioneer. Among the abstract researches undertaken at the Bauhaus, those of Josef Albers (born in 1888), whose work was later to be of influence in the United States, must be cited.

But the Bauhaus, that bastion of the avant-garde, did not survive. Transferred first to Dessau (1926) and then to Berlin (1932), it was finally shut down by the Nazi regime (1933). But in spite of all their difficulties, the Bauhaus people carried out their mission: they deepened the period's awareness of its own style.

127

128

Part 2 / **Abstract art of the thirties**

Painting

Having looked at the origins of abstract painting and sculpture and at the way in which they next developed, one realizes that the period 1910–1920 is the great period when the abstract form was created; the next period, 1920–1930, is on the contrary an experimental phase, in which people were concerned with the practical application of the gains of abstract art. The pioneers had sought forms in the absolute, and these were then continued into the relative, transforming the setting of life. These continuations, though an irrefutable proof of the vitality of abstraction, did not exhaust its possibilities.

Our purpose in discussing the origins and the beginnings of abstract art at some length has been to distinguish more clearly the elements which it contained in embryo—those that were the first to be realized, and those which are being realized now but

which, for lack of distancing, we cannot make out plainly. For we must not forget that the phenomenon of abstraction is one that is still developing, and the nearer a stage of its development is to us the less we can see it in depth: its full significance inevitably escapes us. And so, when we study the abstract art of the thirties, the facts and their significance are much less clear. And they are altogether unclear as soon as one touches on the next stage, the one which began after 1945. One can, with care, disengage certain main lines of the abstraction of the thirties, although for most of the time the artists appear to us as isolated cases that cannot be brought under a common denominator; but in the later period — for us who are its contemporaries — there are only isolated cases, some artists who stand out and others who become indistinct, at the mercy of entirely subjective value judgments.

What first of all distinguishes the thirties is the sheer number of abstract artists. The abstract vision had become general and had, at the same time, lost its sharpness. Around its promoters there had gathered a few fanatics of the first fine frenzy (this was the case above all in Russia), but now the artists who were converts to abstraction came to be counted in hundreds. The "Abstraction-Création" movement, founded in Paris in 1931 and active until 1936, eventually brought together, in the international exhibitions which it organized annually, more than four hundred painters and sculptors — to be precise, 416 at the 1935 exhibition, of whom 251 were French, the others German, Swiss, English, and Dutch, as well as 35 Americans. When one thinks that in Paris the first international exhibition devoted exclusively to abstract art had taken place scarcely five years earlier, in 1930, on the initiative of the "Cercle et Carré" group, this sudden expansion might suggest that there had been a triumph of abstraction; but, since in art quantity does not necessarily bring with it quality, all this hardly rose above the level of fashion.

As fashion, this phenomenon is easily explained. Besides creating their paintings and sculptures, the great pioneers of abstract art, as we have seen, did a great deal of writing. Diverse as their theories were, they had one point in common—they rationalized the creative imagination and gave the impression of providing methods for the elaboration of a work of art, as though this were not, each time, a foray into the unknown. In short, the first abstract painters, in their desire to elucidate their own means of expression, produced what looked like a system, and this "system," being placed within reach of the great mass of artists, gave rise to that fashion for abstract art which reached its height during the thirties.

The same causes which made abstract art the fashion helped, during this period, to drag it down. Systematized abstraction was geometrical, but it had lost that essential value as a quest for the absolute which it had had in the minds of Mondrian, Kandinsky, and Malevich. In the hands of most of the members of "Abstraction-Création" abstract form was not, in spite of the name, creation— it was a totally empty style. To run, now, through the issues of the review, published under that name by the founders of the movement, is to find that it dates badly, because often it is trying to codify plastic geometry and is not concerned with giving it a deeper reason. Abstract art, of all kinds of art, is the least able to bear being generalized. The mistake made by the great majority of such artists in the thirties was that they saw only the outside of geometrical abstraction and had no inkling of its content. So the objectivity proper to geometrical form engendered facility. Some artists thought they could go abstract from one day to the next. Abstraction became separated from the creative instinct, and 1930–1940 was at one and the same time the period during which abstract art was "in" and its first period of regression.

Though most of the artists who rallied to "Abstraction-Création" debased the plastic knowledge which they received,

there were some among them who managed to extend it, or at least to enrich it with some individual nuance. Without exception, they are the ones who look, in abstract form, for a new significance.

That, on the whole, is the historical setting in which abstract art pursued its way, with the imperious logic of its beginnings. Abstract painting had done away with volume and had arrived at the plane; from there it moved on toward the wall. The great dream of objectivity which gave life to the geometrical forms drove them to go beyond the easel picture and to join up with architecture. After all, easel painting had only appeared in European art at the beginning of the Renaissance in the fourteenth century: what could be more natural than that twentieth-century art, in its desire to break with the plastic vision of the Renaissance, should be tempted to move outside the picture and confront the wall? This is the most interesting aspect of a period which is otherwise rather dull, and it is here that the individuality of Robert Delaunay intervenes in the history of art. His researches have sometimes, it seems to me, been not very well understood.

Robert Delaunay

Robert Delaunay (1885–1941) is usually given a place at the beginnings of abstract art: he did in fact paint abstract pictures in 1912–1913, but his passion for color, even though it arrived at abstraction, remained bound to the problems raised by cubism. This confusion, which unquestionably goes back to the time when cubism was considered as an abstract movement, is dissipated by Delaunay himself in his writings, with his characteristic honesty and intelligence.

"Toward 1912–1913," he writes, "I had the idea of a kind of painting which, technically, would rely only on color, on contrasts

of color, but these developing in time and making themselves perceived simultaneously, at one go. I used Chevreul's scientific term: simultaneous contrasts. I played with colors as one might express oneself in music through a fugue of colored phrases treated contrapuntally.... It is impossible to deny the evidence of these colored phrases animating the surface of the canvas with various kinds of cadenced measures which succeed one another, outstrip one another in movements of colored masses — color acting, this time, almost independently, through contrasts."

The pictures Delaunay created in this way form the *Windows* 25
series, thirteen canvasses in which, as he himself states, alongside abstract elements there are still concrete images, bits of curtains, the Eiffel Tower. "These images, though treated abstractly, were reminiscences of old habits, based on an old state of mind rather than saturated, vivified by a new craft, a craft of our own time. . . Then," Delaunay goes on, "it occurred to me to do away with the images seen by the realist eye: the objects that came in to interrupt and corrupt the colored painting. I attacked the problem of formal color. My first circular colored forms fall between 1912 and 1913 — and the whole of that period is one long 24
technical research into painting."

These notes, written in 1933, are not only a valuable formulation but help us to understand Delaunay's own position in the evolution of abstract art. His experience of abstraction was deep and authentic, he knew the requirements of a form free from all connection with external reality, and yet, after 1913, and until about 1930, he continued to paint figurative pictures. The problem uppermost in his mind was that of the cubists: how to introduce reality into a transposed space — with this difference, that for him space was not a geometrical but a purely chromatic transposition. His claim to fame (which he owes to Apollinaire) is that he succeeded in bringing back color into cubist composition, which avoids it on principle. These researches occupied Delaunay

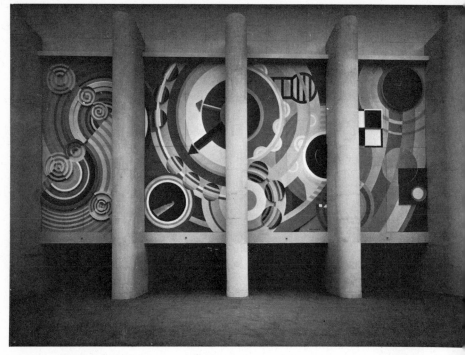

130. Robert Delaunay, *Endless Rhythms.*

completely; but since they were all bound up with color, he had the advantage, when he went abstract in about 1930, not only of his solid technical knowledge but also of an awareness of that autonomous action of the means of expression which is the basis of abstract painting: he had, in short, both the skill for and understanding of abstraction. And so it is not surprising that Delaunay saw in advance and realized the mural potentialities of abstract painting. Abstract art took a step forward in this direction thanks to him. His part as abstract painter was played, then, in the thirties, separately from the importance his work had had earlier in the century.

From 1930 onward Delaunay created a number of painted

reliefs which he usually called *Endless Rhythms*. He did several
of these for the Palais des Chemins de Fer, and a mural painting
of 780 square meters for the Palais de l'Air in the Paris Exhibi-
tion. Until his death in 1941 this highly original conception of
mural painting occupied his mind. He himself explains it in a note
written in 1934: "Abstract art is the complement to the real wall
of modern architecture, the wall being no longer a symbol but a
living reality constructed in space.... Living abstract painting is

130

131. Sonia Terk-Delaunay, *Simultaneous Fabrics*, 1923.

132. *La Prose du Transsibérien et de la Petite
Jehanne de France*, poem by
Blaise Cendrars, with "simultaneous colors"
by Sonia Terk-Delaunay (detail), Paris, 1913.

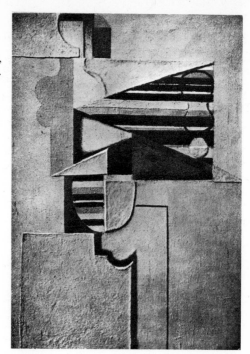

133. Willi Baumeister,
Figure with Bands II, 1920.

not made up of geometrical elements, because novelty does not lie in the distribution of geometrical figures, but in the mobility of the constituent elements."

These constituent elements are circles, whose placing, together with the action of color, creates a rhythm in which the power of pure abstraction is expressed.

Delaunay's work must not be separated from that of his wife, Sonia Terk-Delaunay (born in 1885), who, besides painting pictures that are close to those of Delaunay himself, created in 1913 a "simultaneous book" by illustrating Blaise Cendrars's poem, *La Prose du Transsibérien et de la Petite Jehanne de France*. She also started, in about 1925, "simultaneous fabrics," whose fresh colors and clear forms made a revolution in the French textile industry.

132
131

134. Frank Kupka,
Spring, 1911–1912.

On the eve of the war in 1939, the Delaunays' studio in Paris was a real center for abstract art. Their friends were invited there once a week. At these meetings Robert Delaunay explained his conception of abstract art in detail. In this way he helped young artists to find their way — one of them being Serge Poliakoff, who will be discussed below.

Another artist attracted to mural painting in those years was the German, Willi Baumeister (1889–1955). First a member of the "Cercle et Carré" group and then of the "Abstraction-Création" movement, he had a highly acute sense of material, and this led him, as early as 1920, to consider easel painting itself as a kind of mural painting. In Baumeister's compositions the form, which is always ample and clear, relies on tones which make one feel that

133 the painter has been active in the grinding of the colors, mixing sand and glue in with them in order to enrich the matter of his painting. This materiality, which to Baumeister was the very essence of painting, made him in some ways a precursor of the informal. He was forced to interrupt his work during the Hitler regime, and it was only after the war that he acquired international fame.

26 Frank Kupka (1871–1957), a Czech painter who, settled in Paris in 1894, was also one of the founding members of "Abstraction-Création." He exhibited his first abstract pictures at the Salon d'Automne of 1912. He was to remain faithful all his life to the idea — which, even then, he was acting on — that painting is pure creation; but in spite of this precocious conversion to abstraction, his work does not have the sweep that would have made him a pioneer of abstract art — and this, perhaps, because in Kupka's work abstract form does not succeed in supplementing the elements that have given rise to it. There is in him, on the one hand, the desire to align painting with music (a desire which had driven the Lithuanian painter Čiurlionis to paint some abstract canvases a few years earlier), and there is, on the other hand, the precious taste of Art Nouveau, a consequence of the decorative and illustrative influences which Kupka had been subjected to during the time he spent in Vienna before 1894. Kupka was too much inclined to look for the correspondences "between sounds and colors," and neglected the specific requirements of painting; and since he seems to have been satisfied with "art for art's sake," his kind of abstraction remains more of a rare continuation of the nineteenth century than an assertion of the twentieth. No doubt for this reason, the genuine subtlety of this

134 artist comes out chiefly in his pastels and gouaches.

Auguste Herbin (1882–1960), who was not only the founder but

135. Auguste Herbin,
Yellow, 1946.

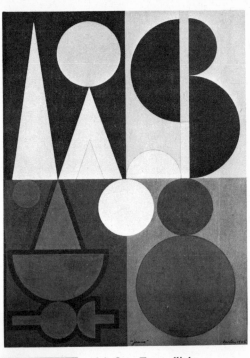

136. Otto Freundlich,
Ink Drawing, 1934.

the principal animator of "Abstraction-Création," is a strange artist in whom the plastic austerity and aestheticism of Mondrian are filtered and modified by a Latin temperament. That "stubborn and proud solitary," as Jean Cassou called him, went in search of the significance of abstract art, which he refused to accept as a merely external combination of forms. Gratuitous abstraction alarmed him. In contrast with the great majority of abstract artists who, at that time, had ceased to think of abstract art's reasons for existing and were sinking into a sterile formalism, Herbin set himself to study symbolic hermeticism and came under the influence, in particular, of the theosophist Hoene-Wronski. All by himself,

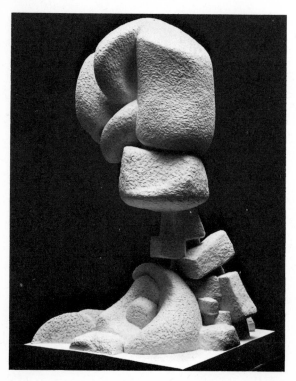

137. Otto Freundlich, *Ascension*, 1929.

he trod the path of Mondrian over again, though in a shorter time, and in the end worked out his own abstract vision, with the conviction that he was contributing by his work as an artist to the perfecting of humanity.

His painting contains only geometrical forms, because in his view these are at the basis of all the forms of nature, and because they offer clear surfaces over which the color can expand. His color, which he required to have as much force as the geometrical form, is often pure and laid on smoothly over the whole extent of the canvas, in order to give to the contrasts the strongest possible resonance. Not only the conception but the technique itself

135

138. Alberto Magnelli, *Woodcut*, 1942. 139. Theodor Werner, *Bird*, 1934.

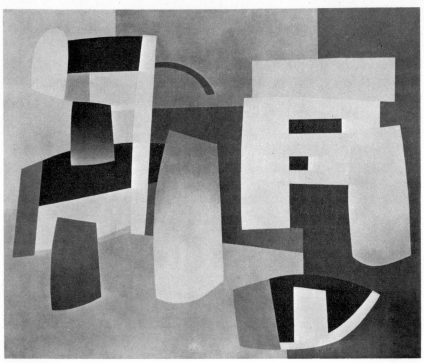

140. Jean Helion, *Equilibrium*, 1934.

becomes system in a picture by Herbin; he went so far as to complete a plastic alphabet, establishing correspondences – absolute, he believed – between forms, colors, and letters as sounds. This excessive rigidity, into which he laces up artistic creation, may sometimes repel the spectator, but it exercised a considerable influence over young abstract painters in France after World War Two. The visual system set up by Herbin made him the leader of geometrical abstraction for a while, especially after the publication, in 1948, of his book *L'art non-figuratif non-objectif (Non-figurative Non-objective Art)*.

With a fervor that was no less fanatical, but supported by a much

141. Fritz Winter,
Construction in White, 1934.

wider culture, Otto Freundlich (1878–1943) also concerned him-
self with finding some universal content in abstract form. This
German artist, who worked in Paris from 1909 onward, faced the
problem of abstraction as early as 1924. He brought his pro-
foundly meditative mind to bear on the essential difference be-
tween art and reality: "We always find ourselves *in front* of a
picture," he wrote, "whereas we are always *in* nature." And he
went on to state a primary truth, one that is at first sight very
simple, but is fundamental to the understanding of abstract art:
"We always have to make a bridge between us and the picture,
whereas the bridge between us and nature is made by our exis-
tence." It is precisely through making this "bridge" that abstract

art is pure, while realism is not, because it substitutes itself for existence. What abstract form refuses is all the pretensions of realism, and what it accepts is an authentic way of being. The depth and originality of Freundlich's thinking are unquestionable, and although his output was very small it gives us, nonetheless, the measure of his exceptional qualities as painter and sculptor.

As a painter, Freundlich tried, above all, to achieve a kind of inner vibration of color: this he obtained by laying closely similar tones side by side, in geometrical forms which seem, in consequence, continuous of one another. (This chromatic con-

136 struction of Freundlich's would later prove to be a valuable lesson to Serge Poliakoff, as he himself has admitted.) The same principle of a progressive unfolding, obtained by this succession of separate forms, gives Freundlich's sculpture a massive cohesion and a power rarely met with in the twentieth century, so

137 that his works are still among the finest examples of abstract sculpture at its least arid, its richest and fullest.

This rapid survey, though necessarily incomplete, must not be rounded off without mentioning certain painters who, converted to abstraction during the thirties, arrived at a personal way of

138 expression. This was the case with the Italian Alberto Magnelli
139 (born in 1888), the Germans Theodor Werner (born in 1886) and
140 Fritz Winter (born in 1905), and the Frenchman Jean Hélion
141 (born in 1904), one of the youngest recruits of "Abstraction-Création," whose return to strict figuration in about 1940 was a brave act which has been often misinterpreted. It was also the case with Ben Nicholson (born in 1894), one of the most prominent British painters. It would be wrong to call him an abstract painter now, although the framework of his compositions re-

142 mains abstract: Ben Nicholson's line, even when it is retracing reality, seems to retain a nostalgia for the purity of geometrical forms; and the same is true of his color, which is always discreet,

142. Ben Nicholson, *White Relief*, 1935.

ready to efface itself in order to let white take over – that white with its scarcely perceptible nuances which this artist's pictures have so often sought to capture.

Sculpture

The sculptor dominant in the abstract circles of the thirties was, unquestionably, Jean Arp (1887–1966). But before discussing his work one must ask the question: to what degree is Arp's sculpture abstract? An all the more precise answer is called for since the question was being raised, in 1930 and thereabouts, with regard to the whole of abstract art.

At that time — twenty years after the appearance of the first abstract forms — the artists who had ceased to be figurative had more and more felt that their works were touching the true depth of reality, that they were therefore not at all abstract, and that it would be more correct to call them *concrete*. It was in this spirit that Theo van Doesburg started the review *Art Concret*. Only one number (April 1930) was ever published, but the term "concrete art" had a great success, especially among the artists them-

143. Sophie Taeuber-Arp,
Floating Thing, *Ruled*,
Oscillating, *Dividing*,
Sustaining, 1932.

selves: it is in their statements and writings that it is most often
to be found. Jean Arp was one of those who made systematic use
of it. "We do not want to copy nature," he wrote. "We do not
want to reproduce. We want to produce like a plant producing a
fruit, and not to reproduce. We want to produce directly and not
through a go-between. Since there is not the slightest trace of
abstraction in this art, we are calling it 'concrete art.'" And he
added: "Concrete art is an elementary, natural, healthy art, which
sets growing in the head and heart the stars of peace, love, and
poetry. Where concrete art enters, melancholy goes out, dragging
its gray suitcases filled with black cares."

This short quotation, besides being a neat illustration of the
reasons which led Arp to prefer the term "concrete art," displays
the dreamy and enthusiastic personality of this one-time dadaist

who was sculptor, painter, and also poet.

Arp's stance as an artist was one of such freedom that the term "abstract" is too narrow for him. In his earliest phase, during *31* the heroic period of dada, he did create works that are completely abstract. He was also abstract when he worked on the decoration *122* of the Brasserie L'Aubette at Strasbourg, for which he had *119* received the commission in 1928 along with his wife, Sophie Taeuber-Arp, and his friend Theo van Doesburg. These decora-

144. Jean Arp,
Muse Torso, 1959.

tions (which no longer exist) were one of the largest schemes of
mural painting carried out in the spirit of the thirties. Sophie
Taeuber-Arp (1889–1943) arrived at abstraction effortlessly, as
early as 1915, perhaps because she had begun her career as a pro-
fessor at the Zurich École des Arts et Métiers; she remained
fanatically attached to abstraction till the end of her life — and
influenced Jean Arp noticeably in this direction. For he, though
possessing a plastic coherence and originality which made him a

120

121
143

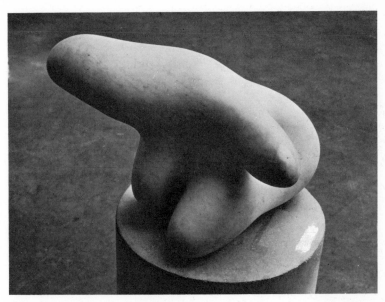

145. Jean Arp, *Human Concretion*, 1934.

leader, went through many fluctuations in his attitude toward
abstraction. In about 1930 Arp was attracted by surrealism and
was a figurative sculptor — figurative, it is true, with a good deal of
latitude, but still anchored in reality. It was only after 1930, when

he started his series of sculptures called *Concretions*, that he
became, in his own way, abstract. And it is understandable that
he should have refused the label "abstract" and wanted to be con-
sidered as a concrete sculptor: the forms carved by Arp seek to
rival nature, to become indistinguishable from anonymous and
perfectly pure forms like certain pebbles shaped by the movement
of water and certain clouds that seem swollen by the wind. After
World War Two, in spite of his ambiguous position in abstract
art, Arp exerted an influence over purely abstract sculptors,
because the sensuality with which he treated the material was
the best weapon against that geometrical desiccation which is apt
to arise in the constant battle abstract sculpture has to wage
against objects in order to keep its quality as a work of art.

144
145

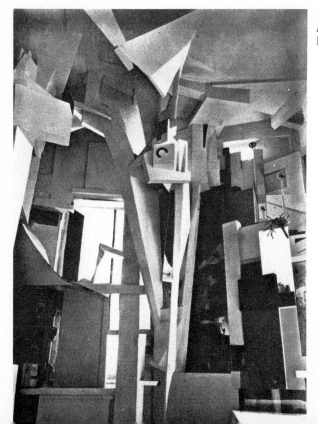

146. Kurt Schwitters, the
Merzbau inside his house in
Hanover, 1918–1938.

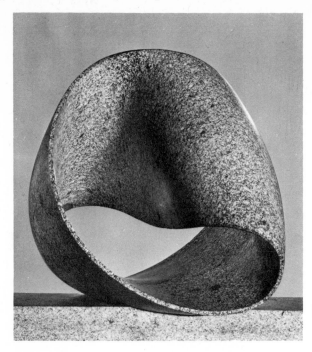

147. Max Bill,
Endless Ribbon,
1936–1961.

148. Henry Moore, *Composition in Four Pieces*, 1934.

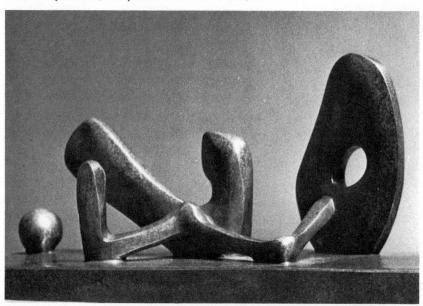

In an even more ambiguous way, that strange German artist Kurt Schwitters (1887–1948) is part of the history of abstract sculpture. A thoroughbred dadaist who many times came close to total abstraction, he belongs to the "concrete" side of abstract art. He gave to his works, whether in painting, sculpture, or writing, the name "Merz" — the second syllable of the German word for commerce, which once by chance stood out, cut off in this way, in the middle of the abstract forms of one of his collages. From 1920 onward all Schwitters' activity, with its many repercussions among the avant-garde, bore this name Merz.

Among his many enterprises he began, in about 1925, to *146* create a Merz construction (*Merzbau*) inside his own house in Hanover. It was a kind of sculpture with tentacle-like forms

149. Barbara Hepworth, *Three Forms*, 1935.

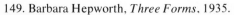

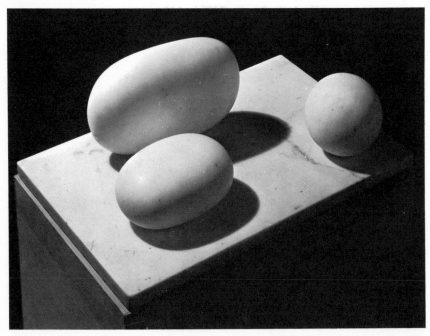

starting in a column and invading the space around, and when they had filled the whole room Schwitters made a hole in the ceiling to give them space in the floor above. In this way the *Merzbau* climbed several floors. Unfortunately the house containing it was destroyed by a bombardment during the war. After leaving Germany in 1935, Schwitters worked on a second Merz construction in Norway, then on a third in England; but the first was by far the most important. To judge from the

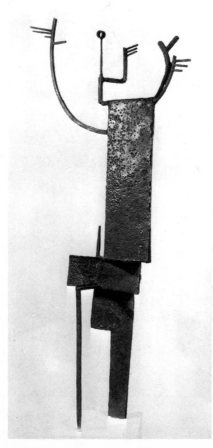

150. Julio Gonzalez, *Woman Doing Her Hair*, 1930–1933.

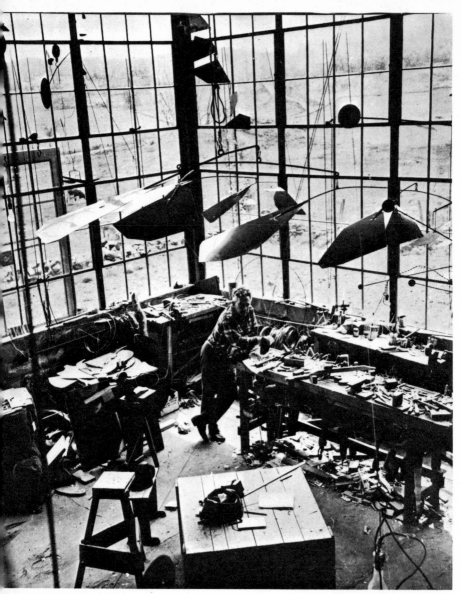

151. Calder in his studio.

surviving evidence, this extraordinary work forestalled that freedom and that rejection of any pre-established order in the organization of volumes which have been characteristic of abstract sculpture since 1945.

A typical representative of the abstraction of the thirties is the Swiss sculptor Max Bill (born in 1908). He is a painter, an architect, and a writer. To him absolute form is no longer a quest, it is certainty: mathematics, for him, comprises the supreme laws and brings peace to his creative torment. Often his sculptures are the spacial development of mathematical formulae, and this flawless strictness, devoid of mystery, sometimes excites admiration among the fanatics of number. *147*

In the very different work of the British artist, Barbara Hepworth (born in 1903), abstraction retains more humanity, in spite of her admiration for the plastic conceptions of Mondrian, whose influence she has succeeded in assimilating and transposing. By a play of convex and concave forms, setting the empty against the full, Barbara Hepworth manages to make space alive — the ambition of every sculptor — and her considerable reputation is not surprising. *149*

The British sculptor with the greatest international fame, Henry Moore (born in 1898), was also abstract at one moment in his development, around 1930, when he was a member of the "Abstraction-Création" group. *148*

To understand the further development of abstract sculpture, with the primary importance it was beginning to give to the material, would be impossible if one left out the researches of such a sculptor as Julio Gonzalez (1876–1942). This Spaniard, who settled in Paris in 1908, never went abstract: "Without a constant study of nature I can create nothing," he used to say. But his family background was, I think, decisive for his sculpture:

he was the son of a goldsmith, and direct work in metal fascinated him. And so, around 1930, when he devoted himself exclusively to sculpture, he began instinctively and without revolutionary intentions to use sheet metal, which he cut and chased till it acquired the form he wanted. His plastic conception was still definitely realistic, but the expressive power of the material heightened and attenuated its traditional aspects. Letting himself be guided constantly by the attraction the material exercised

150 over him, Gonzalez proceeded, around 1932, to use sheet iron — and it was iron that dictated the spareness of his style, which was· to gain a following among the abstract sculptors of the next generation. At the beginning the abstract work of Tatlin, Gabo, and Pevsner went side by side, as we have seen, with the use of new materials; but it was left to a figurative sculptor like Gonzalez to take a decisive step in this direction.

151 The American artist Alexander Calder (born in 1898) exhibits a similar relationship to abstract sculpture. He too constructed his sculptures starting from the potentialities offered by metal, and he arrived at the famous "mobiles," so realizing what is a constant ambition of abstract sculpture — form in movement. During a first phase, in 1929, he obtained movement (not excluding a grain of humor) by adding a small electric motor to the sculpture — an example taken up by others after 1945; but the real mobiles that show this strange sculptor's full originality did not appear until, a bit later, he found a way of incorporating the movement into the sculpture itself, by suspending the mobile and calculating how each of its parts should be suspended. (The fact that Calder studied engineering before devoting himself to art is not irrelevant.) Some of the very first mobiles he created in this way are abstract.

Part 3 / **Abstract art after 1945**

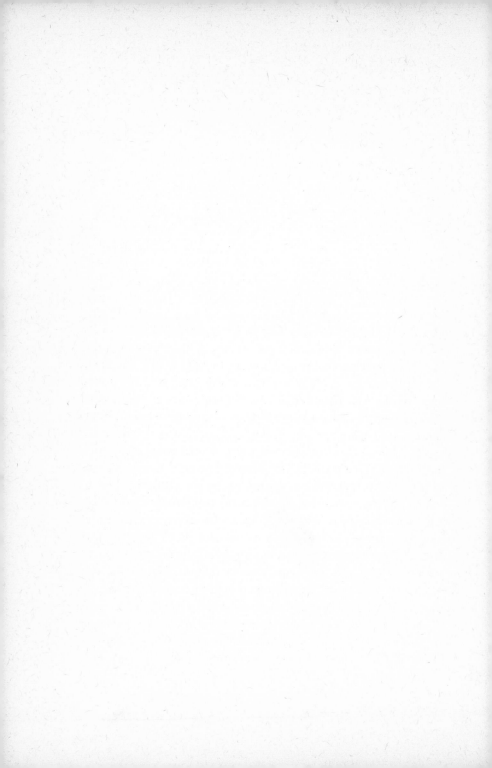

The preceding pages have attempted a systematic account of the development of abstract art up to 1940. But to describe its further development it is necessary to give up any attempt at being systematic: abstract art, as it has developed in the period since World War Two, has produced such profound transformations in both the conception and the execution of a work of art that one often has the impression of being in on a revolution, in which form has lost sight of the past and is venturing out, gropingly, toward a still cloudy future. The only fact that seems indisputable is that abstract art has become a worldwide phenomenon, having been, before the war, confined to Europe. It follows that we, as contemporaries, are involved in an event of such wide range that only our own taste can help us to find our bearings; yet we must be cautious about building a system out of the partial—and partisan—material at our disposal. Some fortunate convergence of circumstances and the right affinities may make a critic and contemporary witness into a lucid commentator on the experiments of one or even several artists, but never on the totality of the new experiments; for time must operate its sifting before distance can allow access to the objectivity which is

needed to complete our subjective choice. In the following pages, therefore, we shall confine ourselves to indicating a few of the main lines in abstract art since World War Two, placing one or two buoys here and there, and determining, when possible, some of its characteristics.

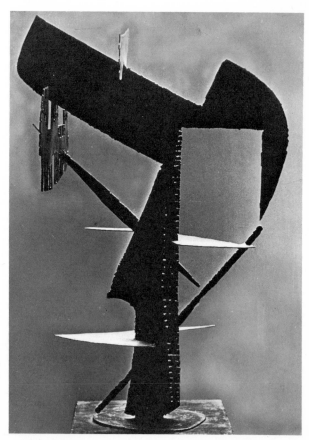

152. Berto Lardera,
Archangel No. 1, 1953.

Sculpture

Throughout the century, as we have seen, sculpture evolved
more slowly than painting. This may be why the end of the war
did not bring with it as clear-cut a break with the past in abstract
sculpture as it did in painting: the abstract forms in sculpture
show an obvious continuity, of which there is practically no sign
in those of the paintings. These, generally speaking, are opposed
to abstraction as conceived in 1930, whereas abstract sculpture
is still engaged in developing what was sketched out during those
years. For instance, we find direct work in metal being practised
more and more; stainless steel, nickel, and duralumin are added to
sheet iron and metal strips. The abstract sculptors (who are far
fewer than the painters) seek to gain advantages from the material
they use; but in sculpture technique is far from being the obsess-
ion it has become in painting.

The situation in which abstract sculpture was placed after
World War Two seems best illustrated in the work of Berto *152*

227

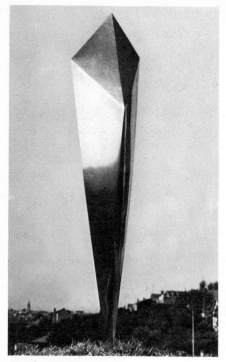

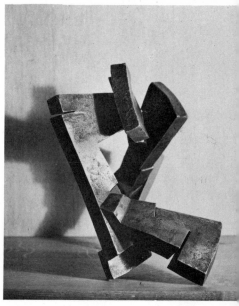

153. Émile Gilioli, *Spirit,
Water and Blood*, 1953.

154. Eduardo Chillida, *Ironquake No. 1*, 1956.

Lardera (born in 1911, working in Paris). His fondness for
metallic strips intersecting at right angles, his total suppression
of volume, and his use of a counterpoint of plane surface and
emptiness — all these elements, with the ambitions and limits
they imply, indicate the persistence, after 1945, of the aesthetic
of the thirties. This is also true of certain sculptors, like Émile
153 Gilioli (born in 1911), who are attracted by the pure geometry of
volume. Order and strictness are equally prevalent in the experi-
155 ments of some younger sculptors, like Hans Kock (German, born
154 in 1920) and Eduardo Chillida (Spanish, born in 1924): both of
these advance a step by trying to make geometrical rigidity

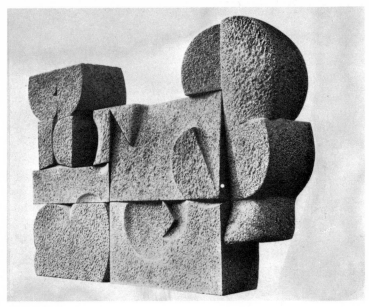

155. Hans Kock, *Sculpture*, 1962–1963.

express the power of mass. At the opposite pole from their aus-
terity there is the Danish sculptor Robert Jacobsen (born in
1912), who tends in his iron constructions to give priority to the
rights of the imagination: a self-taught artist, his extremely sure
sense of form in space has enabled him to give free play to his
plastic inventiveness. These qualities in Jacobsen appear the
more salient if he is compared with some other abstract sculptors,
in whose work the use of metal freezes the form; the German
sculptor Hans Uhlmann (born in 1900) may be taken as their
typical representative — an engineer as well as a sculptor, he
seems to be satisfied with creating forms that possess all the

156

157

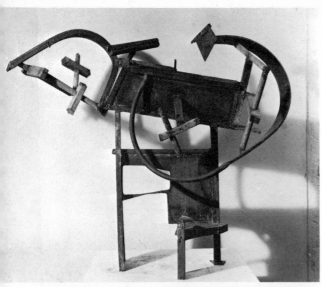

156. Robert Jacobsen,
Marama, 1960.

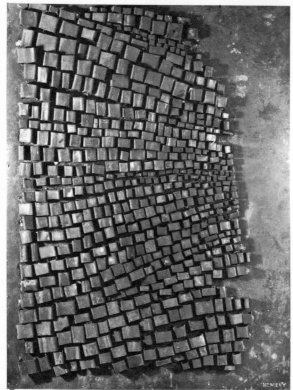

157. Hans Uhlmann,
Sign, 1962.

158. Zoltan Kemeny,
*Movement Stopping before
the Infinite*, 1954.

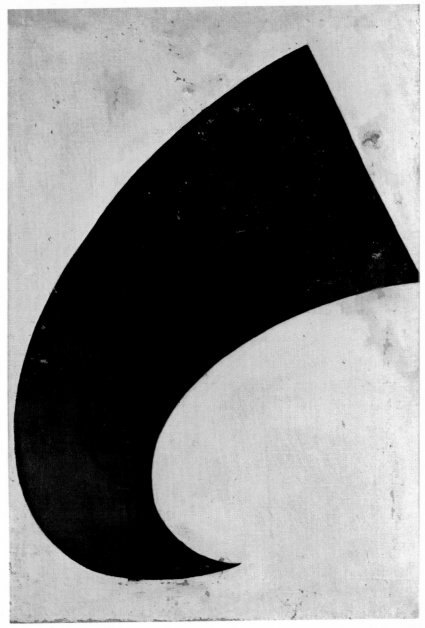

III. Casimir Malevich, *Suprematist Composition*, ca. 1917. Oil, 64 × 45.5. Rome, Sophia Loren and Carlo Ponti Collection.

hardness and coldness of steel. Other and younger sculptors, like Nino Franchina (Italian, born in 1912) and, above all, Brigitte Meier-Denninghoff (German, born in 1923) set themselves to mitigate this hardness and coldness by giving their compositions more suppleness. George Rickey (American, born in 1907) starts from the solidity of steel and conceives forms which, being thinned out to the extreme, like twigs of metal or very long needles, movable ones, dig into the space without dividing it up. In Rickey's sculptures the movement executed by the form has the effect of completing it and stressing its plastic content—differing in this from the kinetic sculptures fashionable in the last ten years or so: these, in my opinion, fail to achieve abstract sculpture's early ambition to "appropriate" movement, because they have recourse only to a mechanical movement devoid of any significance as form.

159

160

161

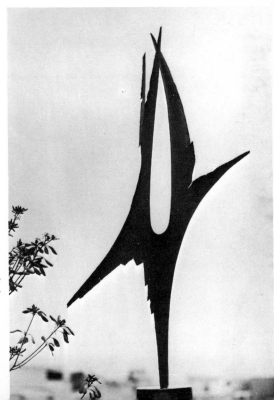

159. Nino Franchina,
Heraldic, 1955.

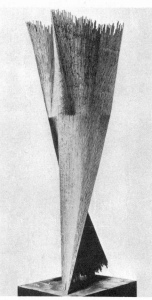

160. Brigitte Meier-Denninghoff,
Pharaoh, 1961. London.

161. George Rickey, *Six Lines*, 1964.

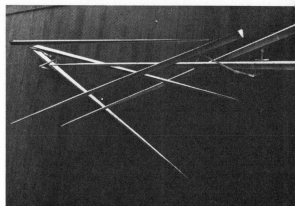

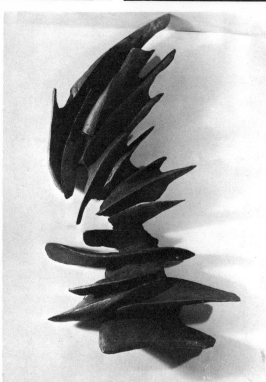

162. Penalba,
Chinese Relief, 1959.

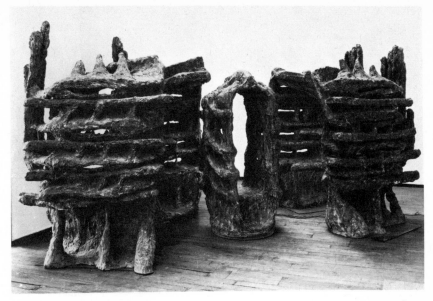

163. Étienne Martin, *Dwelling No. 3*, 1960.

The time dimension (whose natural expression is movement) is much better realized in the reliefs of Zoltan Kemeny (1907–1965). The obsessional repetition of one and the same element, which is the basis of each of his works, is precisely a transposition of time into the material space of sculpture: the procedure is in itself very interesting and, though in Kemeny's work it is not free from monotony, it does indicate a fresh direction in contemporary sculpture. The same procedure characterizes the experiments of François Stahly (born in 1911) and appears—though filtered and thoroughly assimilated—in the work of artists as different from one another as Étienne Hajdu (born in 1907), Penalba (born in 1918), and Étienne Martin (born in 1913). These artists cannot be called fully abstract: they approach reality by starting from an initial form which is abstract and is multiplied so as to come close to being a concrete image without, however, becom-

<div style="text-align: right">

165

164

162

163

</div>

ing identical with it. Whether it be the attraction of the unstable equilibrium that distinguishes Penalba's bronzes, or the compressed tension that gives life to Hajdu's reliefs in hammered metal, or again that inhabitable and inhabited mother-form, the beginning and end of all form, by which Étienne Martin is haunted—we find ourselves at the limit where abstraction and figuration become reversible. This state of reversibility is in itself not only a proof that they have gone beyond the abstract aesthetic of the thirties, but also a sign that sculpture is, in spite of its much slower and more closely limited development, advancing in the same direction as postwar painting.

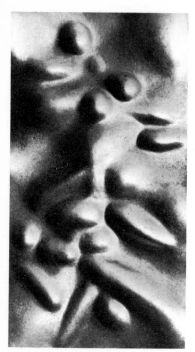

164. Étienne Hajdu, *The Dance*, 1957.

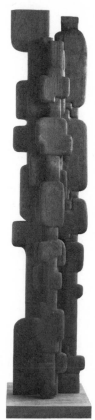

165. François Stahly, *The Big Tree*, 1963.

Painting

In painting, over the last twenty years, the range of the experiments, the number of painters, and the transformations undergone by abstract form have been so great that the present does seem to be resolutely breaking with the past. Only the works of a small group maintain continuity. Its leading figure has been Victor Vasarely (born in 1908). In Hungary, where he was born *166* and studied, Vasarely was initiated into the spirit of the Bauhaus at its purest by his compatriot Moholy-Nagy, and to this spirit he has always remained faithful. More royalist than the king, this painter reduces abstract form to a strictly optical phenomenon. Was it, one wonders, out of reaction (because, when he arrived in Paris in 1930, he was obliged to work in decoration and publicity) that he was afraid of free expression in painting and depicted geometrical form with such intransigence? Compositions traced

166. Victor Vasarely, *Homage to Malevich*, 1949–1954.

with the drawing-pen and compasses, colors laid on flat, chromatic harmonies worked out scientifically – this conception of
painting, which every picture by Vasarely stubbornly exemplifies, was rather widespread immediately after the war, above
all in France: abstract painting was then in the full flush of
expansion, and it was natural that it should attach itself to the
aesthetic of the thirties. But it was not long before the creation of
the Salon des Réalités Nouvelles, exclusively devoted to abstract
art, made clear the academicism which threatens geometrical
abstraction. This was supported by the review *Art d'aujourd'hui*
168 and had as its principal champion Jean Dewasne (born in 1921),
who preferred Ripolin (enamel) to oil painting, as being a less
subjective material and therefore more suited to geometrical
169 abstraction. Unlike Dewasne, Deyrolle (born in 1911) developed
by making his technique more and more personal and his composition more and more mural.

That extreme tendency of abstraction faded away gradually,
from 1950 onward. Only Vasarely, on the contrary, hardened

his work to the point of dogmatism. By remaining so strictly tied to the doctrines of the thirties, he eventually came to be recognized, in 1965, as the precursor of certain group researches into optics and also of op art (optical art), for which the fashion moved from New York to Europe in the years 1964 and 1965: both these lines of research seem to me too much indebted to the past – to a past that is over and done with – to constitute a step

167. Serge Poliakoff,
Composition, 1951–1954.

168. Jean Dewasne, *Direct Drawing*, 1947. 169. Deyrolle, *Soco*, 1947.

toward the future. The same past is perceptible in the work of the British artist Victor Pasmore (born in 1908), underlying the spareness of form and color and the purity of expression which he carries to, perhaps, its furthest limit.

167　　The past certainly ceases to exist – is no more than the starting-point of a new achievement – in the painting of Serge Poliakoff (born in 1906). His exceptional gifts as a colorist have enabled Poliakoff to go beyond the coldness of geometrical abstraction. Poliakoff is reacting against the pre-established order of forms and, to do completely what he sets out to do, he relies entirely on color: in his compositions no line stiffens the forms by outlining them – they are delimited only by the comings and goings of the brush at the hand's sweet will, while the same

movement of the hand lays out the color—and since this frontal
(and mural) use of color is what the painter wishes to stress,
he often uses closely similar tones, an orange-yellow next to a
red, a green next to a blue. So each shade becomes an expanse
over which the eye delights to run.

Poliakoff painted his first abstract pictures in 1939, after

170. Mark Rothko, Black
Dark Sienna on Purple, 1960.

his contacts with Robert Delaunay had led him to think about
the specific qualities of color and he had fallen under the spell
of Freundlich's art of chromatic construction. His work since
then has become an inseparable part of the development of
abstract painting—of a kind that enlarges the active scope of
color.

171. Jacques Germain, *Oil on Paper*, 1963.

170 It is from the same angle, I think, that the work of the American artist Mark Rothko (born in 1903), with his highly personal attitude to color, should be envisaged. Two contrary elements have conditioned his painting: Rothko loves both the light of Matisse's colors and the shade which fascinates the surrealists. It is there that this contemplative painter has found the form and the content of his abstract vision: the painting of Matisse taught him how color can become luminous vibration, and surrealism revealed to him that the real is only opacity. His own painting has grown, in consequence, to be the expression of that opacity, which has neither end nor beginning and becomes pure chromatic vibration, spread over the whole surface of the canvas — light, almost immaterial, and yet impenetrable.

In 1945–1946, under the surrealist influence which was then

172. Jean-Paul Riopelle, *Ventoux*, 1955.

very strong in New York (as we shall see later), Rothko painted
watercolors in which forms, barely traced with the brush tip,
arise and are immediately doubled, as if being sucked out by the
transparency surrounding them. These forms separated from
themselves seem to bear witness to the continuation of one
thing in another, which is not its shadow, or its reflection, but its
opening — the shifting which prevents it from being one thing.
It is as if his consciousness of the ambiguity inherent in a human
being and in things was driving Rothko to see the only possible
unity in the disappearance of the real, this being experienced
as a kind of submerging. Ever since then, no indication of form
has appeared in his pictures, and from 1948 onward he makes his
compositions look like a vaporous mass of colors.

In contrast to Rothko, certain painters (Jean-Paul Riopelle,

172 born in 1923, Jacques Germain, born in 1919) regard color as an
element of structure on which the whole picture rests.

Color is also dominant in the kind of abstract painting which
acquired, in about 1954, the name "tachism." In it, as the word
indicates, the form is a *tache*, or splash of paint — that is to say,
a mode of existence of color which chance can produce by
itself. The artist's will can, if need be, intervene to complete
this spontaneously generated form — the clearest example of this
attitude is given us by the paintings of the American artist Sam
173 Francis (born in 1923). In tachism the virtues proper to color —
its harmonies and its light, the complex play of its shades —

173. Sam Francis, *Blue
and Black*, 1954.

are totally respected: what the splash does call in question, simply by its presence on the canvas, is form as a pictorial element existing outside the instant at which it is realized on the canvas. And so the accent is placed on a factor which had never been important for European painting: time. The strict time taken to execute a form is now considered an aesthetic value.

In the United States this has given rise to *action painting*, or gesture painting. But before we discuss that extreme of abstract painting it will be well to trace the stages by which the factor "time" has made its appearance in European painting.

Abstract painting and the value "time"

It is in the work of Nicolas de Staël (1914–1955) and, to be exact, in the pictures he painted in 1946–1947, that one can best see how the time of execution intervenes in the very nature of the form in a painting. De Staël's pictures during that period were abstract, even though their titles sometimes evoke reality. It was because they were abstract that De Staël, with his characteristic passion and unsparing energy, felt the need to make the forms more eloquent. In his ardor he laid the colors on top of one another and saw that the passage of the brush left a visible trace in the thick layer of matter: so he could accelerate a form or slow it down, according to the way he put the color on. This internal tension which he communicated to his composition was simply time becoming space on the surface of the canvas. From that moment De Staël's problem was to seek and find a possible harmony between different tensions (or, one might say, different speeds): he reserved the slow forms for the parts of the composition conceived as being in the background—parts covered with smooth color that sometimes renders them almost motionless in

174

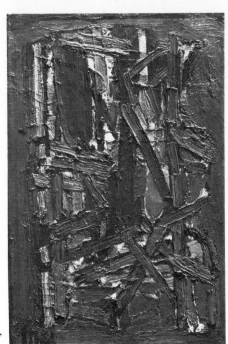

174. Nicolas de Staël,
Fractures, 1947.

comparison with the other forms. These are often thinned out, and cross the picture in all directions, each obeying the rhythm imprinted by the painter's hand and brush in the very matter of the color.

Throughout 1947 De Staël concentrated his efforts on this new element which had come into his painting. And it was from this starting-point that he elaborated his own style. Instead of the brush he came to prefer the knife, which gives still greater speed to the gesture of painting; and even when, later on, he did figurative paintings, each part of these always contained "time."

De Staël's experiments have often been compared to those of
175 André Lanskoy (born in 1902), which appear somewhat close to them. After a rather long career as a figurative painter, Lanskoy

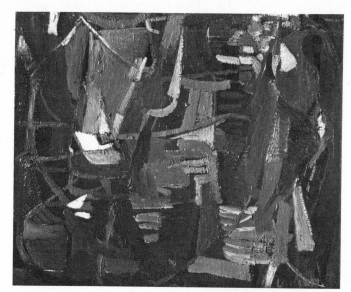

175. André Lanskoy, *Homage to Georges de la Tour*, 1946.

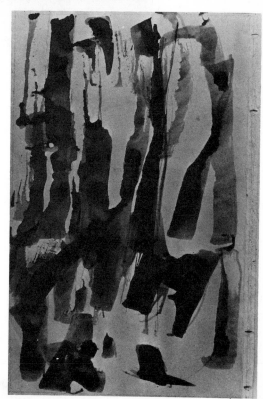

176. Hans Hartung, *Ink*, 1922.

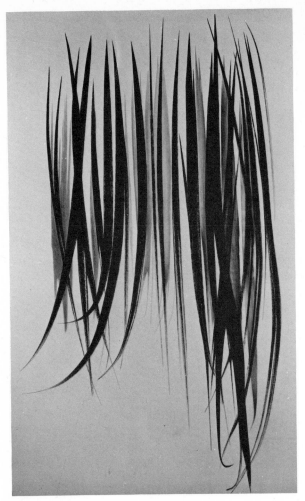

177. Hans Hartung, *Painting*, 1957.

began to produce abstract compositions full of fire — a fire that shows itself partly in the vivacity of the colors and partly in the precipitancy of the forms. But although in Lanskoy's work the composition becomes a wild rush, this simply reflects his tempera-

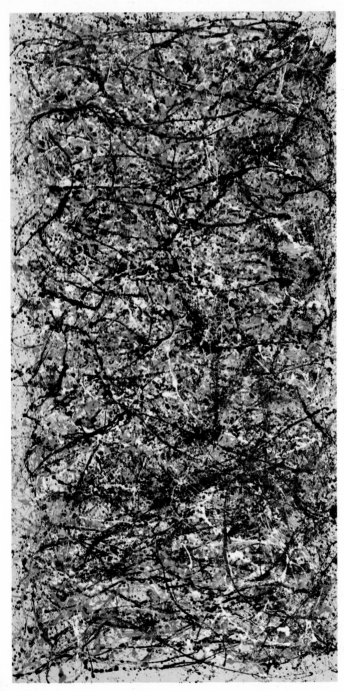

IV. Jackson Pollock, *One (Number 31, 1950)*, 1950. Oil and enamel paint on canvas, 269 × 532. Collection, The Museum of Modern Art, New York. Gift of Sidney Janis.

ment and is certainly not a conscious recourse to the value "time."
The purest expression of "time" meets us in the work of two
definitely abstract artists, Hans Hartung (born in 1904) and
Pierre Soulages (born in 1919), who seem to be attacking the
same problem from two opposite sides. In both these painters
there was from the first a spontaneous rejection of tradition—a
rejection which carried them away from the basic vision of

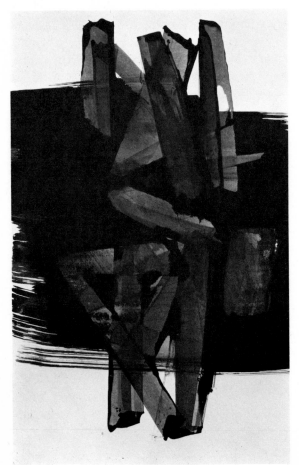

178. Pierre Soulages,
Painting, 1963

Western art and brought them, without their knowing it, close to
the painting of the Far East. We shall see that in other artists,
such as Tobey or Bissier, the knowledge of ancient Chinese and
Japanese painting worked what amounted to a conversion as
regards form itself, precisely because the value "time," till then
unknown to the Western artist, is for a Far Eastern artist the
mainspring of the gesture of painting; but this was not the case
with either Hartung or Soulages. Both of them arrived by intui-
tion at the plastic expression of time, and it was only afterward
that they discovered their affinities with the Far East.

In the case of Hartung, this development may have been deter-
mined by his early musical education. Music, obviously, is dura-
tion. Shaped by music, his sensibility reacted against any kind of
rigidity in plastic expression; but rigidity dominated art at the
time he was growing up, and he ran up against it in the decisive
moments of his development. Hence his acts of refusal: first he
decided not to go and study at the Bauhaus, after having heard a
lecture by Kandinsky which, in his judgment, was too systematic;
and again, in 1927, when he had already left his native Germany
to settle in Paris, he rejected the post-cubist view of art, dominant
at that time. And so this painter, unable to insert himself into any
stream, fell back upon himself and at length discovered, one after
176 the other, the elements of his own style, beginning with some
astonishing wash drawings with India ink, which he created in
1922. In these works of his extreme youth, Hartung plunged
instinctively into abstract painting, through simply searching for
a supple form. Out of this there gradually emerged the graphic
expression which is the foundation of his work. As if to stress the
177 presence of the line, Hartung conceives it as black, more and
more close and more and more tense and syncopated, till he
arrives at that line-form which visibly darts and passes and is time
written into the picture.

If Hartung's painting expresses duration, the tendency of Soulages, in each of his pictures, is to pin down the full instant. His gesture, like Hartung's, aims at capturing the same fugitive element, but he shows it caught in the briefest lapse of time, which reveals it, and which we call "present" — an infinitesimal fraction of time, whose plenitude Soulages asserts. In fact, looking at one of his paintings, one experiences its action as twofold and contrary: the form is rapid, altogether tense, but it is as

179. Pierre Soulages, *Painting*, 1947.

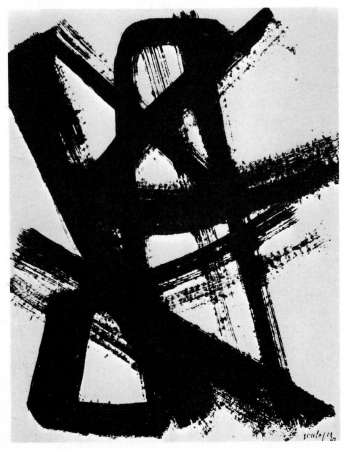

though its tension and speed were only internal, so massive and monolithic is the picture as a whole. And this is certainly not caused by the black which always predominates, but by the very constitution of the form — acting on us, as it does, like time, which is both impossible to capture in its movement and peremptory in the present instant.

178
179
In the work of Soulages the plastic structure of the picture is brought to a point where it ceases to have any reference to the past. In 1946, upon his first contact with Paris (he had lived in the country during the war), the young artist saw both that the teaching at the Ecole des Beaux-Arts was not right for him and that he was indifferent, if not hostile, to the painting of Picasso. This meant a double isolation, which removed him from all influences and forced him to become aware of himself. The result was to accelerate his development.

Violently anti-romantic, Soulages began by rejecting every form of effusion. His color would be black, and his favorite means of expression would be line. But since in his view any suppleness of line was expansiveness, therefore weakness, he took to the knife and the spatula in place of the brush. The color crushed by the broad instrument is no longer line but immediate form; and, what is more, within this form the same gesture that spreads the color can take it away. So light and shade come into being simultaneously, opposite to each other and yet, both of them, inseparable from the totality of the form, which stands out as a compact mass against the always light background of the picture. Hence the peculiar dynamism of Soulages's painting, which is much more complex than that of American action painting.

In the work of the artists just discussed, touch has disappeared, being absorbed by the painter's gesture, which becomes the expression of time on the canvas. But apart from this, the matter of the painting remains traditional. It is, on the contrary, the

pictorial matter itself that is called in question — and rejected — in the work of the pioneer of action painting, the American artist Pollock.

Action painting

The enterprise of Jackson Pollock (1912–1956) has proved to be one of the most exciting events in postwar art. A legend has grown up around his name: this was favored, certainly, by his accidental death at the age of forty-four when his experiments were in full spate, but it has arisen chiefly from the fact that thanks to him the United States has at last asserted its artistic independence, after having been till then a tributary of European art. Indeed the war years, a time of arrested development in European artistic life, were particularly favorable to the development of American artists: New York was then the only living artistic center, and in addition it was in the United States that several European painters of the first water took refuge; their presence was to play a decisive part in the awakening of the young American painters who, headed by Pollock, were soon to arrive at a new and personal vision of art.

181
182

The particular moment in American psychological development and a definite place — the war and New York — were at the basis of the Pollock phenomenon. Like most of the American artists a convinced expressionist, Pollock began by undergoing the influence of Picasso. But while there is vehemence in Picasso there is never excess — and it was excess that this young and enthusiastic American admired in the Mexican painters so much that for a time he was rather heavily influenced by them. Pollock's life at this period was pretty hard, and it was only in 1942 that he was at last able to give all his time to painting. His painting

frenzy redoubled, but in the New York climate it suddenly began to look old-fashioned: he was still painting as Americans had painted in 1938, but New York had changed profoundly since the beginning of the war. The presence of the foreign artists had polarized artistic life: on the one hand there was geometrical abstraction, which had become fashionable since the arrival of Mondrian and was to reach its culminating point in 1944 when the Museum of Modern Art organized a large exhibition of that pioneer of abstract art; on the other hand there was surrealism, given new life by the presence of painters like Max Ernst, André Masson and Matta, and of the poet André Breton. If surrealism won, this was because geometrical abstraction made the painters begin to have some doubts about the expressionism so deeply embedded in the American artistic temperament. Mondrian's strictness produced in the Americans a certain feeling of inferiority—from which surrealism helped them to free themselves, by enabling them to reintegrate their emotional side in painting through the mediation of the subconscious and the instinctive impulses. Such, very briefly, was the context in which Pollock made his appearance. His opposition to geometrical abstraction was as violent as could be—and it made his work perhaps even more feverish. The ferment which the influence of Picasso had deposited at the bottom of his work turned quickly into a paroxysm of expression which, looking for an outlet, moved into line with surrealist automatism and exulted at the sight of Tobey's graphism. At this point painting itself—traditionally involving oil colors, brushes, and a canvas placed on an easel—came to seem to Pollock an unendurable constraint, the more so because automatic writing had shown him the importance of the immediate gesture. And so Pollock's feeling of dissatisfaction with regard to the technique of painting—its slowness in relation to his painting frenzy—led him in 1947 to the *dripping* technique: the canvas is placed flat on the ground, and the piercing of a few holes in the

180

bottoms of cans of industrial colors (duco and aluminum paint) enables the painter to execute his picture by moving about and letting the color drop on the canvas. For Pollock this was the answer to prayer: he was at last, as he himself put it, "literally in the painting." He could paint till his breath gave out. Painting and instant were one.

It is relatively unimportant that Max Ernst was the first to use the dripping technique, relatively unimportant that Miró and Masson, a good many years before, had introduced automatic writing into painting, and that all the surrealists were aware of and rejoiced in the stimulating effect of chance in the course of the creative act: Pollock's gesture was, in spite of this, significant.

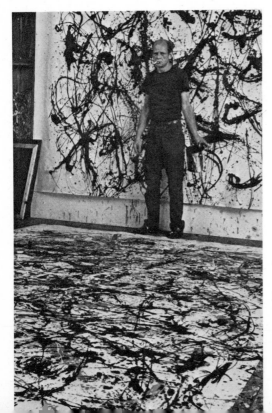

180. Pollock in his studio.

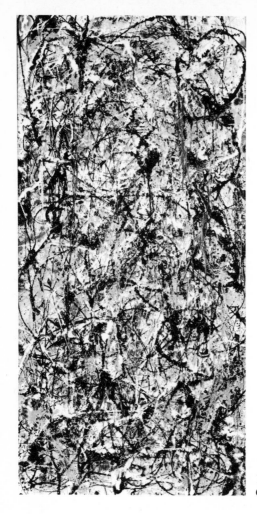

181. Jackson Pollock,
Cathedral, 1947.

While he drew close to surrealism, he also departed from it: for
the surrealists the subconscious is intimacy, for Pollock it is, in a
way, public domain; while they explore its most secret and per-
sonal windings, all that Pollock sees in the subconscious is its
aspect as vital energy in the raw. There is, in fact, in the con-

ception of painting by dripping a definite, bypassing of the individual—and, like a kind of recoil, an exaltation of this by-passing, which drives the painter to attack larger and larger canvasses, as though to make dimension stress even more the disappearance of all that Pollock rejects: all the subtleties and fine shades of traditional painting. In their place he has enthroned the metallic hardness of the industrial paints, whose "matter" he has set swinging in "time," which has caught it and transformed it into energy.

And so for five years of his life, from 1947 to 1952, Pollock did abstract painting in his own way—a kind of hand-to-hand fight with the canvas, with color and with form. Then he tried a new line, having no doubt understood that to make a clean sweep is not a painter's last word: beginning in 1953, he alternated the dripping technique and the traditional technique, and a few realistic motifs made a tentative appearance in his pictures. But death put an end to his researches.

In spite of this, Pollock's discovery soon had a considerable following in the United States, and later in Europe. Painting by

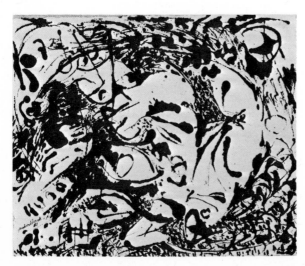

182. Jackson Pollock, *Drawing No. 132*, 1951.

183. Franz Kline,
Black and White, 1951.

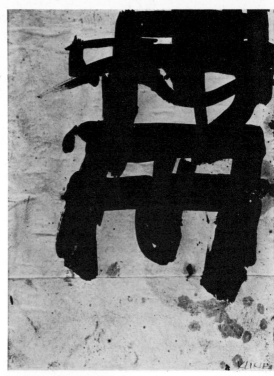

184. Franz Kline,
Study for Corinthian,
1957.

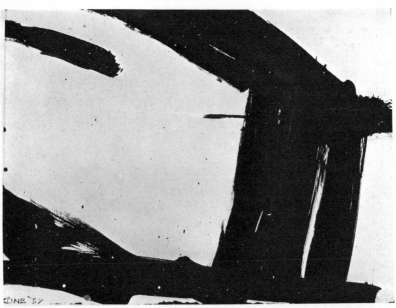

gesture—or "action painting," as the critic Harold Rosenburg was to call it in an article in *Art News* in December 1952—came to be regarded as America's essential contribution to contemporary art, and most of the American painters, whether figurative or abstract, became influenced by it. Among the abstract ones, Franz Kline (1910–1962) confined himself to an austere gestural expression, carried out almost exclusively in black and white. Some of his collages, which are among his earliest abstract works, betray the expressionist origin of this kind of painting, which is often close to that of Soulages but differs from it precisely because of its origin. Soulages's gesture-form might justly be called classical, in the sense that, free though it is, it never floods over: if it takes on breadth, this is because the artist is in control and governs the breadth. The opposite happens in the work of Kline: the impetus of his gesture yields to the expressionist—and romantic—temptation, which makes the form escape control. The result is grandiloquence, and since this is accompanied by the painting frenzy proper to action painting, Kline sometimes forces his gesture so much that it looses its initial intensity: the form gets out of breath and collapes at the first opportunity. Then its all-powerful liberty, instead of being enhanced (which is the point of action painting), becomes inadequacy of expression. For this reason one may prefer to Kline's large canvases the small-scale works of his early days as an abstract painter, in which a muted tension makes itself felt.

183
184

The informal

In France the reversal of values which makes technique the motive force of the image (as it does with Pollock) shows with exceptional strength in the paintings executed by Wols (1913–1951) during the last five years of his life. Was Wols at this period

187

abstract or not? The answer, or rather the impossibility of an answer, was best formulated by Sartre, when he described Wols's forms as "innumerable, rigorously individuated substances, which symbolize nothing and nobody and seem to belong simultaneously to the three natural kingdoms, or perhaps to a fourth unknown till now." Both the life and work of this German artist, known by the pseudonym Wols, were exceptional. After spending some months at the Bauhaus, he left Germany in 1933 and came to settle in Paris, where he earned a living by photography, and lived an extreme Bohemian life; then, in an internment camp during the war, he went back to drawing and painting. At first his drawings, heightened with watercolors and small in scale, were figurative. But gradually the world he depicts becomes dislocated, his line grows convulsive and is governed only by inner pulsations: this is no longer an artist thinking about form, but a man seeking to express something which has no form and yet exists—his anguish, his own incapacity for living. For Wols, painting tends more and more to become the expression of that tragic quality of existence which can be more easily rendered by writing. And so in 1946–1947, after the watercolors, there came into being his large-scale oil paintings, in which the color coagulates, runs, twists, and spatters, in which form is destroyed as soon as it appears. These are the antipodes of painting as Mondrian had meant it to be—anchored in the eternity of the visual laws. Opposed as they are to all lucidly executed pictures, even to the most spontaneous of them, Wols's pictures are certainly close to psychopathic art and possess its disturbing authenticity.

185

An art like this really owes nothing to the past. It is different. But it is so because of its extreme position. It annexes to art values which were excluded from it till then. And yet this development of painting is not a liquidation of the heritage received, but a leap to one side—and at the same time a reversal of values

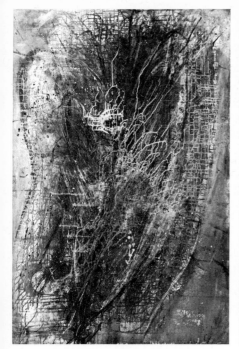
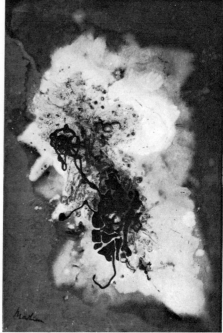

185. Wols, *Manhattan*, 1947. 186. Georges Mathieu, *Trudanité*, 1947.

in the sense that, for the first time, form is subordinated to matter. The aim is not now to realize on the canvas a form already conceived, but to let forms arise from the material of the painting.

Has this art, which was soon called "informal," brought us to the dawn of the greatest aesthetic revolution there has ever been (as some believe), or, on the contrary, into a blind alley?

To decide one way or the other is not possible here, but we can now — twenty years after informal art appeared on the scene — notice that the most interesting moments of this new way of expression have been its beginnings. In the informal period of Wols's work, which coincides with his last working years, the informal looks like the overture to something important; but it is already quite different with Georges Mathieu (born in 1921). *186*

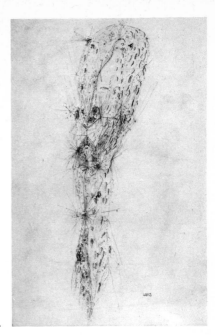

187. Wols, *Drawing*, 1944–1945.

A graduate in literature, he suddenly took up painting, and he has
the merit of having been one of the earliest, if not the first, to
recognize the value of Wols's work. He first came before the
public, as soon as the war was over, with definitely informal
pictures: in them some repressed obsession seems to spread over
the canvas splashes of color that have a viscous movement and
with threads of light running through them here and there, and
the label *Andrisme* must no doubt be interpreted in the same
sense. As long as Mathieu's pictures retain this character they are
touching in the way a personal diary can be touching. Later,
around 1950, there begins the calligraphic freedom which has
made Mathieu famous. But the elegance of his gesture now never
rises to the emotion which emanates from his first pictures —
timid, disturbed, and disturbing, in fact different. It is all very well
for him to squeeze the color directly onto the canvas from the

tube with increasing boldness: the fact remains that the matter of a painting, if it is not sustained by an extremely powerful current of emotion or obsession, falls victim to its own monotony. Only painting—that is to say, the lucid steering of the means of expression—makes it possible to escape this danger. But here such steering is excluded in advance.

It looks, then, as if the informal or calligraphic abstraction of the kind Mathieu aims at, has limits which are dictated by the matter itself of the painting. This brings out, by contrast, the essence of painting as a means of diversifying, refining, and going beyond the matter, of transmuting the inertia of color into harmonies, tones, light and shade. This passage from one to the other, this awakening of an awareness of painting which starts from its matter, comes out clearly in the development of another *188* abstract painter, Jean-Michel Atlan (1913–1960). A poet with a degree in philosophy, he suddenly, in 1944, took to painting some strange pictures: they show an imagination at ease in everything to which the normal technique of painting takes exception—pilings-on of colors, scrapings and rubbings; one can feel how he is caught up in that fascination which the matter of painting can exert over an intellectual accustomed to handling abstract notions. Unawares and in advance of formulation, Atlan was practicing informal painting, the form in his first pictures coming from their matter, which was the element of his excitement. But after a few years there arose in him, out of the very business of handling matter, a need for structure; and, with structure, painting (in the traditional sense) regained the upper hand—plastic problems came up and had to be faced. And so, beginning in 1950, we witness the formation of Atlan's style, with its striving to recover, by using the means of painting, that rough force and almost barbaric joy of which, in (so to speak) the wild state, he had received a foretaste from his contact with the matter of painting.

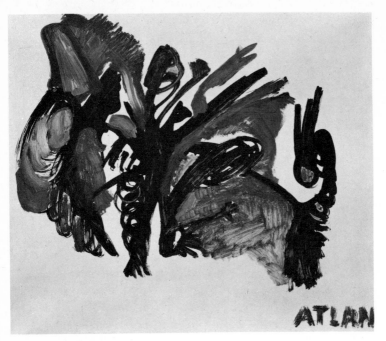

188. Jean-Michel Atlan, *Painting*, 1947.

Atlan's development shows how painting sooner or later assimilates informal expression—how, in short, repetition tends to empty of its substance the immediate, uncontrolled gesture; and Pollock also seems to have become aware of this, even though in the dripping technique "time" came in on equal terms with the material and certainly helped to give it life. But the resulting mistrust of the informal has had a stubborn opponent

189 in, for example, Jean Fautrier (1898–1964). Fautrier painted his first informal pictures, a series called *The Hostages,* while the war was still going on. They were exhibited in 1945 and attracted attention to the painter, who had worked in obscurity till then. And in fact the stress which Fautrier placed on the material of painting was altogether unusual at that time. His pictures, instead of enticing the gaze, repelled it, shut up as they were in

a kind of taciturnity and refusal—refusal of form, which was destroyed by the slumped mass of the piled-on paint, and refusal of color, reduced to *grisaille* by his washed-out tones. But the strength of this painting lay in ambiguity. Fautrier himself was to kill it, later, by turning it into a method, which he repeated faithfully and tirelessly to the end of his life.

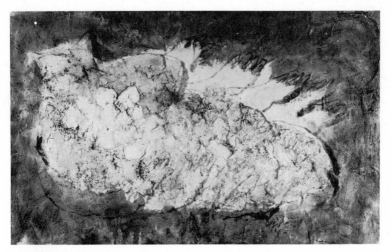

189. Jean Fautrier, *Hostage*, 1945.

The potentialities of the matter of painting are also at the center of the plastic experiments—sometimes figurative, sometimes abstract—of Jean Dubuffet (born in 1901). Dubuffet is *190* more aware than anyone that informal art (or "different art" or "art neat," as he prefers to call it) must never cease to surprise by its novelty: otherwise it at once becomes the victim of the narrowness of its limits. That is why this remarkably intelligent artist, with his great manual dexterity, strains all his ingenuity to

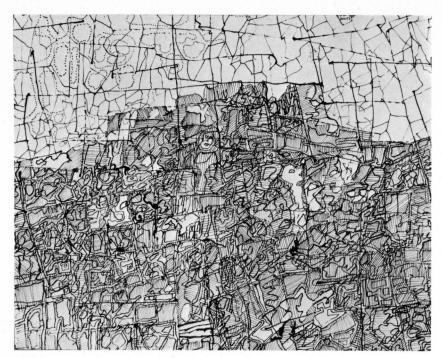

190. Jean Dubuffet, *Landscape with Sky Freezing over*, 1952.

bring more and more materials into use, to dissimulate them, to blend them, and to create an ambiguous matter perpetually renewed. But the danger he runs is that, the more desperately he tries to avoid monotony, the more he falls into artifice, while his painting gains every time it manages to be spontaneous.

Still with ambiguity as the keynote, other artists like the American Clyfford Still (born in 1904) display form as a rift: the Italian artist Lucio Fontana (1899–1968) does it by actual holes in the surface of his canvases. Others, again, remind us of the impenetrability of matter—for instance the Spaniard Antonio Tapiès (born in 1923), who is so fascinated by old decayed walls that he reconstitutes them in his pictures with a copyist's fidelity.

191

192

193

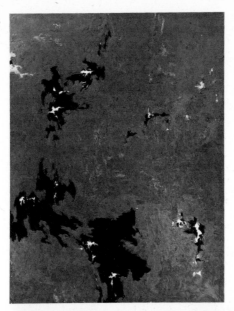

191. Clyfford Still,
Number 2, 1949.

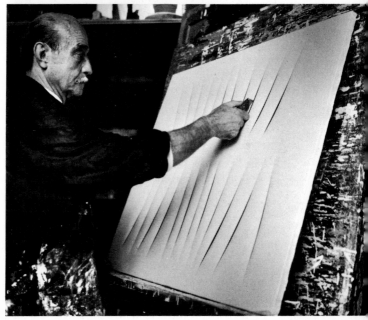

192. Lucio
Fontana working
at one of his
gashed surfaces.

193. Antonio Tapiès,
*Brown and Gray
No. LIX*, 1957.

And finally, the informal sometimes (like dada) sets anti-painting side by side with painting, as if to stress the obsolescence of painting and so to reject it. But in all cases, whether explicitly (as with Dubuffet) or implicitly (and with the more validity, as with Wols), the informal removes painting from its idealist halo. Matter is taking its revenge on spirit. It is a return to things (foreshadowed in the field of philosophy by phenomenology). And it is obvious that in this reversal of values the problem of abstraction cannot arise in the old way. The most striking example is given us in the works of Tapiès: these are totally realistic since they present themselves precisely as the surface of a wall, but this *trompe-l'oeil* wall inside its frame is, as an image, abstract. The fact is, matter is both abstract and concrete as long as the will does not intervene to give it a form. And here we are at what may be called the "zero degree" of abstraction, where abstraction is indistinguishable from figuration. While its character is ambiguity, it is at the same time one more tendency in contemporary painting in which the margin of abstraction is shown at its

culminating point, as an ambivalence – that is to say, an enlarge-
ment of the possibilities both of abstract form and of figurative
form, the two being indissolubly linked in the mind of the artist,
blending together for mutual enrichment.

The margin of abstract art

This margin of abstract art is apparent in the works of many
artists – including some of the most important of this postwar
period – who are not, strictly speaking, abstract and indeed do
not consider themselves as such, yet seem to be so for the simple
reason that they apprehend the real as a totality offered to the
mind and spirit as well as to perception. "Reality," one of these
painters might say, "is outside me. Apprehended by me, on the

195. Julius Bissier, *India ink
on Japanese vellum*, 1937.

194. Giuseppe Capogrossi,
Surface 290, 1958.

plane of the emotion produced, of memory and even of the visual impression, it becomes in me something else. And this is what I want to express." There is, then, in painting of this kind a direct bond with reality, and quite often some of these painters give strictly descriptive titles to their pictures. In different ways — all of them far removed from the very simple copying of a real object, which some of the informal artists practice — these painters are trying to do away with the screen that separates them from the outside world; and because their attitude to forms and colors would not have been possible without the successive achievements of abstract art, they will now be mentioned, at the margin of the abstract experiments.

The first attempts to envisage this kind of expression took place in the thirties; and what makes it not surprising that they should then have passed completely unnoticed is their overall orientation which, rejecting Western civilization en bloc, looked for some basis in the thought of the Far East. The thing to be rejected was the primacy of logic and of conscience — that rational and analytical image of man and of reality which antiquity and the Renaissance have transmitted to us and which twentieth-century art has called in question. Painting, music, and even literature had given more and more prominence to the part of human nature which escapes the control of the conscious. The instinctive forces have invaded artistic creation. The dethronement of pure intelligence has also revealed the limits of a civilization which took it as the supreme value. It was in this state of mind that certain Western artists turned to the Far East, not — like Van Gogh or Gauguin when confronted with the Japanese prints — in search simply of stylistic elements to borrow, but in order to find a teaching, a rule of life. Such was the attitude, around 1930, of the German painter Julius Bissier and the American painter Mark Tobey. Since that time the "imaginary museum," which André Malraux has made us conscious of, has considerably

widened our knowledge of the arts of the Far East: various young
European and American painters have been influenced by them,
and because the speed of communication has made art nowadays
highly international, a backwash of the same current has pro-
duced in Japan a revival of tradition, as the activity of the
Gutaï group shows. Painters in our day are tempted by ideas
that were unknown in European thinking about art — calligraphic
purity, and the sign or diagram; some of these painters, like the
Italian Giuseppe Capogrossi (born in 1900), try to give a Western *194*
version of them, while others, like Mathieu, are content to imitate
oriental form. But it is here that the antinomy between East and
West becomes apparent: in the Far East way of seeing, form
exists only as a function of content, each sign being the profound
expression of and relation between man and the universe. Bissier
and Tobey understood this.

Julius Bissier (1893–1965) was initiated into the arts and thinking *195*
of ancient China by his friend the sinologist Ernst Grosse and,
although he had never been in the Far East, the influence of the
Taoist doctrines led him to call in question his whole conception
of painting. In 1930 Bissier stopped painting abstract pictures in
accordance with the taste of the period. For seventeen years — up
to 1947 — he did only brush drawings with India ink. Cut off from
the world, a spiritual exile in his own country (Nazi Germany
horrified him), Bissier lived all these years withdrawn into himself,
his tense anguish having no outlet except the forms which came
and projected themselves in his brush drawings. (One of the first
to see and appreciate these was the philosopher Heidegger, a
friend of his youth.) In these austere works, living creature and
thing reveal their secret correspondences. First sketch and com-
pleted vision coincide, for all premeditation and all "will to do"
have been abolished.

After 1947 Bissier was ready to attack painting in the same

spirit, having perfected a technique of his own (egg yolk and oil tempera) which enabled him to wash over a color already laid on or to establish outlines that would enrich the color he placed on top. This procedure, which makes the color capable of carrying the form without circumscribing it, of carrying both a secret content and its vast abstract repercussions, gives Bissier's paintings a character that sets them apart. He called them "miniatures" on account of their small scale; they could as aptly be called microcosms.

The civilization of the Far East, which had managed, unlike that of the West, to cultivate and refine instinct and could, because of this, go beyond the strict categories of intellectual knowledge, exercises a profound influence over a man who is without question the most important American painter of today, Mark Tobey (born in 1890). In his case it was the substance of the Zen theories that gave rise to the spiritual elevation from which his painting proceeds.

Like Bissier, Tobey took a long time to become famous: the importance of his work was not recognized till after 1945, although by 1935 he had worked out all the elements of his style. He had also belonged, in his early days in Seattle, to what is called the Pacific School—a group of artists (including Morris Graves) who, instead of being open to European influences like their New York colleagues, looked, as Tobey did, to the Far East for instruction.

Of Tobey himself it may be said that his temperament predisposed him toward flight from the active materialism of Western civilization, which reaches its paroxysm in the United States. Indeed if one studies Tobey's work as a whole (his portrait of Wymer Mills, dating from 1917, is revealing in this respect), one sees that right at the start of his career this exceptional painter, working within an evanescent range of means, is seeking, even

under the most realistic features, to bring out states that are inter-
mediate between dream and reality. It is as if, in his pictures,
reality were taking to the open, having been called upon to reveal
something other than its own appearance. It is evident that Tobey,
confronted with the real, feels a need for an inner expression, a
further content. And for this the European aesthetic tradition,
whether past or recent, is of no help. Like every person who has
broken with his own time, Tobey is "elsewhere"—which indeed
explains the slow consolidation of his style of painting and also
the attraction which certain oriental mystical doctrines had for
him.

In 1934 he was at last able to go to China. From there he went
to Japan and lived for a month in a Zen monastery at Kyoto.

196. Mark Tobey,
Broadway Norm, 1935.

197. Mark Tobey, *Broadway*, 1936.

There Tobey had a clear vision of what he had always been seeking: "One time," he wrote, "when I was sitting just outside my room, which looked out on a small secluded garden full of flowers in bloom, with ballets of dragon flies floating above them, I had the feeling that that little world, almost under our feet, had its natural value, that one's job was to realize it and appreciate it at its own level in space." Deep down in him, Tobey had felt the unshakable connection between the infinitely small and the infinitely great. As soon as he was back in Europe the renewal of his painting became manifest. In 1935 he painted a small tempera picture called *Broadway Norm,* which is nothing other than the symbol for Broadway—a line that has neither beginning nor end,

198. Roger Bissière, *Journey to the End of the Night*, 1955.

unrolling without respite and making a complex arabesque. This was the first appearance of that "white writing" which is characteristic of Tobey's work: he was to develop it chiefly from 1940 onward, and we have already noted its influence on Pollock. But to Tobey completely abstract white writing is not an end in itself: one need only compare *Broadway Norm* (1935) and *Broadway* (1936) to perceive the suppleness of his method and how indifferent he was to the watertight compartments we set up between abstraction and figuration. Whether he is using the sign alone or spontaneously attaching the sign to some concrete form, Tobey is in both cases expressing what to him is the content of reality: a movement woven into the depth of time.

197

198

Another painter whose work succeeds in overcoming the intellec-
tual desiccation of the thirties is the Frenchman Roger Bissière
(1884–1964). He too, like Tobey and Bissier, found his true way
very slowly. But in him the great change took place far away from
any cultural support, in direct contact with nature. In 1939
Bissière left Paris and went to live in his old family house, in the
center of France; there he stopped painting and for five years lived
the life of a farmer. This acceptance of the most unpretentious
physical routine acted on him as a return to the source, and this
artist, till then fascinated by the cerebral side of cubism, redis-
covered the freshness of instinct. In 1945, when he went back to
painting, the past had been erased from his work: a deep lyricism
had replaced the rigor of his earlier pictures, and his freedom was
so great that to "giving an account of emotions" he preferred "re-
creating their causes." As he himself put it, "instead of shutting
up a pictorial effect in a form," he now started from a pictorial

201. Charles Lapicqee, *Boat Racing*, 1946.

200. Maurice Estève, *Copenhagen*, 1959.

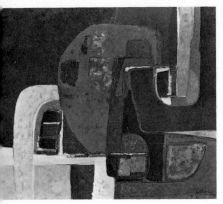

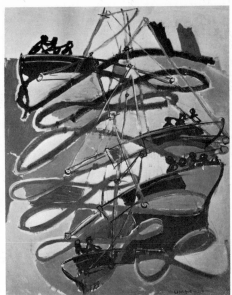

effect and gradually gave it a form—the form of an emotion which always had its origin in nature, in the life that bound Bissière to the reality surrounding him. By a quite different route, in the solitude of his withdrawal to the country, he had reached the same point to which Bissier and Tobey had been led by their Far Eastern influences—the point where life and painting come together in a single flux, where the very movement of existence governs the form.

This attainment of freedom, which favorable circumstances enabled Bissière to achieve at one go, has been a gradual affair in the painting of certain other French artists, such as Estève, Bazaine, and Manessier—the more laborious for them since the hold of cubism over them was stronger. In the case of Maurice Estève (born in 1904) the escape from cubism first took the form of an irrational superimposition of planes, made possible by that

200

transparency of color which is Estève's secret; in later pictures these colored planes are spread out into a single surface, and transparency turns into light—that is, into a confrontation of pure colors)and now the aim of each one of Estève's pictures is to give rise, over against reality, to a world just as real and as dense as it is, but governed by painting.

199 Alfred Manessier (born in 1911) bends his efforts to re-creating an order through allusion: he demands of the picture that it should be, first and foremost, the expression of an atmosphere, and in this direction one of his earliest successes is the painting called *Morning Space.*

202 As for Jean Bazaine (born in 1904), he has described better than anyone what he is doing: "To take part with things does not mean shutting oneself up in them by identifying oneself with them . . . it means introducing oneself into their duration, introducing a living, moving duration, a time of structure, into their arrested space." Far removed from abstraction, which in its extreme form seems to him "a lifeless geometry," his dream is of an act of painting that will make the rational barriers fall away, that will be like "the gesture of nature drawing, with one and the same impetus, the movements of tree, water, or clouds."

201 The painter Charles Lapicque (born in 1898) was at one time closely linked with this group of artists; he has now gone back toward an obvious figuration, after the interesting abstract experiments he made around the fifties.

Among these painters working in Paris a special place must be given to an artist who has elaborated a very strong personal style, *203* Maria Helena Vieira da Silva (born in 1908). The development of her painting since 1947 shows us the represented subject departing gradually more and more from its realist aspect; and, as this distance takes effect and the forms become dovetailed, there emerges a feeling of anguish which modifies the technique. The

brush sometimes presses the canvas, sometimes scarcely touches it; the touch quivers, checks its impulse, resumes its path further on; discontinuous lines overlap, open out space and close it. Towns, streets, their inextricable tangle—these are the favorite elements in a style of painting for which nothing has an end, nothing a beginning.

Like Vieira da Silva, the American painter Philip Guston (born in 1912) gives his touch the utmost possible sensitiveness in order to make it the vehicle for the strong emotional charge from which his pictures originate. But his touch is as though eaten by some disquiet. It is this disquiet that Guston's palette expresses, with its strident tones and the cunning progress of certain colors, which may be thinned out or may flood over others without ever escaping from their indecision. *204*

Another quality that distinguishes Guston among his American

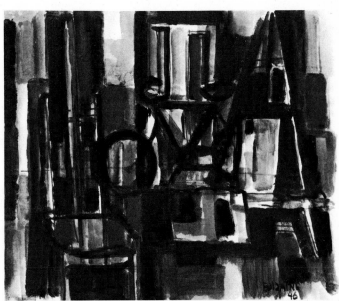

202. Jean Bazaine, *The Studio*, 1946.

203. Maria Helena Vieira da Silva, *The Gare Saint-Lazare*, 1949.

204. Philip Guston, *Zone*, 1953–1954.

colleagues is his sense of fine shades, his search for subtlety of
expression. This is also to be found in the work of Jack Tworkov *206*
(born in 1900). But it is something that postwar American paint-
ing seems generally to reject — not always without setting up some
painful conflicts, as in the case of Robert Motherwell (born in *205*
1915). This artist — perhaps the most lucid American painter of
his generation — seems to me to be dominated by the violent
desire to oppose the European tradition yet at the same time highly
sensitive to its values. Determination to go beyond the cubist
morphology for the sake of a more spontaneous expression is
complicated, in Motherwell, by the psychology peculiar to the

205. Robert Motherwell,
Little Greek, 1960.

206. Jack Tworkov,
Thursday, 1960.

207. William Scott,
Orange and Blue, 1957.

208. Arpad Szenès,
Islands to Leeward, 1962.

American postwar artist, who must at all costs assert his autonomy
with regard to Europe, even when his own personality is in fact
very close to the European artists, especially the French ones.
The result is that deep self-division which is apparent in Mother-
well's work. He passed from the cubist influence to the contrary
influence of surrealism, only to reject both of them, in the end,

as a cumbersome tutelage, and has settled down among flat monochord tints which seem to express a muted desolation; the liveliest part of his work consists of his collages — above all the ones in which he uses torn papers.

The sweeping abridgment of form to which Motherwell returns constantly in his painting is evident also in the works of his compatriot Adolph Gottlieb (born in 1903), and in the even more subtly epitomizing vision of the English painter William Scott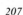

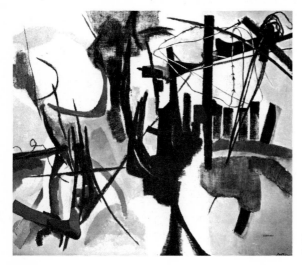

209. Giuseppe Santomaso, *Green Memory*, 1953.

(born in 1913). This method of ellipsis achieves an exemplary plastic purity in the recent landscapes of the French painter Arpad Szenès (born in 1897). The diffused lyricism expressed by *208* Szenès in his paintings, with their predominance of grayish-whites and ochers, had made itself felt in the pictures of the Italian Giuseppe Santomaso (born in 1907) before he was attracted *209*

210. Olivier Debré,
Black in Blossom, 1959.

211. Jean Messagier,
Ribbed July, 1960.

by gestural painting. Lyricism, but with much more tension, likewise distinguishes the paintings of two Frenchmen, Olivier Debré (born in 1920) and Jean Messagier (also born in 1920), who conceive form as an entirely unconstrained relation between the painter and the real.

210
211

Part 4 / **Conclusion**

I

This rapid survey has aimed simply at indicating the main lines of the last phase of abstraction—a phase that is not yet finished and is indeed highly confused since, against all logic, it compels us to speak of figurative abstraction or of abstract figuration, or else simply to say that the pure abstract art of the years before World War Two has been succeeded by a sort of non-figuration. Whatever term the future chooses (or invents) to describe this, it is certain that our Western thinking, when called upon to define these new forms we are now witnessing, experiences them as a contradiction.

But although the recent development of art has had the effect of reviving this contradiction, it did not create it. The contradiction exists germinally in the very formula "abstract art," as this has emerged in our vocabulary. Usage and time had blurred it, indeed, to the point of making people forget it, but now we are being reminded of it by art itself.

There is nothing surprising in this. All formulae which language jibs at and usage consecrates are highly revealing. Think of the words with which the other tendencies of modern art are designated: the word "fauves" is simply a symbolic image, "cubism" scarcely a metaphor, "surrealism" a clear signpost; experience went with the grain of the language instead of straining it. But on the day when, to define certain forms, it became necessary to put "art" and "abstract" together in a single formula, this went clean against the grain. Language and logic were put to the test, and the use of a contradiction to name an art whose existence was a fact, and then the adoption of that contradiction, have marked a break — the break at that part of our life which we feel to be out of tune with the past and which, looked at objectively, represents the twentieth century.

The idea of the pre-eminence of any historical period, such as the Renaissance, that has succeeded in deepening and widening the rational understanding both of the world and of man, is so much alive in every mind that the emergence and spread of abstract art should not be disturbing: we are, after all, the direct descendants of the humanists and also of Descartes. This heritage may make it hard for us to encounter abstract art without a jolt, but does help us to approach it.

The previous pages have shown that, when we follow the development of abstract art stage by stage, it is clearly much more than just a tendency of modern art, it is a phenomenon. It has that amplitude and that complexity. Without any doubt a history of abstract art would at present be premature; but there can also be no doubt that it is essential to question those abstract forms which men have been painting and sculpting now for more than half a century: art, because of its immediate action, is surely one of the best places at which to find out the truth about a period.

The philosophy of abstract art

As soon as thought envisages an abstract art, there arises as an indispensable support the notion of reality. It might be objected — hastily and within the strict limits of aesthetics — that the abstract art we see about us departs from reality, as this was represented in Western art during the nineteenth century. If abstract art were just a tendency and not a phenomenon it would be enough, by way of explanation, to refer to the example of Mondrian: starting from a chosen piece of reality, he progressively purified it and arrived at an abstract image, which later developed according to its own laws. This — taking such an example and making it the rule — is more or less the explanation that was given us by the first exponents of abstract art. But although it was satisfactory to those who had experienced the first coming of abstract art, it is no longer so for us who, since the war, have been watching a radical transformation of abstract form — a decline of abstraction as it appeared at first, self-evident and pure, but also a second growth of the abstract within figuration, as shown in the work of a number of important artists. These artists, who were studied in the last chapter, are certainly not abstract — whether we take Wols, Tobey, or Vieira da Silva, or any of the others mentioned along with them — and yet the forms they create do not contain a recognizable reality. They are forms connected closely with reality — but what is this reality which is not the same as the one we see? What is this plastic structure which inescapably disturbs the structure of our thinking, because it forces us to admit that figuration does not mean realism?

This dissociation being an accomplished fact, it is no longer enough for us to explain abstract art as a departure from reality. The notion of reality is what has to be reconsidered, even if something inveterate in us is opposed to this. The way in which

the progress of art as a whole has changed course since the beginning of the century—this end of realism and its replacement first by an explicit abstraction and then by an implicit abstraction. In short this cunning persistence of the abstract vision, even more disturbing when in the guise of figuration—forces us to analyze the very image of reality, going outside our habits and beyond accepted ideas. In relation to men's consciousness, art is surely always like a seismograph. In what deep strata, then, has the displacement occurred that has produced abstract art?

To answer this question it is necessary, I think, to go back in time.

The kind of reality that abstract art is bringing to an end is precisely the one which gained the upper hand in the fifteenth century and was clarified completely in sixteenth-century Italian painting. That way of representing the world which filled the men of the Renaissance with pride and was to dominate artistic expression till the end of the nineteenth century is the most perfect and coherent embodiment of what the abstract work of art is essentially calling in question. We know what brought it into being and, in due course, established its strong position: this was man's confidence in the absolute power of his intelligence to achieve its mission of unveiling the external world. From the fourteenth century onward direct observation prevailed, and it relied on the one means then capable of preserving its conquests: the hand of the artist. Art and knowledge went together. The painter *expressed* in proportion to what he discovered. And it did not take long for men to glimpse, through the forms they discovered, infallible norms, an infallible method and system: as linear perspective became indispensable in painting, it was at one and the same time figuration of space and scientific certainty. This is why the resulting realism has come to constrict our minds— European minds—like a crust, and why in the end it made us confuse its data with the conception of reality itself.

And yet, as early as the middle of the sixteenth century, art began to be separated from science. After Galileo had supplied proof for the guesses of Copernicus, which the Roman court denounced as heretical, he recanted—but he knew that the earth still revolved. The autonomy of art asserted itself. Its forms continued on their way. Various styles came to birth and died in Europe, but the visual laws established by the Renaissance remained unshakable. In our eyes reality remains attached to the data which tradition and routine converge to maintain: strange as it may seem, we are rooted to the ground from which aesthetic experiment took off more than half a century ago. If it is inevitable that most people should be behind their times, it is obvious that the distance behind is increased whenever there is some real break. If ever there was a break concerning civilization itself, surely we have it in precisely this inadequacy—which one is aware of as soon as one tries to understand abstract art—of the categories of the past to the judgment of the present.

But the great obstacle to our becoming conscious of this rupture is the power which the Renaissance still has over us. Its way of seeing continues to cloud our minds. And yet, even if it is hard for us to imagine that there can be any other way of seeing, we do possess a means of escape from it: this is by taking the trouble to go around it and to return to its origin, to the point where what has been called the Renaissance and its way of seeing were themselves neither more nor less than a rupture with the period that preceded them. Then only, by seeing how one period breaks off from the other, shall we be able to realize that the relation of the Renaissance to the Middle Ages is analogous to the relation of present-day abstract art to the Renaissance.

Perspective had pierced the one-dimensional colored backgrounds of medieval painting, even though these solemnized the inviolable mystery of Creation sealed by God, and three-dimensional space—the *reality* which had then arisen—was

certainly as new for the people who lived then as the reality of abstract art is for us. But because this new reality was at the same time knowledge as opposed to faith, and because this objective knowledge (which later became science) at first went along side by side with art (its subjective twin), this initial bond between art and science has continued to condition the minds of us Europeans. Subjectivity disturbs us, objectivity reassures us. We need to believe in an objective reality, to see it in front of us. We are convinced, unconsciously, that art has as its corollary reality as the Renaissance saw it, as though this were fixed once and for all. This is why we are so at a loss when we have to envisage an abstract art, an art which has shed its traditional corollary, the more so since subjectivity, in expansion ever since romanticism, has reached in the abstract works of art an extreme that, to be counterbalanced, demands of judgment an equally strong objectivity. As long as this is lacking, our thinking will be out of balance, and this will make us treat abstract art with criteria that belong to the past: we shall be tempted — our way of thinking will lead us, if only by the force of inertia — to take as our term of comparison precisely that reality which abstract art is busy eluding.

That is where the contradiction between "art" and "abstract" lands us. Anyone who wishes, in full awareness, to overcome it has no choice but to *presuppose* a kind of reality that is a break with the past as the reality of the Renaissance was in its time, a *reality to come*, and to look, by analogy, for the objective bases for this in science — which, let us not forget, was continuous with the art of the Renaissance at the moment when it rejected the medieval way of seeing. So confronted with present-day science, art would remain abstract and yet resume its traditional function as mirror, as soon as what was in it was found to exist outside it. Reference to the content of science would re-establish

And yet, as early as the middle of the sixteenth century, art began to be separated from science. After Galileo had supplied proof for the guesses of Copernicus, which the Roman court denounced as heretical, he recanted — but he knew that the earth still revolved. The autonomy of art asserted itself. Its forms continued on their way. Various styles came to birth and died in Europe, but the visual laws established by the Renaissance remained unshakable. In our eyes reality remains attached to the data which tradition and routine converge to maintain: strange as it may seem, we are rooted to the ground from which aesthetic experiment took off more than half a century ago. If it is inevitable that most people should be behind their times, it is obvious that the distance behind is increased whenever there is some real break. If ever there was a break concerning civilization itself, surely we have it in precisely this inadequacy — which one is aware of as soon as one tries to understand abstract art — of the categories of the past to the judgment of the present.

But the great obstacle to our becoming conscious of this rupture is the power which the Renaissance still has over us. Its way of seeing continues to cloud our minds. And yet, even if it is hard for us to imagine that there can be any other way of seeing, we do possess a means of escape from it: this is by taking the trouble to go around it and to return to its origin, to the point where what has been called the Renaissance and its way of seeing were themselves neither more nor less than a rupture with the period that preceded them. Then only, by seeing how one period breaks off from the other, shall we be able to realize that the relation of the Renaissance to the Middle Ages is analogous to the relation of present-day abstract art to the Renaissance.

Perspective had pierced the one-dimensional colored backgrounds of medieval painting, even though these solemnized the inviolable mystery of Creation sealed by God, and three-dimensional space — the *reality* which had then arisen — was

certainly as new for the people who lived then as the reality of abstract art is for us. But because this new reality was at the same time knowledge as opposed to faith, and because this objective knowledge (which later became science) at first went along side by side with art (its subjective twin), this initial bond between art and science has continued to condition the minds of us Europeans. Subjectivity disturbs us, objectivity reassures us. We need to believe in an objective reality, to see it in front of us. We are convinced, unconsciously, that art has as its corollary reality as the Renaissance saw it, as though this were fixed once and for all. This is why we are so at a loss when we have to envisage an abstract art, an art which has shed its traditional corollary, the more so since subjectivity, in expansion ever since romanticism, has reached in the abstract works of art an extreme that, to be counterbalanced, demands of judgment an equally strong objectivity. As long as this is lacking, our thinking will be out of balance, and this will make us treat abstract art with criteria that belong to the past: we shall be tempted — our way of thinking will lead us, if only by the force of inertia — to take as our term of comparison precisely that reality which abstract art is busy eluding.

That is where the contradiction between "art" and "abstract" lands us. Anyone who wishes, in full awareness, to overcome it has no choice but to *presuppose* a kind of reality that is a break with the past as the reality of the Renaissance was in its time, a *reality to come*, and to look, by analogy, for the objective bases for this in science — which, let us not forget, was continuous with the art of the Renaissance at the moment when it rejected the medieval way of seeing. So confronted with present-day science, art would remain abstract and yet resume its traditional function as mirror, as soon as what was in it was found to exist outside it. Reference to the content of science would re-establish

the balance, at least for philosophy, and the reality contained in abstract art would become conceivable.

Abstract art and the findings of science

When one turns to the sciences it is striking to find that in the higher spheres of physics, the purest science of nature, the word "real" is no longer current. It has fallen into obsolescence. There too, just as in art, the finite and limited character of realism belongs to the past. As a means of description it is too sluggish to catch that movement in which the external world incessantly makes and unmakes itself: it would be an artifice, an empty manner, nothing more. For nothing in the findings of science corresponds any longer to that reassuring objective presence which we still — for how long now? — call reality.

That science has reached the point where the reality to which it was accustomed has lost its distinguishing marks is clear when we look at the stages through which scientific research has passed. Toward the middle of the nineteenth century, physics took on a new look: it began to depart from its traditional course. The change took the form of a tendency to exclude direct observation, inaugurating a type of investigation in which the rigid data of experimental realism became gradually blurred — as did those of pictorial realism in the impressionist pictures. Translated into a parallel image, the real loosens: remember Monet's last works. Meanwhile, at this period, physics was "defining and extending in all directions the knowledge of the phenomena that take place on the human scale." (Was not the human scale, in painting, the safeguard of the object? If a painter like Cézanne or Seurat analyzed the object, he nonetheless respected its integrity.) And yet that world within range of the eye was doomed. Its stability was revealing itself as illusory: this was proved by wave

mechanics, which replaced the Newtonian system, and Max Planck, whose name remains bound up with the quantum theory, explained the passage from one to the other in this way: "Just as classical physics spacially disintegrates the system, considered in its smallest parts, and thereby reduces the movements of material bodies to the movements of their material points considered *a priori* as invariables, so quantum physics disintegrates every movement into periodical material waves..." The conclusion may be beyond the uninitiated, but an attentive reader can hardly help seeing in that notion of "spacial disintegration" the very operation cubism was carrying out at the exact moment when it arrived at abstract forms, an operation that was close to and yet still separate from the strictly abstract experiment.

In painting, the threshold between figuration and abstraction, or the hinge between them, was precisely cubism's analytical curiosity, which reduced the object to an abstract form and yet continued to presuppose reality as our senses perceive it. Even when Braque and Picasso, in the pictures they painted in 1912 and 1913, regroup the forms that have emerged from a preceding analysis into a synthesis, and when the picture as a whole takes on all the appearances of abstraction, a definite and known object is still the origin of the picture—now modified insofar as it no longer accepts the real as it is, but transposes it. The consequence is that, in cubism, the central role of the senses remains uncontested. On one hand the painter, on the other reality. Between the two, to unite them, perception.

But abstract art begins at the moment this bond is broken.

In the field of physics, research struck at the past as soon as it began to situate reality beyond the perceptive faculties. Even since the last century the structure of the world of physics has,

to quote the words of Planck, "not ceased to move away from the world of the senses, thus gradually losing its original anthropomorphic characteristics." "The human eye," says Planck, "is no more than a fortuitous reactor, a very sensitive one, to be sure, but also very limited, for it only perceives radiations within a short region of the spectrum, extending over barely an octave." The senses being thus dethroned, what was left to the man of science except the possibility of acceding by way of abstraction to regions where the senses had no access? In spite of this, abstraction seemed at the start to have only a complementary value: it carried on perception from a certain point where reality went beyond its range. On this side of that point, within the restricted field of perception, the external world continued to exist, equal to itself, with its immutable "objective" conformation standing opposite human subjectivity.

212. Vineyards on the right bank of the Dordogne.
From *L'Image en souffrance* by Georges Duthuit.

But this situation was due to end, in its turn. From the fact of being limited—infinitely limited—in relation to the totality of the real, perceptions were misleading: the image of reality revealed to us by them was an illusion. This is what Albert Einstein was to prove, when in 1905 he formulated the first part of his famous relativity theory. Space and time were one. Though concretely measurable, this other space and other time which order our daily experience were shams, pure conventions. Perception was the victim of deception, while the intellect was aware that there was only a single shifting unity, of space plus time plus energy. There was only one bond between it and man: abstraction. Conceiving replaced seeing.

From that point onward scientists could justly describe the former realism as naïve. So could art historians. By those secret intercommunications that exist between the various activities of a period, between the discoveries of the mind and those of the senses, the very first abstract watercolor painted by Kandinsky in 1910 (color plate, number I) has less affinity with the fixed three-dimensional space of the nineteenth century than with the shifting space-time unity conceived by Einstein.

In this painting the imagination, freed from all ties, is sheer impetus. It stretches the forms, propels them, exalts the colors. It is as though the unconstrained space of abstraction demands this launching into lyrical flight. For several years after that, Kandinsky's pictures developed in an atmosphere of joy, until the liberty which had been won made its backlash felt. What form did this backlash of abstraction's liberty take? An increase of lucidity and a new, possibly superhuman ambition: the ambition to attain an absolute form. A will to order now makes its appearance. The painter questions the new space, appeals to geometry, and dreams of visual laws. The passionate reliance on the circle, the square, and the right angle is an unmistakable sign of the

faith which animated the great pioneers of abstract art — faith in a primary, universal form: Mondrian aspired to it even more than did Kandinsky, but Malevich had already, in a single rush, given a foretaste of its limits when in 1918 he painted his *White Square on a White Ground.* Malevich, however, lived in Moscow, and his disturbing message was slow to reach the West. In the event, no painter was destined to put his finger on the origin and the end of abstraction as he did, and science alone would echo his premonition.

In the physical sciences, the unprecedented uprush let loose by Einstein's discoveries passed through various phases, which correspond with strange closeness to the course of abstract art. First came the euphoria caused by increased lucidity — pride in knowledge that had grown immensely more lithe, capable now of dealing with the subtlest obstacles; and also the full ambition that went with that. How can one help comparing this with the parallel ambition of abstract art? During the twenties, when the abstract painters were trying desperately to find a geometrical absolute that would express the visual world, the physicists believed firmly in their power to reach the ultimate constituent of matter and so to enclose the external world, from the infinitely small to the infinitely great, within a single law. There was nothing absurd about such a desire, since the bond between the two infinities had already been laid bare, and since science had apprehended the constitutive analogy that exists between the solar system and the ultimate layer of matter. But in 1927 Heisenberg announced the "uncertainty principle," the physical law which takes away the hope of arriving at a final certainty. The great loop thrown wide at the beginning of the century remains wide open. The limit is the limitless, Malevich's "white on white," that form which is but does not exist, just as, at a temperature close to absolute zero, "matter is but does not exist."

213. Mosaic structure of a crystal of sodium chloride, observed with an electron microscope.

The way of abstraction was clearly leading too far. If one applies to art Max Planck's quiet statement, that "in this aim at an absolute reality, and the inability of science to attain it, the irrational element inherent in scientific activity resides," one sees at once how heavy with consequence it is.

Once the geometrical stage of abstract art was over, culminating shortly after 1930 in the large-scale movement "Abstraction-Création," the irrational broke in, and has given rise since 1945 to the various tendencies we have discussed, in which abstraction, without being called that, survives under the most diverse guises. All these tendencies—whether tachism, the informal, action painting, calligraphic expression, or even figuration—take form as by nature not predominant, not foreseeable, not to be pinned down—and yet decisive, a sovereign result whose first cause is out of reach. The imagination, excited to the highest degree by its glimpse of abstract space, which it has recognized but not brought under control, becomes doubly disquieted and seems to take upon itself, almost literally, the task which Louis de Broglie assigned to science: "To satisfy the curiosity of the human mind,

it is not enough to know how material bodies behave when taken as a whole, in their global manifestations, how the reactions between light and matter achieve their play when observed in quantity; it is essential to get down to details, to try to analyze the structure of matter and of light and to define the elementary acts whose agglomeration gives rise to the global appearances."

This is unmistakably the true image of postwar abstract expression, of that latest phase in the evolution of the abstract whose perplexed contemporaries we are. These forms, which seek to express "the elementary acts whose agglomeration gives rise to the global appearances," are no longer abstract in intention, yet they carry abstraction in themselves as an inner value inseparable from their substance. And as for the insoluble ambiguity which distinguishes them, this also is not unreality but reality as science now depicts it, touched, even (so to speak) contaminated by abstraction, having become that discontinuous mass — simultaneously absence and presence — which can be described, as Stéphane Lupasco has said, not as "element, but as event."

Whereas formerly the senses established a definite bond between man and the outside world, abstraction has dug an abyss. Every path is a detour: a detour in relation to the convincing simplicity of bygone custom, a vertiginous short cut toward the future. Modern physics, having ripened through the patient observation of natural phenomena, produced a salvo of prodigious discoveries as soon as it was set on the path of abstraction; and, as it neared the peak, it did not hesitate to make the confessions expressed as follows by Werner Heisenberg: "... This new situation in modern natural science shows us that we can certainly no longer consider as 'a thing in itself' the building-blocks of matter, which originally were held to be the objective reality, that they escape from any attempt to pin them down objectively

in space and in time, and that still, fundamentally, the only object of science at our disposal is what we know of these particles. . . We find ourselves in the middle of a dialogue between nature and man, of which science is only one part, so that the conventional division of the world into subject and object, into inner world and outside world, into soul and body, is no longer applicable and gives rise to difficulties. For natural science . . . the subject of research is therefore no longer nature in itself, but nature subjected to human interrogation, and to this extent man . . . here meets only himself." And finally, Heisenberg's conclusion: "For the first time in history, man finds himself alone with himself on this earth, without partner or adversary."

If this extreme widening of the scope of abstraction, which is now hemming man in on all sides, can be *put into words* by science, this is because the speciality of science is precision. Even uncertainty is formulated and becomes certainty, a certainty of the uncertain. It occupies the place of the demoted reality, outlines the void at the point where the values that were considered absolute have sunk. Is it any wonder that the abstraction which is melting that reality down — abstraction to the power of two, so to speak — should now determine artistic creation as a whole, far beyond abstract art itself? The necessity of going beyond an expired realism compels form to take risks — even if, for lack of an objective support of any kind, it pursues its adventure in the midst of its own self-questioning.

This side of abstract art and beyond it

At a scientific congress in 1927 Lecomte du Nouÿ was struck by the "tragic appeal" made by a great physicist to his colleagues: "Can one not keep determinism, if only as a belief?" Determin-

214. Ruled surface.

215. The Great Saint Bernard tunnel.

ism, that prop and stay of objective, knowable reality, which Heisenberg's uncertainty principle had just destroyed. It would be impossible to imagine a simpler way of expressing the disarray of understanding cut off from its own roots.

It is a similar disquiet that people feel when faced by an art which nothing any longer recalls the realist vision of the outside world. For realism goes far beyond the "good likeness" to which it is summarily treated as equivalent: it is always, still, the basis of our approach to visual art, even if likeness is rejected as a criterion of excellence. No one nowadays will say that a form is beautiful because it is a good likeness — but everyone is instinctively at ease in front of a form which he recognizes. The reflex that makes us look for the title of a picture whose subject we cannot tell at once is simply the desire to be guided so as to penetrate the forms. Realism is an Ariadne thread, and the habit of having it constantly within reach makes abstract art, for us, a labyrinth. So, through the mediation of the likeness, realism favors and insures communication. It is the bridge between the artist's isolated self and other people. It is cognition extended by passing through recognition.

It is enough, nonetheless, to remember that, if realism acts on us, it does so through form, therefore for aesthetic reasons outside and independent of the object figured; once this is remembered, the fact of recognizing the thing a work of art represents is revealed as what it is — secondary. The other aspect of realism then comes to the fore, its limitative aspect. Realism, that traditional guarantee of communication, is also a brake upon the imagination.

Cubism was the first to react against any such brake. A cubist picture accepts the outside world but does not stop at its conformation: on the contrary, it equips form to go beyond that. The object, associated with a geometrical figure, passes outside its own limits, moves away from itself; and this movement into the non-known is each time a longer one, and becomes the essential.

The object is not excluded; only, its movement in the painting is left open, and it is for the eye to set out upon that movement, in the opposite direction, to find the object again at the other end. "The person looking at the picture goes over again the same path as the painter," says Braque. What now matters to the artist is the path leading to the object and the direction this path will take.

It is clear that this form, joined as it is to the object and yet independent of it, is at the borders of abstract art. Historically it came before, but also—as we can see today—it follows. Apart from the original expressionist or surrealist tendencies, apart from the new figuration, the whole of present-day painting has— with an attitude of mind similar to that of the cubists, but different formal exigencies—resumed contact with reality beyond the limits of the object, without even thinking of these formerly impassable limits. The present-day figurative way of seeing is a total opening of the sensibility, an utterly direct approach to reality: amplifying the mental freedom of the cubists, it places itself altogether outside any likeness. Everywhere the art of our century, whether abstract or not, rejects realism.

But when we have perceived the two margins that contain pure abstraction, and when we see how the power of abstraction has extended to forms that imply reality, then the question of communication arises all the more imperiously because it concerns almost the whole of the art of today. Exactly how does this art act? Where does the relationship between creator and spectator establish itself, now that realism, the traditional ground of this relationship, does not exist?

Abstract art and communication

Once again, the answer must be sought obliquely.

Since the experience of which an abstract work of art tells is centered on the specific means of expression of that art, its signifi-

cance has to be read in the interaction of the forms, in the combination of the colors. Being subjective in the highest degree, every abstract painting and every abstract sculpture will be always at the same distance from our understanding, whether it is barely sketched or finished: unlike a realist work of art, it will not be more "clear" at the end than at the beginning. What then makes its structure attract and hold us? And what part of us does it attract and hold?

Gestalt psychology has undoubtedly given the most exhaustive answer to that question, because it has managed to discover objective beacons deep down in our most subjective experience of form — because it has been able to observe certain constants in the immediate reactions of our senses, apart from the understanding and not bound up with it in any way. By so doing it has completed classical psychology, which considered subjectivity as unsurmountable precisely because introspection could only increase unintelligibility; on that slope where a fall into the incommunicable seemed inevitable, Gestalt psychology applied a brake when it provided scientific proof that the ineffable is not necessarily incommunicable. And since the whole adventure of the abstract work of art takes place far away from what can be stated logically, it seems to me that the key to its message must be looked for in the *Gestalt* — that untranslatable German term for a form conceived as somehow including both the form-aspect *and* its experience. It seems, in short, that there is an infallible correspondence between pure form, taken in all its complex appearance, and our sensory structures by virtue of which we perceive it. What is more, we seem to be sensitive to a balance or imbalance in forms, and this is spontaneously perceived through being a reflection of these same sensory structures — especially when we are dealing with forms produced by man (like those of art), because they have been created out of the man's sensory structure, which is like ours. That balance, felt on the sensory

level, must give the spectator, it seems to me, the assurance which likeness gives him in a realist work of art; and it is at that level that communication probably takes place in abstract art — closer than words, closer than intellectual categories, within an area where there are only sensory data common to artist and on-looker. Gestalt psychology has noted that within this area the image organizes itself according to visual fields, obeying corresponding lines of force, and that optical permutations are accomplished in a way that does not vary from one individual to another. It has thus been able to distinguish, beyond the isolated form, wholes made up of forms in which each element exists only in virtue of the rest, so that we apprehend at once the whole and the part — that is to say, the relation uniting them. This immediate and complex experience, at one and the same time total and full of fine shades, is what abstract art offers us. Its clarification is the most advanced — and most disputed — point reached by Gestalt philosophy: it seems to me essential for the "comprehension" of abstract form — in itself a point in favor of this theory, which indeed is contemporary with abstract art since its earliest rudiments date from about 1920.

Dead end of critical language and deepening of abstraction

To arrive at envisaging an objective behavior of forms, to arrive at linking their action to our reactions without passing through the subjective content which particularizes expression ad infinitum, is an enormous step forward. An Ariadne thread that is other than realism, an imperceptible one, guides us unawares. And so the abstract work of art, as it turns away from the outside world, turns toward something deeper which we have in common with the artist, and seeks to render this visible. What

it discovers belongs to us the more indissolubly since the conscious mind cannot step back from it to give it a label. Just where, in appearance, an abyss separates creator from spectator, there is only proximity between the thing and its expression–a proximity inconceivable in the past. And it is by becoming abstract that art has produced it and acquired it. Inside, within its enclosures, it has been ceaselessly refining its means. Perception has tightened up, until it can apprehend its own arising and transmit it to form. So this effort of interiorization, this concentration of expression upon itself has ended by becoming an opening out, in the opposite direction: the initial, geometrical, rational, remote abstraction has been succeeded by a *figuration-in-proximity*, which defeats critical language. It does, in fact, figure the external world, but because it does not step back from this to see it at a distance, because it is attentive to the relationship which makes part merge into whole, it is, to the understanding, abstract. In this way, abstraction and figuration have become, in our day, reversible. They have infiltrated each other, while the words designating them continue to treat them as opposites.

The result is a gap between sensibility, projected forward by plastic experiments that sharpen it, and understanding, held back by its categories. Hence the difficulties experienced by language when it is faced with present-day art. If it enters upon explanations it becomes breathless under an overload of ideas, and this inevitably hinders comprehension. As an instrument for dealing with forms, language has become superannuated, and is of little use for communicating to a wider public plastic expression at the stage this has reached. To what extent is abstract art accepted nowadays? That is hard to answer; for one would have to know just how far a work of art in which realism is lacking makes the majority of spectators ill at ease. The habit of expecting an intellectual content is a powerful brake on people's

responses, and it is, after all, only for a couple of generations that we have been looking at abstract pictures and sculptures. We are not conditioned to them. We can only explain them by some detour. It would take little to make people deny Gestalt theory any value and consider communication as having been abolished – or momentarily broken off, according to some people who are waiting for a frank return to figuration to enable art to resume contact with the general public.

But to reason in this way is to leave out the essential – to forget that ambiguity which is now the motive power of forms: ambiguity from the rational point of view, but in fact a condition of multi-valence, for we are dealing (as we have seen) with a multiplicity of extended powers, the very opposite of the twofold inadequacy characteristic of ambiguity. The uneasiness felt by spectators is only intellectual, and communication has not been either abolished or broken off – it has simply been repelled by the

216. Microphotograph of wood.

understanding and has turned into impregnation. Whether understood or not, abstract art has marked our daily life for good. The short cut taken by abstract form has imposed its laws upon the technique of publicity in all its graphic aspects. The purposive epitome (or ellipsis) of abstract line turns up as the basis of industrial design and is evident in its successful examples. Finally, functional economy of ornament in architecture stems directly from the abstract aesthetic. All these signs, together with others that belong to the field of semiology, are unmistakable. The setting of our lives has given a welcome to something that still has to force aside the frame of our thinking in order to gain admittance. Daily life has assimilated abstraction and, to a certain extent, reduced it to subjection. So abstract forms have worked in depth. May not this be a marginal confirmation of the results of the Gestalt theory? In any case art—which never proves, but indicates, because it precedes—has once again been the traditional mediator. Through the devious course of its abstract development it has smoothed, is still smoothing, the passage from the classically conceived reality to the reality which has replaced it: our own.

II

The indispensable condition for arriving at abstract art was, in my opinion, to succeed in separating reality from realism and in finding, for this "new" reality, a possibility of communication apart from the intellect. Both these enterprises cost considerable mental effort. We are all bad at and have trouble in objectivating what is part of ourselves. Knowledge of this difficulty, and awareness of the obstacles that keep us at a distance from abstract art, have made us seek support in science and ask help

from Gestalt psychology. But once the direction leading to abstract art has been recognized, a caveat becomes necessary.

Art as opposed to science

In spite of their parallel progress toward an abstract condition, and in spite of the period which they share, art and science have continued to exhibit the essential opposition which has always existed between them and always will. The further their achievements have gone, the more they have withdrawn into separation — have even stayed ranged in a mutual conflict, so that in the end art has become the remedy for the excesses of science.

To this also abstract art bears witness. Its development, the kind of spiral course it seems to have taken, compels us to recognize that, when in the thirties abstract form reached its fullest expansion, it became empty — and then, to regain vigor, withdrew into itself. What caused this exhaustion (since in principle a form of expression, once arrived at its plenitude, maintains itself for a certain time before dissolving)? What does that withdrawal mean?

The question deserves our attention; it brings us up against the difference there really is between art and science as regards abstraction, the point where the specific working of art and the diametrically opposed working of science are clearly apparent.

In the pre-1914 world, which was still tied to the past, art opened up the future when it foretold the power of abstraction. What nourished it was this prophetic condition, the attraction of a new aspect of form coming to birth. When abstraction was no longer a path leading to the unknown, but a level and open road, art turned away and went back. Abstraction pushed to the extreme and made into a system has no meaning in art. But in

science, on the contrary, it acquires its meaning precisely when it is raised up into a system, because then it makes progress possible. So the antinomy is clear: the very movement which exalts science kills art. And when the future foreshadowed by abstract art and molded by scientific progress transforms life radically, precipitates man into abstraction and threatens to cut him off from his roots, it is then that — precisely where (and this is a triumph of science) abstraction is establishing its empire — abstract art reacts against the facility lying in wait for it: it withdraws and deepens. Form, menaced with becoming stereotyped through clinging to pure abstraction (as it became menaced around 1930), quickly changes — as though identifying itself with man, similarly menaced unawares — and becomes a refuge for our sensibility: a more and more secret, more and more intimate refuge, the necessary antidote with which to fight the desiccating power of abstraction. So we see art allying itself with man against the leveling caused by scientific progress, and fulfilling in this day and age, under the sign of abstraction, the function it has always had: to guarantee to the human being a precinct of survival.

Paris 1965

Comparative chronology

1887 Birth of Jean Arp, Kurt Schwitters, and Marcel Duchamp.
1889 Birth of Willi Baumeister.
 World Exhibition in Paris, opening of Eiffel Tower.
 Bergson publishes "Les données immédiates de la conscience."
1890 Birth of Gabo, Tobey, and Lissitzky.
 Death of Van Gogh.
1891 Birth of Rodchenko.
 Gauguin in Tahiti.
 Retrospective exhibition of Van Gogh at the Salon des Indé-
 pendants.
1893 Birth of Julius Bissier.
1895 *Impressionists' exhibition in Moscow.*
 Cézanne exhibition at Vollard's gallery.
1897 *Foundation of "The Secession" in Vienna: President, Gustav*
 Klimt.
1899 *Foundation of "The Secession" in Berlin: President, Max*
 Liebermann.
1900 *Gaudi constructs the "Labyrinth" in the Güell Gardens,*
 Barcelona.
 The Jugendstil at its height in Munich.
 Planck publishes the quantum theory.
1901 *Retrospective exhibition of Van Gogh at the Galerie Bernheim,*
 Paris.
1902 *First performances of Debussy's "Pelléas et Mélisande."*
1903 Birth of Rothko.
 Death of Gauguin and Pissarro.
1904 Birth of Hartung.
 Cézanne exhibition at Cassirer's gallery in Berlin.
 Exhibition of Cézanne, Van Gogh, and Gauguin in Munich.
1905 *Foundation of the "Brücke" at Dresden.*
 The Fauves exhibit at the Salon d'Automne.
 Einstein publishes limited theory of relativity.
1906 Birth of Poliakoff.
 Retrospective exhibition of Gauguin at the Salon d'Automne,
 Paris.
1907 Worringer writes "Abstraktion und Einfühlung."

Matisse exhibition at Cassirer's gallery in Berlin.
Retrospective exhibition of Cézanne at the Salon d'Automne.
Picasso finishes "Les Demoiselles d'Avignon."

1908 Birth of Vieira da Silva.
Braque exhibits his cubist landscapes at Kahnweiler's gallery in Paris.
Matisse publishes his "Notes d'un peintre" in the "Grande Revue."
Brancusi finishes "The Kiss."

1909 Kandinsky publishes his first writings on art in the Russian review "Apollon."
The "Futurist Manifesto" is published in Paris, in "Le Figaro."
Diaghilev starts the Ballets Russes.
The cubists exhibit at the Salon d'Automne.

1910 Kandinsky paints his first abstract watercolor; a first draft of "Concerning the Spiritual in Art" appears in Russian, under the title "Content and Form," in the catalogue of the Second International Salon at Odessa.
Picasso paints the "Portrait of Ambroise Vollard."
Foundation in Berlin of the gallery and review "Der Sturm," directed by H. Walden.
First performances of Stravinsky's "Firebird" by the Ballets Russes.
Webern composes "Orchesterstücke," opus 6.

1911 Kandinsky and Franz Marc found the "Blaue Reiter" and prepare the exhibition with the same name, which takes place at the end of the year.
Mondrian arrives in Paris.
Braque paints "Le portugais."
The Cubist Room creates a scandal at the Salon des Indépendants.
Foundation of the review "Soirées de Paris."
In Rome, first exhibition of futurist painting and sculpture.
Malevich comes under the influence of futurism.
Malevich, Tatlin, and Goncharova take part in the Youth Union Exhibition in St. Petersburg.
Exhibition organized by the "World of Art" at St. Petersburg.

First performances of Stravinsky's "Petrouchka" by the Ballets Russes.
Schönberg writes his "Harmonielehre."
In December 1911 Kandinsky's "Concerning the Spiritual in Art" is brought out by the Munich publisher Piper. (The printer's note at the end gives the date "January 1912.")

1912 Delaunay paints his "Windows" and the first of his "Circular Forms."
Kupka exhibits his first abstract pictures at the Salon des Indépendants.
Larionov paints his first rayonist pictures, which are abstract.
At the "Der Sturm" Gallery, Berlin, Kandinsky exhibits the paintings done by him from 1901 to 1912.
The second edition of "Concerning the Spiritual in Art" appears in Munich in April, and the third in December.
Birth of Jackson Pollack.
Gleizes and Metzinger publish "Du Cubisme."
The "Blaue Reiter" Almanac appears in Munich.
The first Paris futurist exhibition is organized at the Galerie Bernheim–Jeune, before going to London, Berlin, Amsterdam, Vienna, etc.
The exhibition of the "Golden Section" takes place at the Galerie "La Boétie," Paris.
Second "Blaue Reiter" exhibition in Munich.
International exhibition of the Sonderbund at Cologne.
Second post-impressionist exhibition organized by Roger Fry at the Grafton Gallery, London.

1913 Malevich paints his "Black Square" and does the settings and costumes for the melodrama "Victory over the Sun."
Mondrian paints the "Trees" series.
Tatlin goes to Paris and meets Picasso.
The "Rayonist Manifesto" appears in Moscow, and the "La Cible" exhibition groups together the rayonist works of Larionov and Goncharova.
Kandinsky publishes "Klänge" (Sonorities), his book of poems illustrated by woodcuts; also "Looking Back."
Delaunay exhibition at the "Der Sturm" Gallery, Berlin.
The Americans Morgan Russell and Macdonald Wright, influenced by Delaunay, create synchronism.

First exhibition of Boccioni's sculptures at the Galerie "La Boétie," Paris.
The Armory Show takes place in New York and in Chicago.
Apollinaire publishes "Les peintres cubistes."
First collages of Braque and Picasso.
First performances of Stravinsky's "Sacre du Printemps" by the Ballets Russes.

1914 Tatlin creates his first counterreliefs.
Birth of Nicolas de Staël.
Marcel Duchamp signs his first "Ready-mades."
Boccioni publishes "Pittura scultura futuriste" in Milan.

1915 Mondrian paints the "Plus and Minus" series.
First abstract drawings of Rodchenko.
Malevich sends 36 suprematist works, including "Black Square," to Exhibition "0.10," organized in St. Petersburg.
Van Doesburg meets Mondrian.

1916 Malevich publishes in Petrograd "From Cubism and Futurism to Suprematism."
First dada exhibitions at Zurich.
Death of Boccioni and Franz Marc.

1917 Foundation of the "De Stijl" group. The first number of their review appears in October 1917 — the last in January 1932.
Founding members: the painters Van Doesburg, Van der Leck, Huszar, and Mondrian; the sculptor Vantongerloo; the architects Oud, Wils, and Van't Hoff; and the poet Kok.
Tatlin, Rodchenko, and Yaculov work on the decoration of the "Picturesque Café" in Moscow.
Resumption of the Ballets Russes. First performances of "Parade" with Picasso's settings and costumes.

1918 Malevich exhibits his "White on White" pictures at the Tenth State Salon, which opens its doors in Moscow in December; he is appointed professor at the Vitebsk School of Art.
Kandinsky, returning to Russia, is appointed professor at the State Art Workshops, then at the Fine Arts Academy in Moscow. Founder of the Academy of Arts and Sciences, he sets up 22 provincial museums.
The founding members of the "De Stijl" review publish their manifesto in the November number.

Ozenfant and Charles Jeanneret (Le Corbusier) publish "After Cubism" and organize the first purism exhibition.
Death of Apollinaire.

1919 First retrospective exhibition of Malevich in Moscow; 153 works exhibited.
Mondrian returns to Paris after five years in Holland.
Foundation of the Bauhaus at Weimar.
Schwitters creates his first "Merzbild."
Birth of Soulages.
Dada exhibitions at Cologne and Berlin.

1920 Tatlin sends the model of the "Monument for the Third International" to the exhibition organized to celebrate the Third Congress of the Komintern.
Gabo and Pevsner publish the "Constructivist Manifesto."
Ozenfant and Le Corbusier found the review "Esprit nouveau."

1921 Gabo works on his first "Kinetic Constructions."
In New York Marcel Duchamp begins his abstract film, "Anemic Cinema."

1922 Exhibition of Russian abstract art at the Damien Gallery, Berlin.
First contacts of Lissitzky with the Bauhaus.
Start of the series of books published by the Bauhaus (Bauhausbücher), under the direction of Moholy-Nagy.
Moholy-Nagy begins work on a "luminous machine" (not completeted until 1930).
In Berlin the Pole, Henryk Berlewi, works out his theory of "Mécanofacture," a kind of fusion of graphic art and abstract painting.
Ilya Ehrenburg and Lissitzky publish the review "Vescht, Gegenstand, Objet" in Berlin.
Presentation in Berlin of the abstract film by Viking Eggeling, "Diagonal Symphony."
Kandinsky, returning to Germany, becomes professor at the Bauhaus.
Dissolution of dada.
Baumeister decorates the Stuttgart Exhibition Palace with mural paintings in relief.
Joyce publishes "Ulysses."

1923 "De Stijl" exhibition in Paris at the Galerie "L'effort moderne," directed by Léonce Rosenberg.
Rodchenko for the first time uses photomontage to illustrate a poem by Mayakovski.
Tobey becomes professor at Seattle.
Le Corbusier publishes "Vers une architecture."

1924 Schwitters begins the first Merz construction in his house in Hanover on which he is to work for ten years.
Léger makes the film "Le Ballet mécanique."
André Breton publishes the "Surrealist Manifesto."
Kandinsky, Klee, Feininger, and Javlensky found "Les quatre bleus" group.
Brancusi creates "The Egg" or "The Beginning of the World."

1925 The Bauhaus is transferred to Dessau.
Mondrian's writings appear in the Bauhaus publications under the title "Neue Gestaltung."
International Exhibition of the Decorative Arts in Paris.
Arp and Lissitzky publish "Die Kunstismen" (The Isms of Art).
Tobey works in Paris.
Arp settles at Meudon.
Calder gives the first performances of his "Miniature Circus."
First surrealist exhibition at the Galerie Pierre, Paris.

1926 Arp, Sophie Taeuber-Arp, and Van Doesburg start work on the decoration of the restaurant and cabaret "L'Aubette" at Strasbourg: completed in 1926; since destroyed.
Kandinsky publishes "Punkt und Linie zu Fläche" (Point, Line, Surface).
Van Doesburg publishes the "Elementarist Manifesto" ("De Stijl," Nos. 75–76).
International exhibition of abstract art at Zurich.

1927 Journey of Malevich to Poland; stay in Germany and return to Soviet Union. A room is devoted to his painting at the Grosse Berliner Kunstaustellung. "Die Gegenstandslose Welt" (World Without Object) appears under the Bauhaus imprint.
Pevsner and Gabo design the décor for "La Chatte" for the Ballets Russes.
Josef Albers begins his plastic studies in paper, as part of his

course at the Bauhaus, linking abstract art theory with mass production.

Hartung arrives in Paris.

Klee exhibits in Paris for the first time. Heidegger publishes "Sein und Zeit" (Being and Time).

1929 Kandinsky exhibits in Paris for the first time.

International exhibition of abstract and surrealist painting and sculpture at the Kunsthaus in Zurich.

Foundation of the Museum of Modern Art in New York.

1930 Exhibition of the "Cercle et Carré" group, organized in Paris by Michel Seuphor and bringing together 46 abstract artists.

Van Doesburg creates the review "Art concret."

Calder at work on what Duchamp later names "mobiles."

First of Julius Bissier's brush drawings with India ink.

Retrospective exhibition of Malevich at the Tretiakov gallery, Moscow.

1931 Foundation in Paris of the "Abstraction-Création" group.

Death of Van Doesburg.

Second surrealist exhibition at the Galerie Pierre, Paris.

1932 The Bauhaus is transferred to Berlin.

Important Picasso retrospective at the Galerie Georges Petit, Paris.

1933 Bauhaus closed by the Nazis.

Tatlin exhibits in Moscow the model and drawings for his glider "Letatlin."

Important Braque retrospective at the Kunsthalle, Basel. Start of the review "Le Minotaure" predominantly surrealist.

1934 Tobey goes to China with the English potter Bernard Leach. He moves on to Japan and lives for two months in a Zen monastery at Kyoto.

Hans Hofmann opens his school of painting in New York.

Kandinsky meets Delaunay and Mondrian.

1935 Tobey achieves his "white writing"; his series of "Broadway" pictures.

Death of Malevich.

Marcel Duchamp finishes the "Disques visuels" series–abstract compositions which, by a rotatory movement, give the impression of having three dimensions.

1936 The Museum of Modern Art in New York organizes a big exhibition devoted to cubism and abstract art.
Exhibition of Kandinsky, Arp, Hartung and Hélion at the Galerie Pierre in Paris.
Large-scale international surrealist exhibition in London.

1937 Moholy-Nagy opens the New Bauhaus in Chicago.
Delaunay paints reliefs and a mural painting 780 sq.m. in the setting of the International Exhibition in Paris.
Sophie Taeuber-Arp founds the review "Plastik" (1937–1939).
World Exhibition in Paris: the pavilion of Republican Spain features works by Gonzalèz and Miró, and Picasso's "Guernica."

1938 Exhibition of abstract art at the Stedelijk Museum, Amsterdam.
Tobey returns to Seattle.
Sartre publishes "La nausée."

1939 First Réalités Nouvelles exhibition takes place at the Galerie Charpentier, Paris.

1940 Mondrian in New York begins his "Boogie Woogie" series.
Death of Klee.

1941 Ben Nicholson's "Notes on Abstract Art" appear in the review "Horizon."
Deaths of Delaunay and Lissitzky.

1942 First one-man show of Mondrian's work at the Dudesing Gallery, New York.

1943 First exhibition of Jackson Pollock in New York, at the Art of This Century Gallery directed by Peggy Guggenheim.
Death of Sophie Taeuber-Arp.
Foundation of the Salon de Mai in Paris.

1944 Death of Mondrian.
Death of Kandinsky.
"Art concret" exhibition in Basel.
First one-man show of Tobey at the Marianne Villard Gallery, New York.
First one-man show of Motherwell at the Art of This Century Gallery, New York.
Dubuffet exhibition, presented by Jean Paulhan, at the Galerie Drouin, Paris.
Death of Marinetti.

1945 "Art concret" exhibition at the Galerie Drouin, Paris, grouping Kandinsky, Mondrian, Delaunay, Arp, Herbin, Van Doesburg, Pevsner, Sophie Taeuber-Arp, Freundlich, Magnelli, Domela, and Gorin.
Exhibition of Fautrier's "Otages" (Hostages) at the Galerie Drouin, Paris, with catalogue prefaced by André Malraux.
First exhibition of abstract paintings by Poliakoff at the Galerie "L'esquisse," Paris.
Exhibition of watercolors by Wols at the Galerie Drouin, Paris.
Opening of the Galerie Denise René, Paris.
Opening of the First Salon de Mai.

1946 First salon of the Réalités Nouvelles.
Exhibition of abstract painting at the Galerie Denise René, Paris, grouping Dewasne, Deyrolle, Marie Raymond, Hartung, and Schneider.
Exhibition of Domela, Hartung, and Schneider at the Salle du Centre de Recherches, Paris.
Exhibition of Vasarely at the Galerie Denise René, Paris.
Exhibition of Herbin at the Galerie Denise René, Paris.

1947 First one-man show of the paintings of Hartung at the Galerie Lydia Conti, Paris.
Exhibition of Atlan at the Galerie Maeght, Paris.
First exhibition of the pictures of Wols at the Galerie Drouin, Paris.
"L'Imaginaire" exhibition at the Galerie du Luxembourg, Paris, grouping Arp, Atlan, Bryen, Leduc, Mathieu, Riopelle, Ubac, and Wols.

1948 H.W.P.S.M.T.B. exhibition organized by Mathieu at the Galerie Allendy, grouping Bryen, Hartung, Mathieu, Ubac, Wols, Stahly, and Michel Tapié.

1949 "The First Masters of Abstract Art," two exhibitions presented by Michel Seuphor at the Galerie Maeght, Paris.
Exhibition of Pevsner, Vantongerloo, and Max Bill at the Zurich Museum.
First one-man show of Soulages at the Galerie Lydia Conti, Paris.

1950 Dewasne and Pillet open the Atelier d'Art/abstrait, Paris, which lasts into 1952.

1951 Pierre Guéguen uses the word "Tachisme" for the first time.
Michel Tapié organizes, at the Galerie Paul Facchetti, Paris, the exhibition called "Les signifiants de l'informel" (The significant artists of the informal), grouping together Fautrier, Dubuffet, Mathieu, Michaux, Riopelle, and Serpan.
Mathieu and Michel Tapié organize at the Galerie Nina Dausset the exhibition called "Véhémences confrontées," bringing together Bryen, Capogrossi, de Kooning, Hartung, Mathieu, Pollock, Riopelle, Russell, and Wols.
At the Copenhagen Museum, Denise René organizes the exhibition called "Klar Form," bringing together nonfigurative painters and sculptors of the Paris School. The same exhibition later goes on to Helsinki, Stockholm, and Oslo.
"Abstract Painting and Sculpture in America" exhibition at the Museum of Modern Art, New York.
Retrospective exhibition of Tobey at the Whitney Museum, New York.

1953 "Ballet abstrait," a movie in color, painted directly on the film by the painters E. W. Nay, Hans Erni, and Severini.
Death of Tatlin in Moscow.

1954 First Abstract Sculpture Room at the Galerie Denise René, Paris.
Death of Matisse.

1955 "Le mouvement" exhibition at the Galerie Deni' e René, Paris, bringing together work by Agam, Bury, Calder, Marcel Duchamp, Jacobsen, Soto, Tinguely, and Vasarely. On this occasion Vasarely publishes some "Notes for a Manifesto."
Retrospective exhibition of Ben Nicholson at the Tate Gallery, London, then in Paris, Brussels and Amsterdam.
Death of Léger.

1956 Sam Francis does mural paintings for the Kunsthalle of Basel.
Death of Pollock.
"India Ink in Contemporary Japanese Calligraphy and Painting": exhibition at the Cernuschi Museum, Paris.

1958 Retrospective exhibition of Pollock at the Museum of Modern Art, Rome.
Retrospective exhibition of Kupka at the National Museum of Modern Art, Paris.

1959 Exhibition called "Jackson Pollock and the New American Painting" at the National Museum of Modern Art, Paris.
Retrospective exhibition of Bissière at the National Museum of Modern Art, Paris.
Retrospective exhibition of Mathieu at the Cologne Kunstverein.

1960 Foundation in Paris of the Recherches d'Art Visuel group.

1961 International Exhibition of Visual Art at the Museum of Contemporary Art, Zagreb.
Retrospective exhibition of Tobey at the Museum of the Decorative Arts, Paris.

1962 Retrospective exhibition of Rothko at the Museum of Modern Art of the City of Paris.
Retrospective exhibition of Jean Arp at the National Museum of Modern Art, Paris.

1963 Retrospective exhibition of Vasarely at the Museum of the Decorative Arts, Paris.
Retrospective exhibition of Nicols Schoeffer at the Museum of the Decorative Arts, Paris.
Retrospective exhibition of Mathieu at the Museum of Modern Art of the City of Paris.
Death of Braque.

1964 Retrospective exhibition of Sophie Taeuber-Arp at the National Museum of Modern Art, Paris.
Exhibition called "Nouvelle tendance" (International Exhibition of Visual Art) at the Museum of the Decorative Arts, Paris.
Retrospective exhibition of Fautrier at the Museum of Modern Art of the City of Paris.

1965 Retrospective exhibition of Calder at the National Museum of Modern Art, Paris.
Exhibition called "Mouvement 2" at the Galerie Denise René, Paris.
International exhibition called "Light and Movement" at the Berne Kunsthalle.
Death of Julius Bissier.

1966 Death of Jean Arp.

1967 "Light and Movement" exhibition at the Museum of Modern Art of the City of Paris.

Retrospective exhibition of Willi Baumeister at the National Museum of Modern Art, Paris.

Retrospective exhibition of Soulages at the National Museum of Modern Art, Paris.

1968 Exhibition of Josef Albers at the Landesmuseum, Münster, Germany.

1969 Exhibition of Mondrian at the Museum of the Orangerie, Paris.

Selected Bibliography

General Works

Alloway, L. *Nine Abstract Artists.* London: Tiranti, 1954.

Alvard, J. *Témoignages pour l'art abstrait.* Paris: Editions "Art d'aujourd'hui," 1952.

Apollonio, U. *Pittura italiana.* Venice, 1950.

Bakuchinski, A. "Sovremennaya rouskaïa skoulptoura" (Contemporary Russian Sculpture), *Iskusstvo*, Nos. 2–3, 1927.

Barr, A. H. *Cubism and Abstract Art.* New York: Museum of Modern Art, 1936.

Baur, J. I. H. *Nature in Abstraction.* New York: Whitney Museum of American Art, 1958.

Bayer, H., Gropius, W., and Gropius, I. *Bauhaus 1919–1928.* New York: Museum of Modern Art, 1938; reprints: Boston, 1952; Stuttgart, 1955.

Beskin, O. *Formalism v jivopisi* (Formalism in Painting). Moscow: Vsekhundozhnik, 1933.

Bouret, J. *L'Art abstrait.* Paris: Le Club français du livre, 1957.

Brion, M. *L'Art abstrait*. Paris: Albin Michel, 1956.

Bru, C.-P. *Esthétique de l'abstraction*. Paris, 1955.

Cavallini, A. *Arte astratta*. Milan: Gianpiero Giani, 1958.

Crispolti, E. *Appunti per una storia del non-figurativo in Italia*. N. p., 1958.

Degand, L. *Témoignage pour l'art abstrait*. Paris: Editions "Art d'aujourd'hui," 1952.

Domnick, O. *Die schöpferischen Kräfte in der abstraken Malerei*. Bergen: Müller & Kiepenheuer, 1947.

Dorfles, G. *Ultime tendenze nell'arte d'oggi*. Milan, 1961.

Duthuit, G. *L'Image en souffrance*. 2 vols. Paris, 1961.

Edouard-Joseph, R. *Dictionnaire biographique des artistes contemporains 1910–1930*. 3 vols. Paris: Art & Edition, 1930–1934.

Estienne, C. *L'Art abstrait, est-il un académisme?* Paris: Editions de Beaune, 1950.

Fasola, G. N. *Ragione dell'arte astratta*. Milan: Istituto editoriale italiano, 1951.

Fiedler, C. *On Judging Works of Visual Art*. Berkeley and Los Angeles: University of California Press, 1949.

Galvano, A. *Le Poetiche del simbolismo e l'origine dell'astrattismo figurativo*. Rome, 1956.

Giedion-Welcker, C. *Plastik der XX. Jahrhunderts*. Stuttgart, 1955.
———. *Contemporary Sculpture*. New York: Wittenborn, 1955.

Gindertael, R. V. *Permanence et actualité de la peinture*. Paris, 1960.

Goodrich, L., and Baur, J. *American Art of the Twentieth Century*. New York: Praeger, 1961.

Gray, C. *The Great Experiment—Russian Art 1863–1922*. New York: Abrams, 1962.

Grenier, J. *Entretiens avec dix-sept peintres non-figuratifs*. Paris, 1963.

Guichard-Meili, J. *La Peinture d'aujourd'hui*. Paris, 1960.

Habasque, G. "Les Documents inédits sur les débuts du Suprématisme," *Aujourd'hui Art et Architecture*, No. 4, 1955.

Haftmann, W. *Malerei im 20. Jahrhundert*. 2 vols. Munich: Prestel-Verlag, 1954–1955; rev. ed., New York: Praeger, 1960.

Heath, A. *Abstract Painting: Its Origin and Meaning*. London: Tiranti, 1953.

Hess, T. B. *Abstract Painting: Background and American Phase*. New York: Viking, 1951.

Jaffé, H. L. C. *De Stijl 1917–1931*. Amsterdam: Meulenhoff, 1956.

Jourdain, F., and Degand, L. *Art réaliste, art abstrait*. Souillac, 1955.

Kepes, G. *The New Landscape in Art and Science*. Chicago: Theobald, 1956.

Kopp, Anatole. *Ville et révolution: Architecture et urbanisme Sovietiques des années 20.* Paris: Editions Anthropos, 1967.

Lozowick, L. *Modern Russian Art.* New York: Société anonyme, 1925.

Marchiori, G. *Arte e artisti d'avanguardia in Italia 1910–1950.* Milan: Comunità, 1960.

———. *La Scultura italiana dal 1945 ad oggi.* Turin, 1961.

———. *Modern French Sculpture.* New York: Abrams, 1963.

Mats, I. *Iskusstvo sovremennoi Evropy* (European Art Today). Moscow, Leningrad: Gosydarstvennoe Indatelistvo, 1926.

Mojniagoun, S. E. *Abstraktionnism rasrouchénié estétiki* (Abstract Art as a Destruction of the Aesthetic). Moscow, 1961.

Paulhan, J. *L'Art informel.* Paris, 1962.

Poensgen, G., and Zahn, L. *Abstrakte Kunst, eine Weltsprache, mit einem Beitrag von W. Hoffman "Quellen zur abstrakten Kunst."* Baden-Baden: Waldemar Klein, 1958.

Ponente, N. *Peinture moderne, tendances contemporaines.* Geneva: Skira, 1960.

———. *Modern Painting, Contemporary Trends.* Geneva: Skira, 1960.

Ragon, M. *L'Aventure de l'art abstrait.* Paris: Laffont, 1956.

Read, H. *Art and Society.* New York: Macmillan, 1937; rev. ed., London: Faber and Faber, 1945.

Restany, P. *Lyrisme et Abstraction.* Milan: Apollinaire, 1960.

Rey, R. *Contre l'art abstrait.* Paris: Flammarion, 1957.

Ritchie, A. C. *Abstract Painting and Sculpture in America.* New York: Museum of Modern Art, 1951.

———. *Sculpture of the Twentieth Century.* New York: Museum of Modern Art, 1952.

Rosenberg, H. *The Tradition of the New.* New York: Horizon, 1959.

Salmon, A. *Art russe moderne.* Paris: Editions Laville, 1928.

Schmidt, G. *Kunst und Naturform.* Basel: Basilius Presse, 1960 (text in German, English, and French).

Seuphor, M. *L'art abstrait. Ses origines, ses premiers maîtres.* Paris: Maeght, 1949.

———. *Dictionnaire de la peinture abstraite.* Paris: Hazan, 1957; eng. ed., New York: Paris Book Center, 1957.

———. *La sculpture de ce siècle. Dictionnaire de la sculpture abstraite.* Neuchâtel: Griffon, 1959.

———. *La peinture abstraite, sa genèse, son expansion.* Paris, 1962.

———. *Abstract Painting.* New York: Abrams, 1962.

Stelzer, O. *Die Vorgeschichte der abstrakten Kunst. Denkmodelle und Vor-Bilder.* Munich: Piper, 1964.

Sweeney, J. J. *Plastic Redirections in Twentieth-Century Painting.* Chicago: University of Chicago Press, 1934.

Tapié, M. *Un art autre.* Paris: Gabriel-Giraud, 1952.

————. *Observations of Michel Tapié.* New York: Wittenborn, 1956.

Trucchi, L. *Qualche ritratto: da Cézanne a Pollock.* Rome, 1961.

Tugenhold, J. *Isdusstvo oktyabr'sky épokhi* (Art at the time of the October Revolution). Leningrad: Academia, 1930.

Umanskij, K. *Neue Kunst in Russland 1914–1919.* Munich: Hans Goltz Verlag, 1920.

Venturi, L. *Arte figurativa earte astratta.* Florence, 1955.

————. *The World of Abstract Art. American Abstract Artists.* New York, 1946.

————. *Pour et contre l'art abstrait.* (C. Estienne, L. Degand, Le Courneur, etc.) Paris, 1947.

————, *Perché l'arte non é popolare?* Milan, 1953.

————. *Sens de l'art moderne. Enquête. La Pierre-qui-vive.* Saint-Léger-Vauban, 1954.

————. *Arte figurativa e arte astratta. Mélanges de Fondation Giorgio Cini.* Florence, 1955.

————. *Révolution de l'infiguré.* Jarnac, 1956.

————. *L'art contemporain et la peintre.* Paris, 1961.

Monographs on the Principal Artists

Giedion-Welcker, C. *Jean Arp.* New York: Abrams, 1957.

Soby, J. T. *Arp.* New York: Museum of Modern Art, 1958.

Cathelin, J. *Arp.* Paris, 1959; New York: Evergreen Gallery Books, 1959.

Marchiori, G. *Arp.* Milan: Alfieri, 1964 (in Italian, English, and French).

Read, H. *Jean Arp.* London, 1968.

Ragon, M. *Atlan.* Paris: Georges Fall, 1962.

Dorival, B. *Atlan.* Paris, 1963.

Grohmann, W. *Willi Baumeister.* Stuttgart: W. Kohlhammer, 1952 (in German, English, and French).

————. *Willi Baumeister.* New York: Abrams, 1965.

Staber, M. *Max Bill.* London, 1964.

Schmalenbach, W. *Julius Bissier*. London, 1964.

Vallier, D. *Julius Bissier*. Stuttgart, London, 1965.

Fouchet, M.-P. *Bissière*. Paris: Georges Fall, 1955.

Mathey, F. *Bissière, journal en images. Oeuvres de 1962 à 1964*. Paris: Hermann, 1964.

Francastel, P. *Estève*. Paris: Editions Galanis, 1956.

Muller, J.-E. *Maurice Estève*. Paris, 1961.

Paulhan, J. *Fautrier, oeuvres*. Paris, 1943.

Ponge, F. *Notes sur les Otages*. Paris: Pierre Seghers, 1946.

Arcangeli, F. *Tempere disegni litografie di Fautrier*. Bologna, 1958.

Argan, G. C. *Matière et mémoire, Fautrier*. Milan: Apollinaire, 1960.

Buccarelli, P. *Jean Fautrier*. Milan: Il Saggiatore, 1960.

Paulhan, J. *Fautrier l'Enragé*. Paris, 1962.

Aust, G. *Otto Freundlich*. Cologne: M. Dumont Schauberg, 1960.

Read, H. *Constructivism: The Art of Naum Gabo and Antoine Pevsner*. New York: Museum of Modern Art, 1948.

Olson, R., Chanin, A. *Naum Gabo, Antoine Pevsner*. New York: Museum of Modern Art, 1948.

Read, H. *Gabo: Constructions, Sculptures, Paintings, Drawings*. London: Lund Humphries, 1957.

Read, H., Martin, L. *Gabo*. London: Lund Humphries, 1957.

Peissi, P., Giedion-Welcker, C. *Pevsner*. Neuchâtel: Griffon, 1961.

Ganzo, R. *Hajdu*. Paris: Georges Fall, 1957.

Rousseau, M. *Hans Hartung*. Stuttgart: Domnick-verlag, n.d.

Gindertael, R. V. *Hans Hartung*. Paris: Tisné, 1960.

Grohmann, W. *Hans Hartung. Aquarelles*. Saint-Gall, 1966.

Hodin, J. P. *Barbara Hepworth*. London: Lund Humphries, 1961.

Grohmann, W. *Wassily Kandinsky: Life and Work*. New York: Abrams, 1958.

Korn, R. *Kandinsky und die Theorie der abstrakten Malerei* (Abstract Art Studied and Challenged from the Marxist Viewpoint). Berlin, 1960.

Lassaigne, J. *Kandinsky*. Geneva: Skira, 1964.

Ragon, M. *Zoltan Kemeny*. Neuchâtel: Griffon, 1960 (in French, English, and German).

Cassou, J., Fedit, D. *Kupka*. Paris: Tisné, 1964.

Cayrol, J. *Manessier*. Paris: Georges Fall, 1955.

Moholy-Nagy, S. *Moholy-Nagy: Experiment in Tonality*. New York: Harper, 1950.

Seuphor, M. *Piet Mondrian: Life and Work.* New York: Abrams, 1956.

Gioseffi, D. *La falsa preistoria di Piet Mondrian e le origini del plasticismo.* Trieste, 1957.

Lewis, D. *Mondrian.* New York: Wittenborn, 1957.

Ragghianti, C. *Mondrian e l'arte del XX secolo.* Milan, 1962.

Menna, F. *Mondrian: cultura e poesia.* Rome: Edzioni dell'Ateneo, 1962.

Grohmann, W. *The Art of Henry Moore.* New York: Abrams, 1960.

Read, H. *Henry Moore: sculpture and drawings.* London: Lund Humphries, 1944 (vol. 1) and 1965 (vols. II and III).

Read, H. *Henry Moore: A Study of His Life and Work.* New York: Praeger, 1965.

Hedgecoe, J. *Henry Spencer Moore.* New York: Simon & Schuster, 1968.

Read, H. *Ben Nicholson, Paintings, Reliefs, Drawings.* London: Lund Humphries, 1948.

Reichardt, J. *Victor Pasmore.* London, 1961.

Seuphor, M. *Penalba.* Amriswil, 1960.

Ragon, M. *Poliakoff.* Paris, 1956.

Vallier, D. *Serge Poliakoff.* Paris, 1959.

O'Hara, F. *Jackson Pollock.* New York: Braziller, 1959.

Robertson, B. *Jackson Pollock.* New York: Abrams, 1960.

O'Connor, F. V. *Jackson Pollock.* New York: Museum of Modern Art, 1967.

Apollonio, U. *Santomaso.* Amriswil, 1959.

Haftmann, W. *Santomaso in Puglia.* Bari. Leonardo da Vinci editore, n.d.

Themerson, S. *Kurt Schwitters in England.* London. Gaberbocchus, 1958.

Alley, R. *William Scott.* London, 1961.

Bowness, A. *William Scott.* London. Lund Humphries, 1964.

Juin, H. *Soulages.* Paris, 1958; New York. Evergreen Gallery Books, 1960.

Ragon, M. *Soulages.* Paris, 1962.

Tudal, A. *Nicolas de Staël.* Paris, 1958.

Gindertael, R. V. *Staël.* Paris: Hazan, 1960.

Giedion-Welcker, C. *François Stahly.* New York: Wittenborn, 1962.

Schmidt, G. *Sophie Taeuber-Arp.* Basel: Holbein verlag, 1948.

Tapié, M. *Antonio Tapiès.* Barcelona: Dav al Set, 1955.

Pounin, N. *Tatline protiv coubisma* (Tatlin against Cubism). St. Petersburg: Gosvdartsveunoe Izdatelistvo, 1921.

Anderson, T. *Vladimir Tatlin.* Stockholm: Moderna Museet, 1968.

Roberts, C. *Tobey.* Paris, 1959; New York: Evergreen Gallery Books, 1960.

Choay, F. *Tobey.* Paris: Hazan, 1961.

Schmied, W. *Tobey.* New York: Abrams, 1966.

Solier, R. de. *Vieira da Silva.* Paris: Georges Fall, 1956.

Weelen, G. *Vieira da Silva.* Paris: Hazan, 1960.

Roché, H.-P. *Souvenirs sur Wols.* Paris, 1958.

Sartre, J.-P., Roché, H.-P., and Haftmann, W. *En personne, aquarelles de Wols.* Cologne, Paris, 1963.

Writings by Artists

Baumeister, W. *Das Unbekannte in der Kunst.* Cologne, 1961.

Bazaine, J. *Notes sur la peinture d'aujourd'hui.* Paris: Editions du Seuil, 1953.

Delaunay, R. *Du Cubisme à l'art abstrait.* The notebooks of Delaunay, published posthumously by P. Francastel together with a catalogue of Delaunay's works made by G. Habasque. Paris, 1957.

Freundlich, O. Extracts from Otto Freundlich's writings, published in the catalogue of the exhibition of his sculptures, at the Galerie Claude Bernard, Paris, 1957.

Gabo, N. *On diverse arts.* London, 1962.

Herbin, A. *L'art non-figuratif non-objectif.* Paris: Edition Lydia Conti, 1949.

Kandinsky, V. *Concerning the Spiritual in Art.* New York: Wittenborn, 1947.

———. *Rückblick (1901–1913).* Baden-Baden: W. Klein, 1955. *Regard sur le passé.* Paris: Galerie René Drouin, 1946.

———. *Punkt und Linie zu Fläche.* Munich: A. Langen, 1926; New York; Solomon R. Guggenheim Museum, 1947. *Point Ligne Surface.* Paris, 1963.

Lapicque, C. *Essais sur l'espace et la destinée.* Paris, 1937.

Lissitzky, E., and Arp, H. *Die Kunstismen 1914–1924*. Zurich: E. Rentsch, 1925 (in German, French, and English).

Malevich, K. *O novih sistémah v iskusstve* (The New Systems in Art). Vitebsk, 1922.

————. *Suprematism.* (In Russia.) Vitebsk, 1920.

————. *Bog ne skinut: iskusstvo, tserkov, fabrika* (God Has Not Fallen: Art, Church, Factory). Vitebsk, 1922.

————. *Die Gegenstandslose Welt.* Munich: Albert Langen, 1927.

————. *Suprematismus – Die Gegenstandslose Welt.* New edition, revised and corr. Introduction by Werner Haftmann. Cologne: Dumont Schauberg, 1962.

————. *The Non-objective World.* American translation abridged from *die Gegenstandslose Welt,* 1927 ed. Chicago: Paul Theobald, 1959.

Mathieu, G. *Au-delà du Tachisme.* Paris, 1963.

Moholy-Nagy, L. *Von Material zu Architektur.* Munich: Albert Langen, 1929.

————. *The New Vision.* New York: Wittenborn, 1946.

Mondrian, P. *Le Néo-plasticisme.* Paris: Léonce Rosenberg, 1920.

————. *Plastic Art and Pure Plastic Art 1937 and Other Essays, 1941–1943.* New York: Wittenborn, 1945.

Moore, H. *Henry Moore on Sculpture.* Edited and with an introduction by P. James. London, 1966.

Pevsner, A. "Propos d'un sculpteur," *L'Oeil,* No. 23 (November 1956).

————. *Les écrits de Pevsner dans: Pevsner au Museé National d'Art Moderne.* Paris, 1964.

Schwitters, K. "Les Merztableaux," *Abstraction-Création,* 1932, p. 33.

————. "Merzbau," *Abstraction-Création,* 1933, p. 41.

Van Doesburg, T. *Classique, Baroque, Moderne.* Paris: Léonce Rosenberg, 1921.

————. "Elémentarisme," *Abstraction-Création,* 1932, p. 39. See also De Stijl, January, 1932: number devoted to Van Doesburg.

Vantongerloo, G. *L'art et son avenir.* Antwerp: De Sikkel, 1924.

————. "Préliminaire, axiome, postulat," *Abstraction-Création,* 1932, pp. 40–41.

————. *Paintings, Sculptures, Reflections.* New York: Wittenborn, Schultz, 1948.

Periodicals

These have ceased to appear but were devoted exclusively to abstract art:

De Stijl. 1917–1932. Leyden, later Clamart and Meudon.
Vecht, Gegenstand, Objet. Berlin, 1922.
Zeitschrift für elementare Gestaltung. Berlin, 1923.
Cercle et Carré. Paris, 1930.
Art Concret. Paris, 1930.
Abstraction-Création. Paris, 1932–1933.
Axis. London, 1935.
Art Abstrait. Brussels, 1952.

These have published in the past and continue to publish important texts on abstract art:

Art Forum. New York.
Art in America. New York.
Art International. Zurich.
Art News. New York.
Art News and Review. London.
Arts Magazine. New York.
Aujourd'hui Art et Architecture. Paris.
Cahiers d'Art. Paris.
Cimaise. Paris.
La Biennale. Venice.
L'Oeil. Paris.
Quadrum. Brussels.
XXe Siècle. Paris.

List of illustrations

1. Painting on beaten bark (New Guinea). Paris, Musée de l'Homme. Photo. from museum.
2. Paleolithic: schematic human and animal figures, painted, in the cave of La Graja (Spain). From copy H. Breuil.
3. Neolithic: inside of cup. Painted earthenware (Susa). Photo André Vigneau; pub. by Tel.
4. Bronze standard in the form of a bird's head (Ulski). Leningrad, Hermitage Museum.
5. Coin from Gaul: Atrebates. Laurel-wreathed head with profile missing. Paris, Bibliothèque Nationale, Cabinet des Médailles. Photo. from library.
6. Coin from Gaul: Nervii. Same elements transformed into ideogrammatic expression. Paris, Bibliothèque Nationale, Cabinet des Médailles. Photo. from library.
7. Coin from Gaul: Velocasses. Head composed of symbols. Paris, Bibliothèque Nationale, Cabinet des Médailles. Photo. from library.
8. Aurignacian: meanders traced in clay by fingers. Cave of Gargas. Photo. M. Barrat; pub. by "Cahiers d'Art."
9. Pablo Picasso, *Still Life*, 1908. Oil on canvas, 73 × 65.7.* New York, The Solomon R. Guggenheim Museum. Photo. from museum.
10. Georges Braque, *Harp and Violin*, 1912. Oil on canvas, 116 × 81. Düsseldorf, Kunstsammlung Nordrhein-Wesfalen. Photo. Witte.
11. Piet Mondrian, *Composition No. 1* (Trees), 1911. Oil on canvas, 85.5 × 75. Rotterdam, J. Hudig collection. Photo. Haags Gemeentemuseum.
12. Casimir Malevich, *The Guardsman*, 1912–1913. Oil on canvas, 57 × 66.5.

*All dimensions are in meters unless otherwise specified.

Color Illustrations

Index